KU-033-822

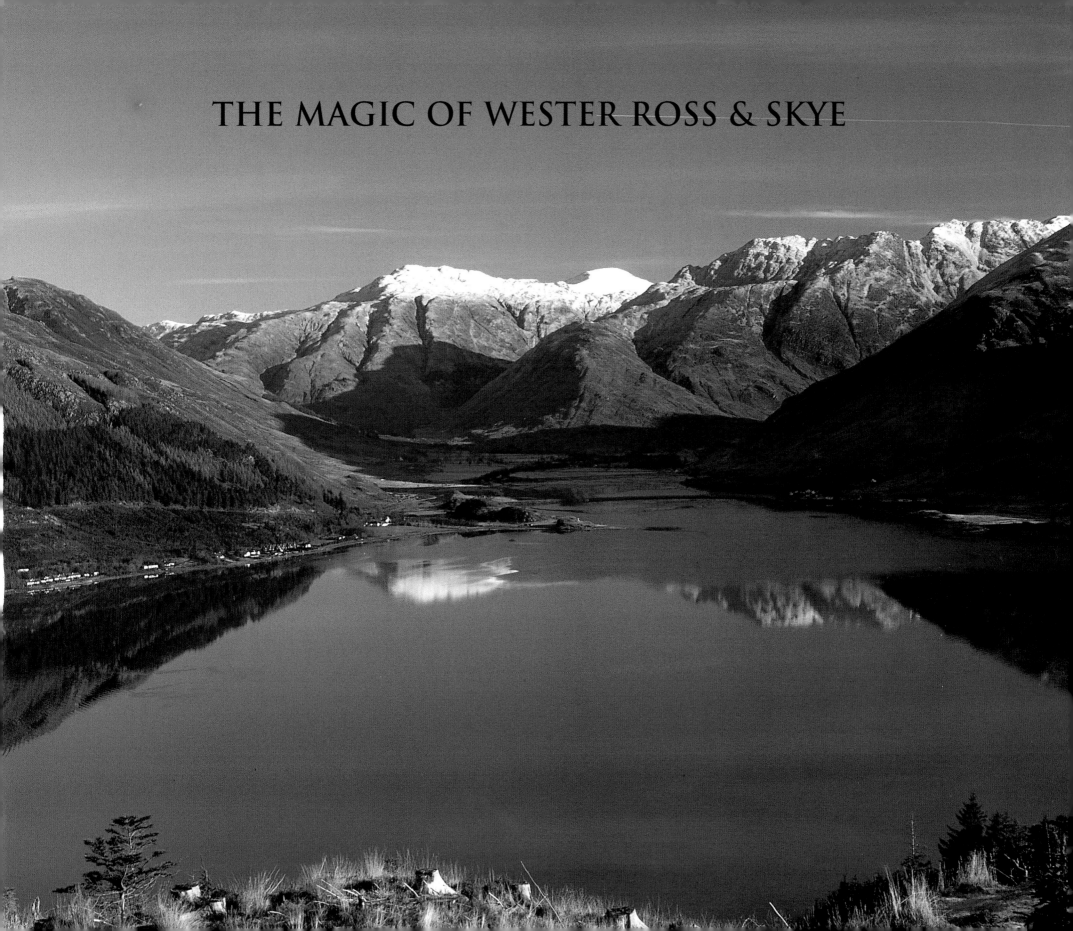

THE MAGIC OF WESTER ROSS & SKYE

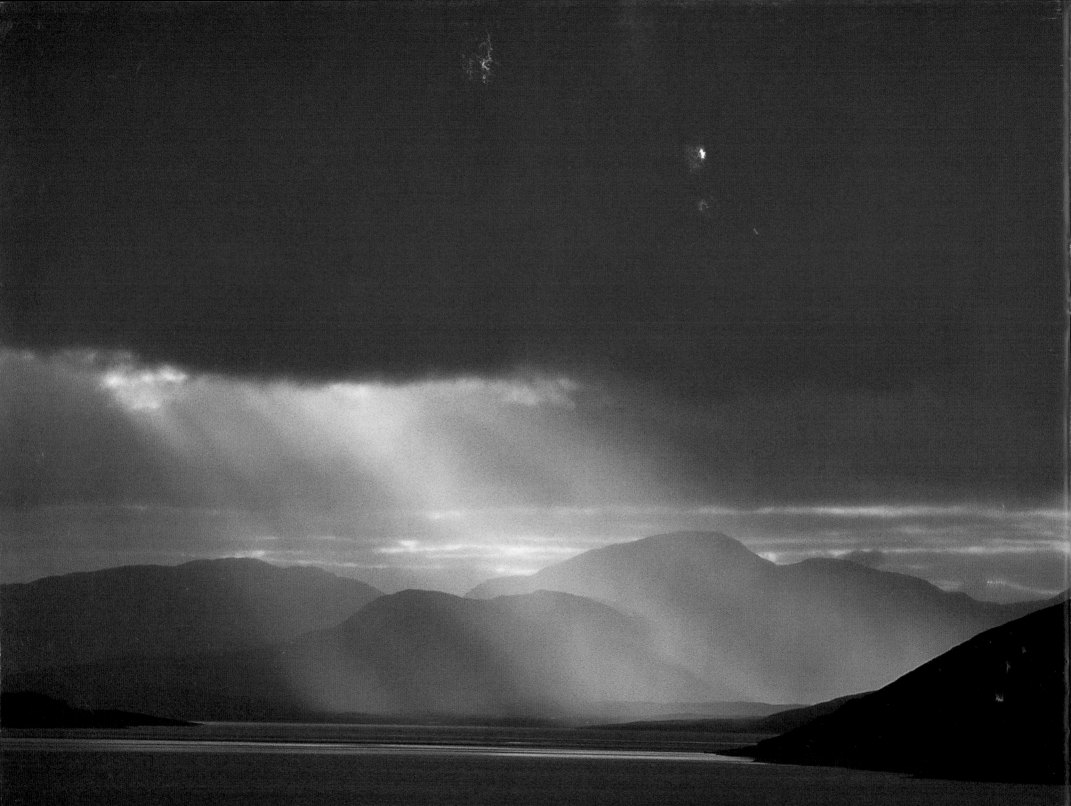

THE MAGIC OF
WESTER ROSS
& SKYE

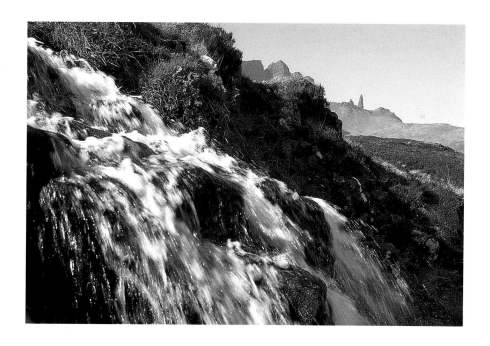

With best wishes

Clarrie Pashley *Martin Moran*

David & Charles

A DAVID & CHARLES BOOK

First published in the UK in 2001

Copyright © Martin Moran
and Clarrie Pashley 2001

Martin Moran and Clarrie Pashley have asserted
their right to be identified as authors of this
work in accordance with the Copyright,
Designs and Patents Act, 1988.

All rights reserved. No part of this publication
may be reproduced, stored in a retrieval system,
or transmitted, in any form or by any means,
electronic or mechanical, by photocopying,
recording or otherwise, without prior
permission in writing from the publisher.

A catalogue record for this book is available
from the British Library.

ISBN 0 7153 1148 4

Edited by Sue Viccars
Book design by Les Dominey
Maps drawn by Ethan Danielson

Printed in China by Hong Kong Graphics
for David & Charles
Brunel House Newton Abbot Devon

Page 1
A'Ghlas-bheinn and Beinn Fhada,
viewed across Loch Duich from Mam
Ratagan.

Page 2
Showers over Loch Glascarnoch,
looking towards the Beinn Dearg
range.

Page 3
Spring run off tumbles down the
burns from the Storr hills of
Trotternish.

This page
Liathach and Spidean Coire nan
Clach from the Beinn Eighe ridge.

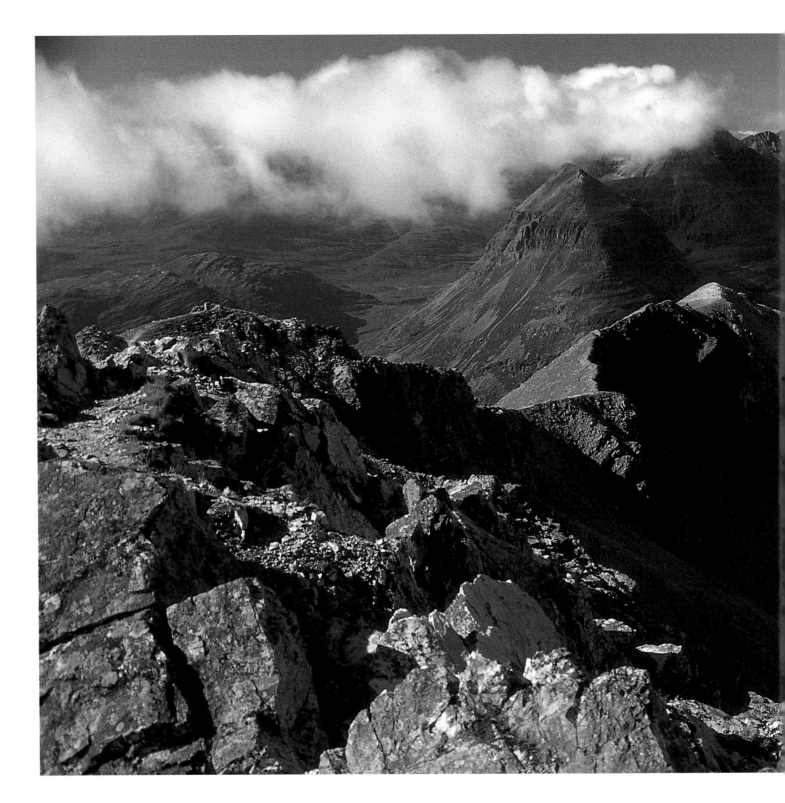

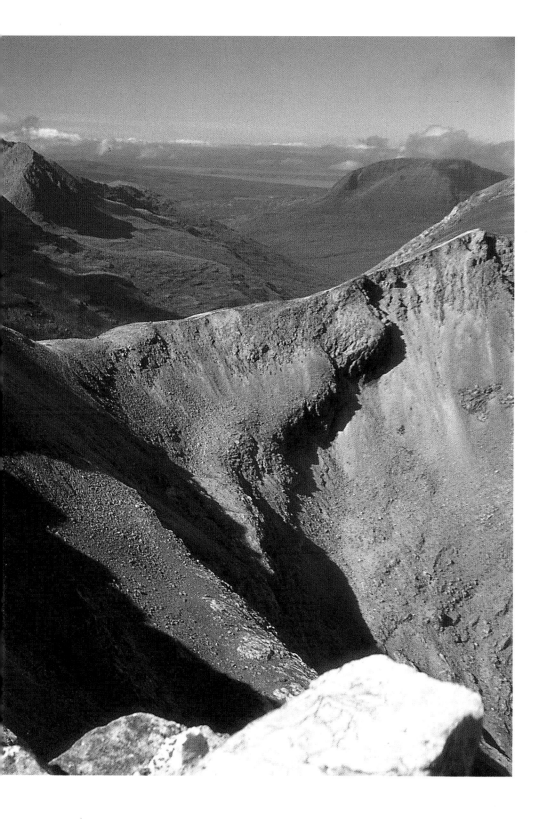

CONTENTS

INTRODUCTION

This book is the celebration of two of Britain's special places, the district of Wester Ross and the Island of Skye. Geographically adjacent and now joined by the bridge at Kyle of Lochalsh, blessed by the same maritime climate and forged culturally from a common social and economic history, they bear sufficient similarity to sit comfortably together in the same volume. Yet they are also quite distinct in many ways. Their geology is very different, giving rise to striking variations in landscape. Skye's scenery has the raw edge of isolation and exposure to the ocean, with deeply indented sea lochs and blunt, storm-lashed headlands, whereas Wester Ross has oases of fertility in its sheltered glens, bays and woodlands. There is such variety between and also within each area as to inspire all who see beauty in Nature's grander creations. In their landscape, seascape and the climatically controlled interplay of cloud, light and colour, Wester Ross and Skye rank alongside the most beautiful places, not just in the British Isles, but in the whole of the world.

A photographic portfolio inevitably reflects the partialities of human perception of the day. Where now we sense beauty at one time people felt only dread and loathing. The untamed mountains — barren of resource, harbouring storm and flood, mandating extra toil and suffering — have been transformed by eighteenth- and nineteenth-century Romanticism into places of awesome splendour and perfect peace, to be loved and protected. The mobilisation of these feelings in the second half of the twentieth century has created a growing movement in hillwalking and mountaineering which cuts across all social divides. The mountain is now worshipped with as much devotion as it was feared by the ancients. In the Torridon and the Cuillin Hills we have some of Britain's finest peaks, and views of them and from them feature strongly in the selection.

Were the Highlands still blanketed with scrub woodland and mature forest would we perhaps ignore the rich glow of the bark and the unfathomable green of the needles of the lone Scots pine as it reflects the winter sun? Would we fail to perceive a pride and nobility in its ancient branches, gnarled and stunted in their struggle against the storms of centuries? But what becomes rare and endangered quickly becomes valued, and today we glory in the beauty of those tracts of native woodland which survive in Wester Ross. For the photographer these trees become an essential component of a landscape picture.

Since the break-up of clan society, and until recent decades, the human history of Skye and Wester Ross was one

of social upheaval, resettlement, and a prolonged fight against poverty. With retrospect from a more prosperous age, these trials tend to be viewed with a tragic sentiment, which enhances the scope of the beauty we see in the places. The deserted cottage, where generations were raised only to leave their land, possesses poignant echoes of the past. The house becomes an essential foreground to a picture of the stormy seas beyond. The rectilinear strips of crofting fields of the coastal community, each with its whitewashed house, where families scraped a meagre living, today add a geometric focus to a landscape and please the eye. And the harbours and coves where the herring boats once sheltered from the storm now form a pretty assemblage of buoys, yachts and shoreline cottages.

Eileann Donan Castle silhouetted at sunset, looking over Loch Alsh to the Red Cuillin hills.

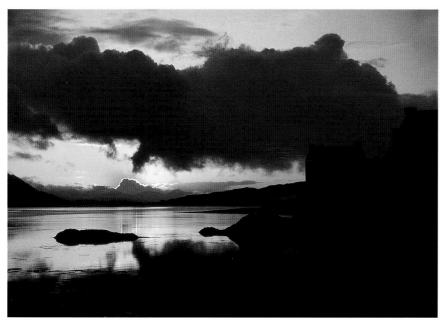

In Wester Ross and Skye human fortunes have been closely tied to the land and its resources. Man's imprint on the landscape reflects that harmony and we can readily absorb human activity into the scenes we admire. Time softens the harder edges of development. Today, we can include the Torrin marble quarries in the camera's range without feeling that we are spoiling the view. But the derelict corrugated iron sheds round and about – well maybe not! Fish-farm cages were an eyesore when they first appeared in the sea lochs in the 1970s. Today they are accepted as an integral part both of the scene and the local economy. The traditional croft house is currently the desired foreground to a West Highland picture, but in 50 years time the modern bungalow may look just as tasteful. Opinions on the Skye bridge vary but already we think it an elegant addition to the dramatic narrows of Loch Alsh. Permanence tends to foster aesthetic acceptance, but perhaps we will always resist gross scenic impositions such as wind farms and super-quarries.

A portfolio of photographs is not only selective in choice of valid subject, but must use the skills of composition to maximise its impact. Composition might be seen as trite or contrived but can be justified on two grounds. The transfer of a scene to the confines of the printed page robs the viewer of the ability to refocus and adjust the range to that portion of a view which is of interest. Unless the essential components of a picture are within the frame the eye will tend to wander off the page in search of missing stimulation. The arrangement of

subject and counterpoint, light and shade, rounded and angular outlines is essential to hold the gaze. A well-composed picture is also the one which jumps out from the page and recreates the original thrill of the actual view.

In the use of zoom lenses and filters the pictorial photographer can go beyond the faithful reproduction of an actual view and attempt to create what the eye might have wished to see, just as the landscape painter does with the brush. The telephoto shot produces extra drama and impression to a relief, while the polarising filter cuts the glare and produces contrast with a sky where the naked eye might have been squinting to decipher any horizon. The acceptable limits of such artistry lies ultimately with the viewer, whose senses will object when a photograph is over-dramatised or else appears falsely tinted. In Wester Ross and Skye neither zoom nor filters need be over-indulged for the power of the scenery and depth of colours are outstanding in themselves.

.

In choosing the title for the book we pay a debt to Walter Poucher whose *Magic of Skye*, published in 1949, opened many eyes to the unique atmosphere of the Cuillin mountains, and also to Irvine Butterfield whose book *The Magic of the Munros*, published in 1999, gave us the idea to expand the magical theme from the high mountains to encompass the whole landscape of our finest regions.

The pictures have been chosen with many criteria in mind. Foremost is the desire to provide a balanced geographical coverage of the area, but inevitably there are some wonderful places which are not featured: Achiltibuie and the Summer Isles, Red Point sands, the hills of Glen Carron and Waternish all come to mind. There is a mixture of the familiar and the unexpected; classic scenes cherished by generations of photographers mingle with views of wild secluded corners known to few. A full range of seasons and weather conditions is included, but it should be said that autumn, winter and early spring take the lion's share of the selection. For clarity of air, dramatic lighting angles, vivid colours, and the high probability of a snow-covered backcloth, these are the best seasons to be out with a camera. Summer's visitors are often served a relatively benign offering of greenery and hazy horizons compared to the rich impact of the colder seasons.

There are timeless landscapes which will barely change within the next millennium alongside specific snapshots of the passing generation which give a current historical context. And we have tried to represent every scale, from the sweeping horizon to the minute detail of leaf and petal.

It has been a privilege to live in this marvellous part of the world and to have an opportunity to record its beauties on camera. We can but humbly hope that those who see this book will either sense a reflection of their own love of Wester Ross and Skye, may see familiar country in a new light, or else discover new lands of promise to explore.

MARTIN MORAN
CLARRIE PASHLEY
December 2000

From left to right: Beinn Alligin, Beinn Dearg and Liathach from the south side of Loch Torridon.

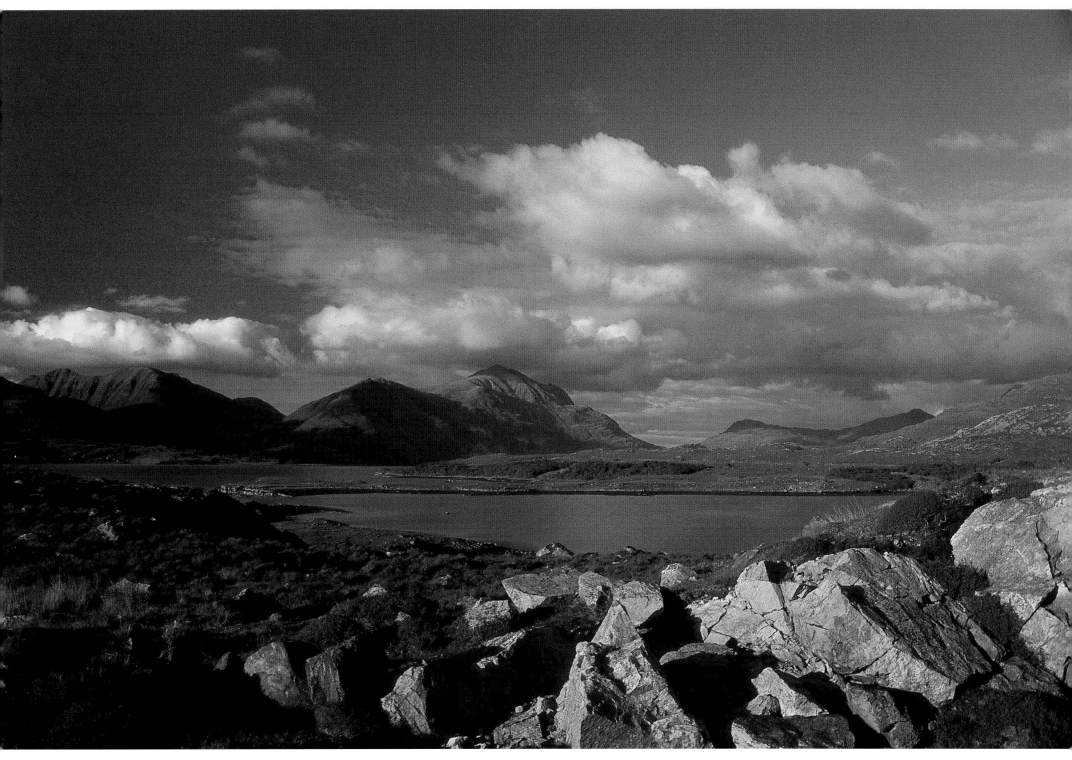

WESTER ROSS: INTRODUCTION

The landscape of the Highlands reaches a fitting climax in the district of Wester Ross. The onset of Torridonian geology north of Glen Carron produces some of the most dramatic and distinctive of Scotland's mountain chains. Prolonged glaciation during the Ice Ages has carved out deep fjord-like trenches, now filled by four of the finest sea lochs: Duich, Carron, Torridon and Broom.

Extensive crofting and fishing settlements fringe the coastline, supporting resilient communities several thousand strong in total, which contrast with wild and desolate hill tracts inland. Many pockets of native Scots pine, oak and ash survive on the slopes together with extensive new plantings of mixed woodland. The private estates of Wester Ross have made their contribution to the area's beauty by planting luxuriant gardens which today can be enjoyed in their full maturity.

And always in Wester Ross there is the seaward view, to Raasay, Rona, Skye and the Outer Hebrides, an island archipelago to rank with any.

The maritime climate of the region is one of constant flux. A mild south-westerly airstream prevails for a quarter of the year, conveying copious rainfall but also a humid warmth to the coast. This enables a remarkable range of plants, shrubs and trees to prosper, from sub-tropical to sub-arctic in origin, forming a deep well of potential colour which explodes when the sun reappears.

Then the polar airflows take over, bringing west and north-westerly winds off the North Atlantic in a dramatic sequence of sunshine and storm. Black cumulo-nimbus cloud masses fill the sky bringing intense squalls of stinging hail and silvery shower veils, to be succeeded within minutes by piercing sunshafts, glorious rainbows and glittering colour across land and sea.

When Arctic air sweeps down from the north east Wester Ross enjoys sharp night frosts and bright days which sing with zest and purity. The east and south-easterly winds are held at bay by Atlantic weather systems for much of the year, but once they take hold the west receives its deserved share of sun and balmy summer warmth.

The weather of Wester Ross is for long spells wild and glowering, and in late autumn and winter can be so persistently bad as to induce profound despondence. Yet equally it possesses the caprice to change within an hour

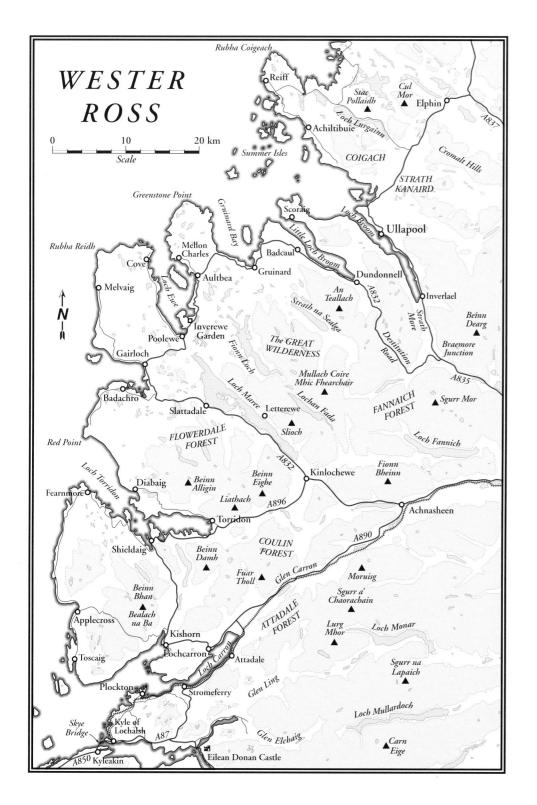

WESTER ROSS

from gloom to brilliant light, which casts stunning permutations of colour and contrast upon the landscape. So sudden a transformation can swell the stoniest heart to the verge of tears.

Wester Ross has no administrative significance other than being the westerly half of the now-defunct county of Ross and Cromarty. The old county boundaries placed Glen Shiel and Kintail as the southern limits and the Coigach peninsula as the northern edge of the district. On strict geographical assessment these adjuncts are better assigned to the Western Highlands and Sutherland regions respectively, but romantic attachment to traditional delineation is strong. Therefore this book begins its tour of the district with Coigach and Stac Pollaidh in the north and ends in Kintail with the unmistakable outlines of Eilean Donan Castle and the Five Sisters ridge.

It is down in Kintail and the Lochalsh peninsula where the inspiring scale of the landscape of Wester Ross might be first realised. Having already journeyed nearly two hours north and west of Fort William the traveller turns off the main A87 trunk road at Auchtertyre to be greeted by a sign proclaiming 'The North'. Following the coastal roads, Ullapool in the north of the district is still 131 miles away! The best is about to begin – and there is plenty of it.

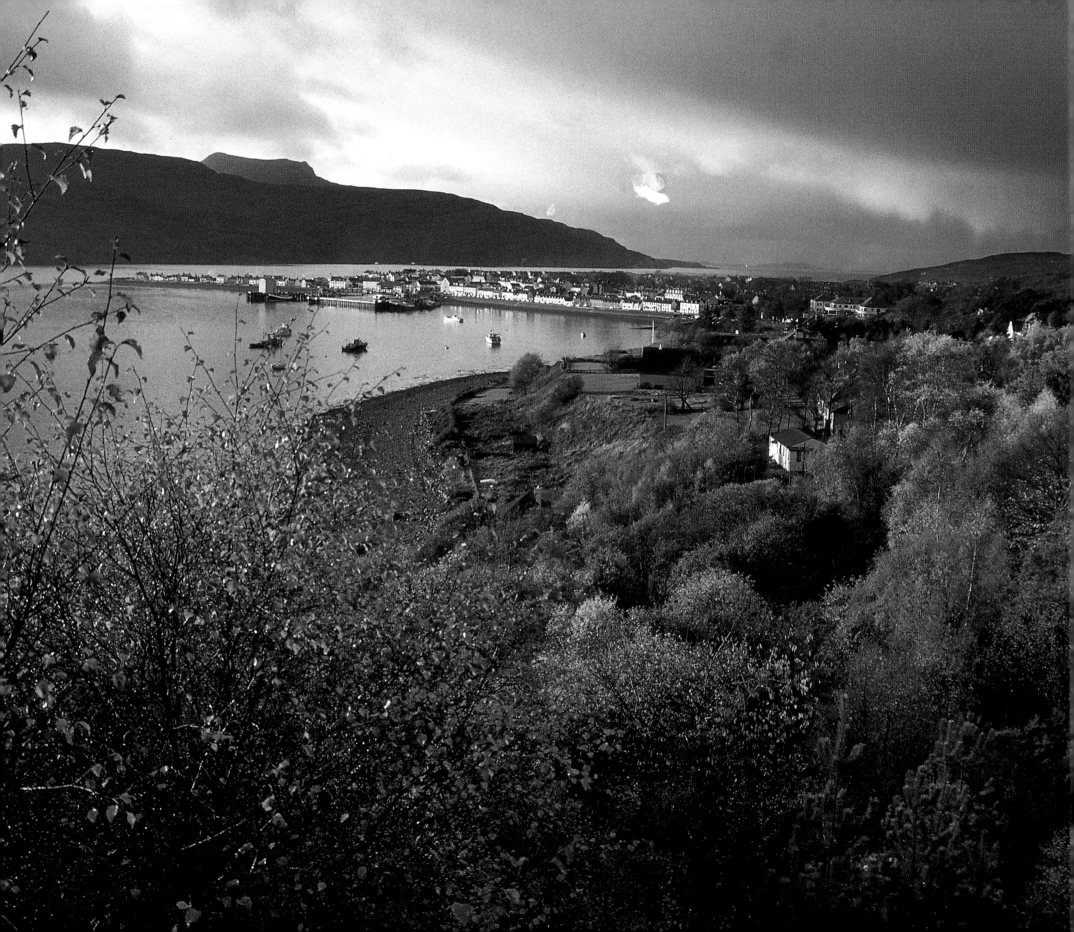

GATEWAY TO THE NORTH

The fishing port of Ullapool marks the geographical transition from the continuously hilly country of the West Highlands to the treeless wastes of the far north west, where isolated peaks rise imperiously from a moorland plateau of jumbled knolls and lochans. A journey beyond Ullapool gives the powerful sense of entering new and challenging country. Wester Ross extends some distance into this wild and tangled land to include the peninsula of Coigach, and the northern extremity of the region is marked by the remarkable little mountain of Stac Pollaidh. Although only just over 2,000ft high, it encapsulates in miniature all the dramatic features of the bigger Torridonian peaks, and is more regularly trodden than most Munros.

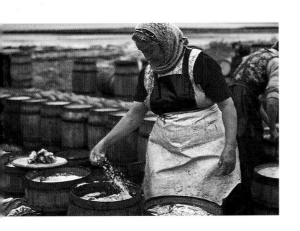

Above
Herring fishing was the mainstay of Ullapool's economy through the nineteenth century. As recently as 1961, when this picture was taken, herring landings were gutted, cured, barrelled and salted on the foreshore by east-coast women who came over to work during the fishing season. With herring stocks severely depleted this trade is unlikely ever to return to the town.

Opposite
With a population of 1558 in the 1991 census Ullapool is the largest settlement in Wester Ross. The name is Norse in origin, *Ulli-bol* meaning Ulli's steading. However, the modern town was built in 1788 as a planned development by the British Fisheries Association with a grid-iron framework of central streets. Ullapool has survived several booms and troughs in herring and mackerel fishing, and though no longer significant for landing fish, the port does support many local prawn fishermen, provides boat-chandling services, possesses the terminal for the Western Isles ferry to Stornoway and enjoys a lively summer tourist trade.

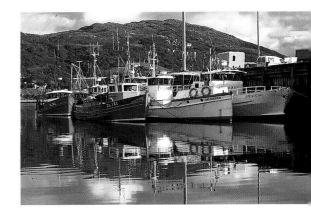

Above
Small fishing boats and pleasure cruisers mingle at Ullapool harbour. In the holiday season daily cruises run down Loch Broom and out to the Summer Isles, once the home of and inspiration to the naturalist Frank Fraser Darling.

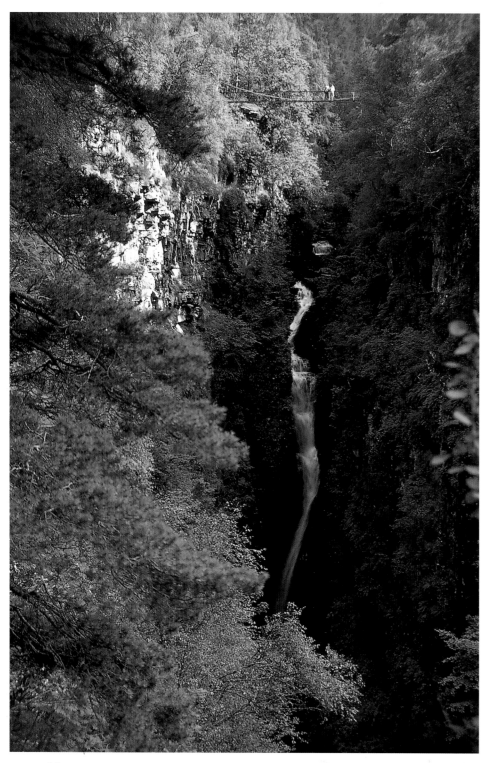

Left

The lush and fertile glen of Strath More reaches almost 4 miles beyond the head of Loch Broom, but is abruptly terminated in the chasm of Corrieshalloch Gorge where the Abhainn Droma plunges nearly 400ft within a mile. This is one of Britain's best examples of post-glacial meltwater erosion. As the ice sheets retreated between 10,000 and 18,000 years ago the earth's crust rebounded from the release of the immense weight of ice. Meltwater quickly cut a gorge through the rising land and the block jointing of the schistose rock favoured the plucking of a square-cut box canyon. The 130ft Falls of Measach are the centrepiece of Corrieshalloch, and can be viewed from a suspension bridge just a few yards from the A835 road. Owned by the National Trust for Scotland the gorge possesses a rich flora, including many rare mosses, liverworts and ferns.

Right

At 21 miles, Loch Broom is the longest sea loch in north-west Scotland. Its name derives from the Gaelic *a'bhraoin*, and means 'loch of the showers', well illustrated in this view from Ardcharnich on the north side. The remains of duns and forts on the south shores at Loggie and Rhiroy indicate pre-Christian settlement here.

Below

A busy summer day in Ullapool Bay looking up Loch Broom to Beinn Dearg. Through the 1980s factory ships from Eastern Europe were a common sight here, buying up huge quantities of mackerel caught by east-coast trawlers. In 1988 152,000 tons of mackerel, worth £17.5 million, were traded at Ullapool, and Polish and Russian crewmen were frequent visitors in the town. The trade collapsed with the break up of the Communist bloc and diminution in mackerel stocks.

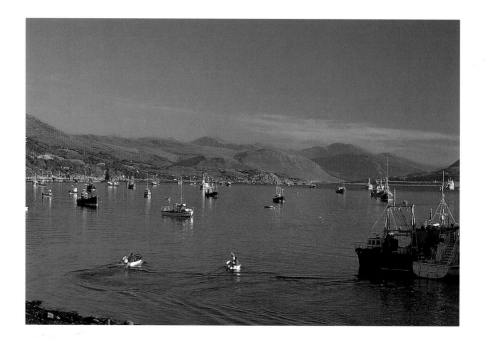

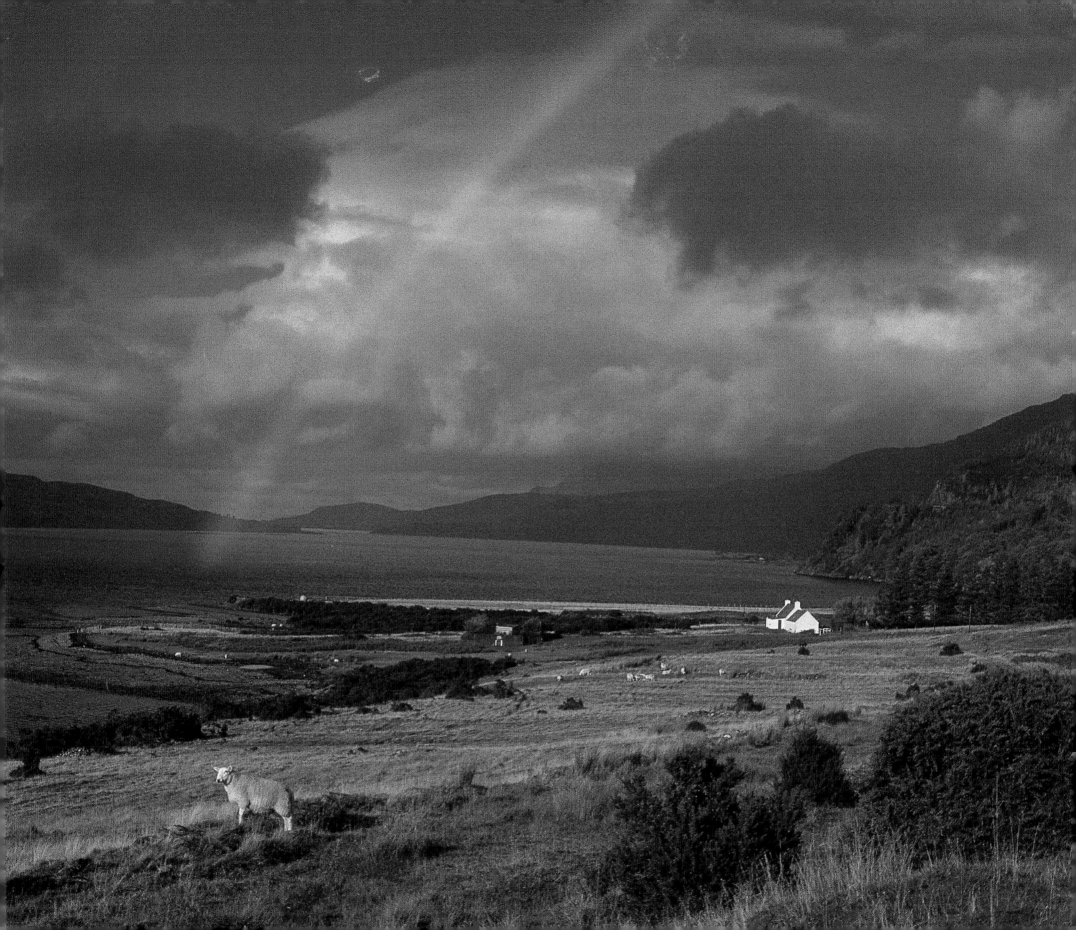

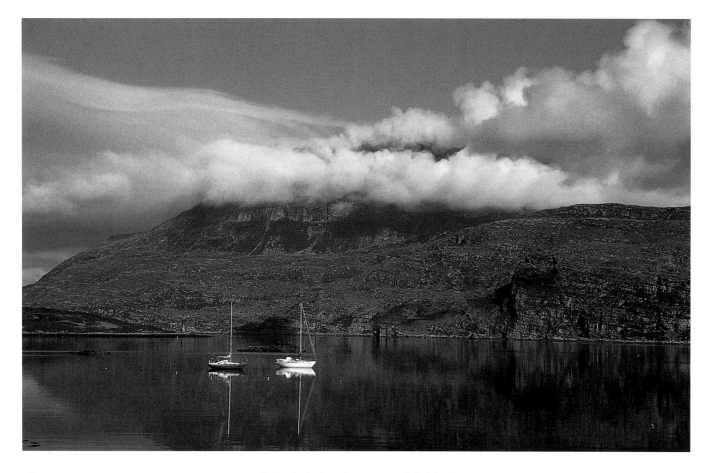

Opposite
Afternoon light sparkles across the tiny lochan by the main road south of Drumrunie with the silhouetted massif of Ben Mor Coigach behind.

Below
Springtime by the shores of Loch Lurgainn on the road from Drumrunie to Achiltibuie looking towards Beinn nan Caorach, most westerly of Ben Mor Coigach's four main tops. Achiltibuie is the largest of several crofting townships scattered round the Coigach coast and was the final home of the great Himalayan explorer Tom Longstaff.

Above
Three miles past Ullapool the A835 swings over a moorland swell and an exciting panorama opens northwards over the coast and hills of Coigach. This is truly where the far north west begins: to some the feeling is joyful, for here is a holiday domain where peace and freedom are guaranteed; others are oppressed by the stark and awesome beauty of the region. Coigach, more properly spelt *Coigeach*, means the 'fifth part', it being an old Celtic custom to divide lands into five portions. In this view the craggy ramparts of Ben Mor Coigach are seen across Ardmair Bay. To the left are the shores of Isle Martin, an early outpost of Christianity in St Columba's time but now uninhabited. The ruins of its ancient chapel and 'cross stone' remain.

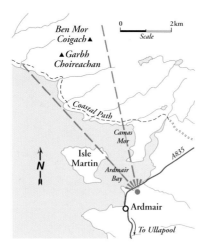

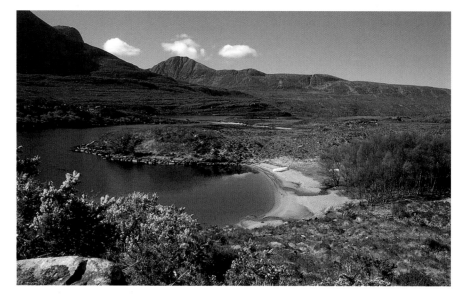

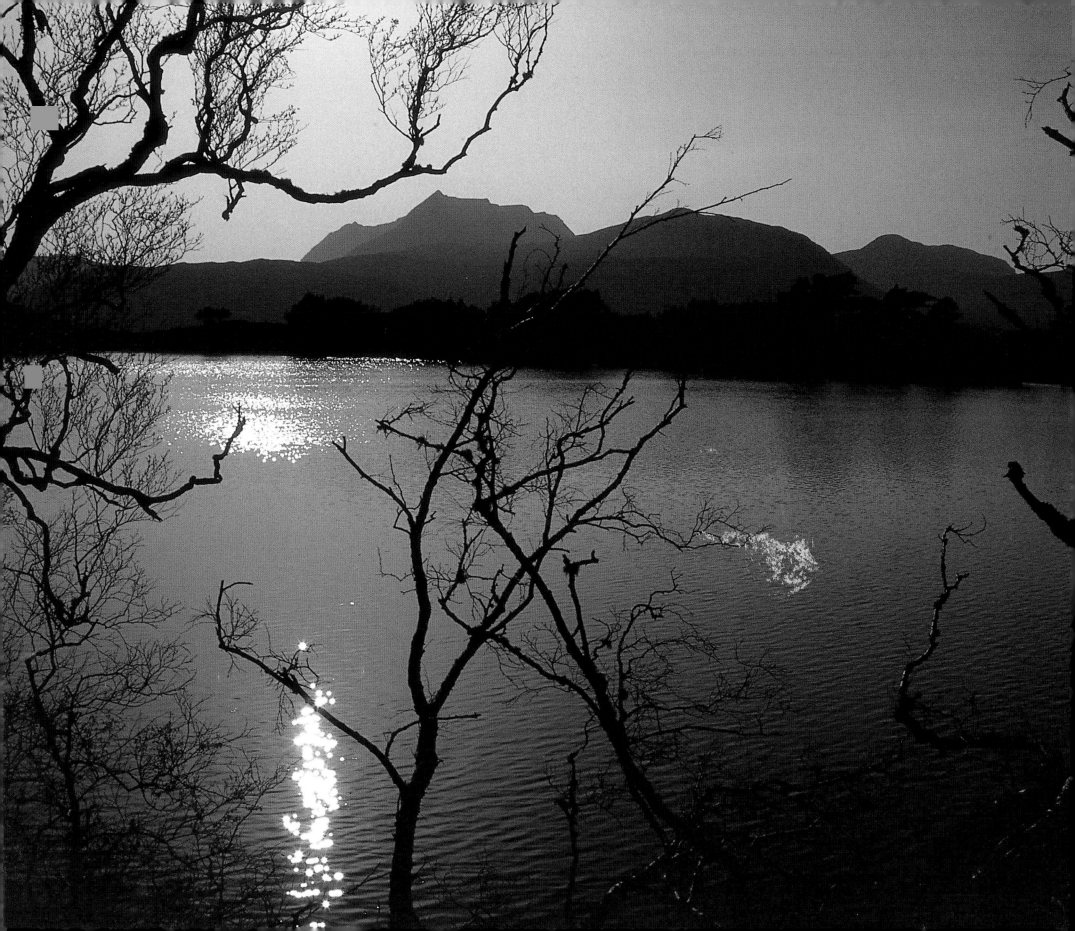

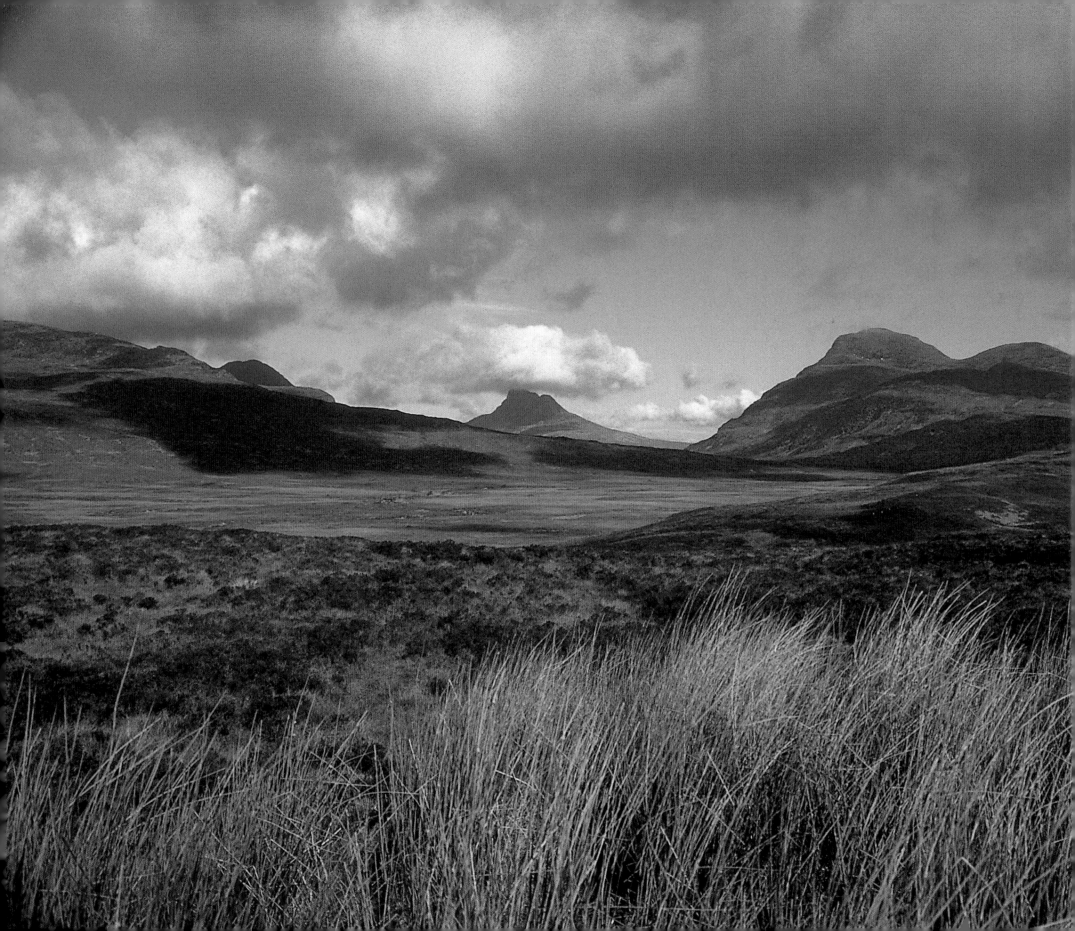

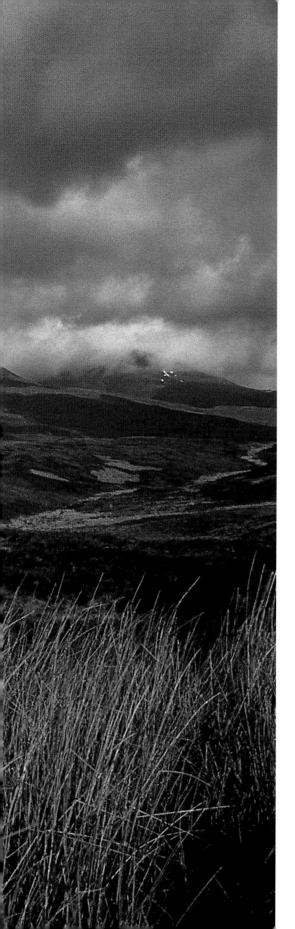

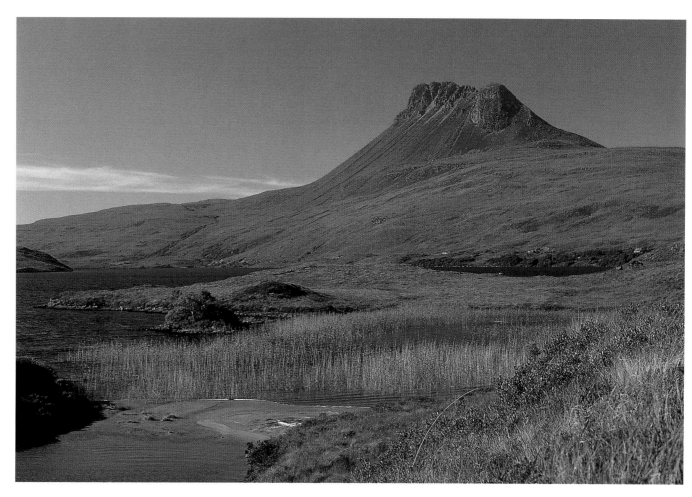

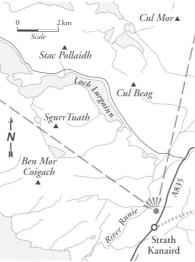

Left
When travelling north from Ullapool on the A835 views of the Coigach peaks unfold across the moors above Strath Kanaird. The slim profile of Stac Pollaidh can immediately be picked out in centre frame in preference to the bulkier mass of Cul Beag on its right.

Above
Rising elegantly above the shores of Loch Lurgainn, Stac Pollaidh provides a beautiful landscape composition. A reeded inlet on the loch shore provides the ideal foreground in this classic view of the mountain. In the opinion of the pioneering mountain photographer Walter Poucher, 'Stac Pollaidh is the most rewarding and sensational subject in all Scotland'.

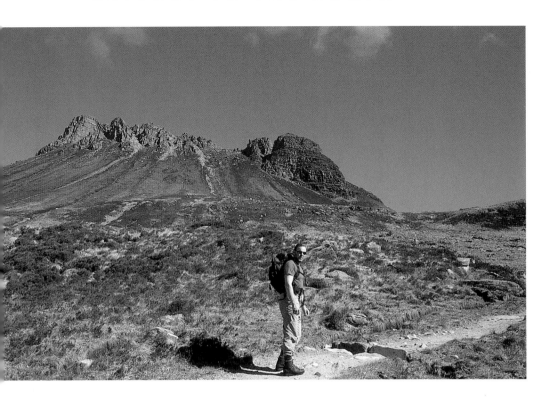

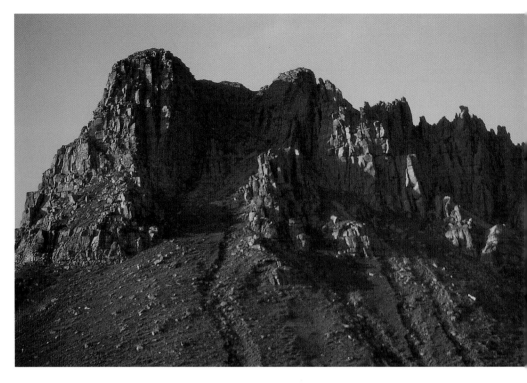

Above

Half a century ago it was barely conceivable that human footprints could progressively destroy a mountain so grandiose as Stac Pollaidh. Yet erosion of the southern flanks of the mountain became so severe that in 1998 large-scale remedial work was instigated at a cost of nearly £1/2 million with funding from several public bodies and the Heritage Lottery Fund. The new path from the car park is admirably well-laid and is drained at regular intervals, giving an enjoyable climb round the north side of the peak to gain the summit ridge at its lowest point. It is hoped that this track will accommodate the thousands of visitors who attempt the climb each summer, preventing any further damage to this gem of a peak.

Above

Viewed in evening light directly from below, the south-west face displays a chaotic mass of weird pinnacles, leaning buttresses and shadowed gullies. A new traversing path encircles the base of the cliffs to allow the walker the closest contact with the blockwork of the peak. Here too is an atmospheric playground for the serious rock climber.

Right

The direct traverse of the crest to Stac Pollaidh's summit is an exhilarating scramble for those with good balance and a head for heights. For the cautious easier trods weave round the northern flank avoiding most difficulties. However, a 15ft wall must be surmounted in order to gain the highest point at the western end, this requiring a couple of deft moves on sloping

ledges. Diversions can be made on to poised blocks of sandstone at several points, giving spacious views north and east across the twisted lochans of Inverpolly Forest to the trident-topped peak of Cul Mor. All this magnificent country is a National Nature Reserve, harbouring a prized range of moorland birds such as the black-throated diver and greenshank, and providing excellent trout fishing.

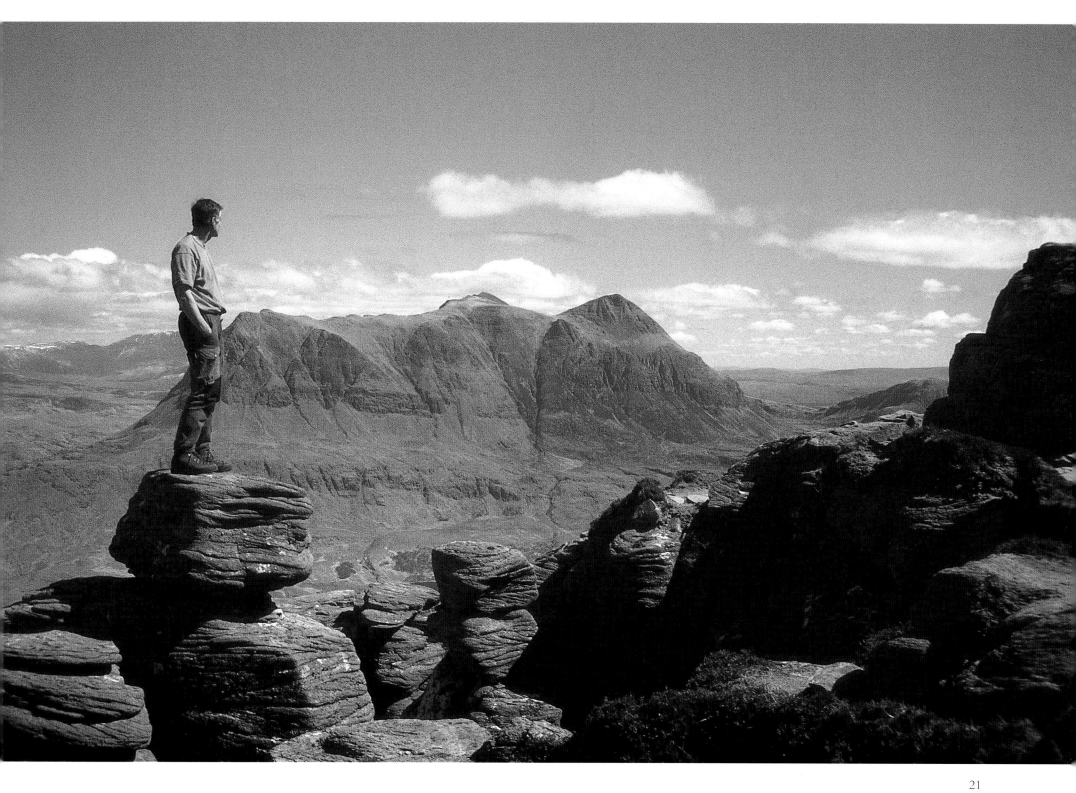

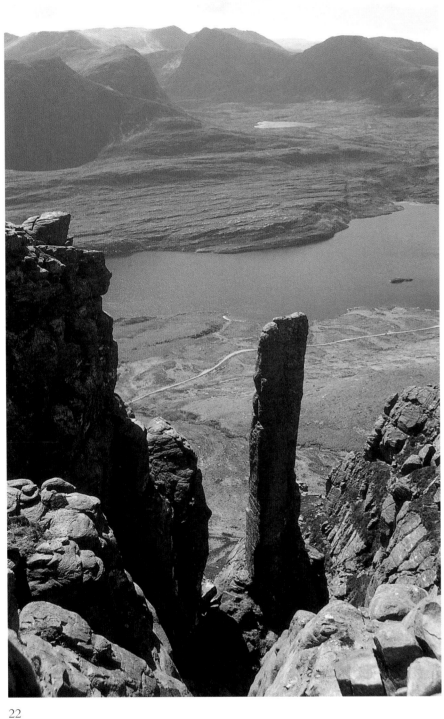

Left and right

Cracked and fissured by frost, then smoothed by millennia of weathering and wind erosion, rounded columns of ancient Torridonian sandstone clutter the sides of the summit crest. The most impressive of these pinnacles is the Lobster's Claw, also known to climbers as the Virgin and Child. This slender column balances improbably in one of the southern gullies, which frame a magnificent prospect over Loch Lurgainn to the massif of Ben Mor Coigach.

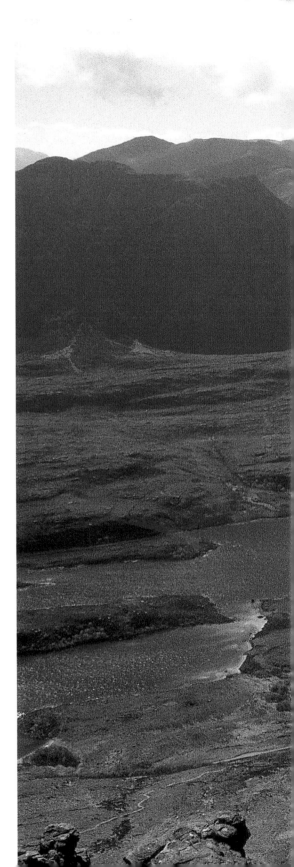

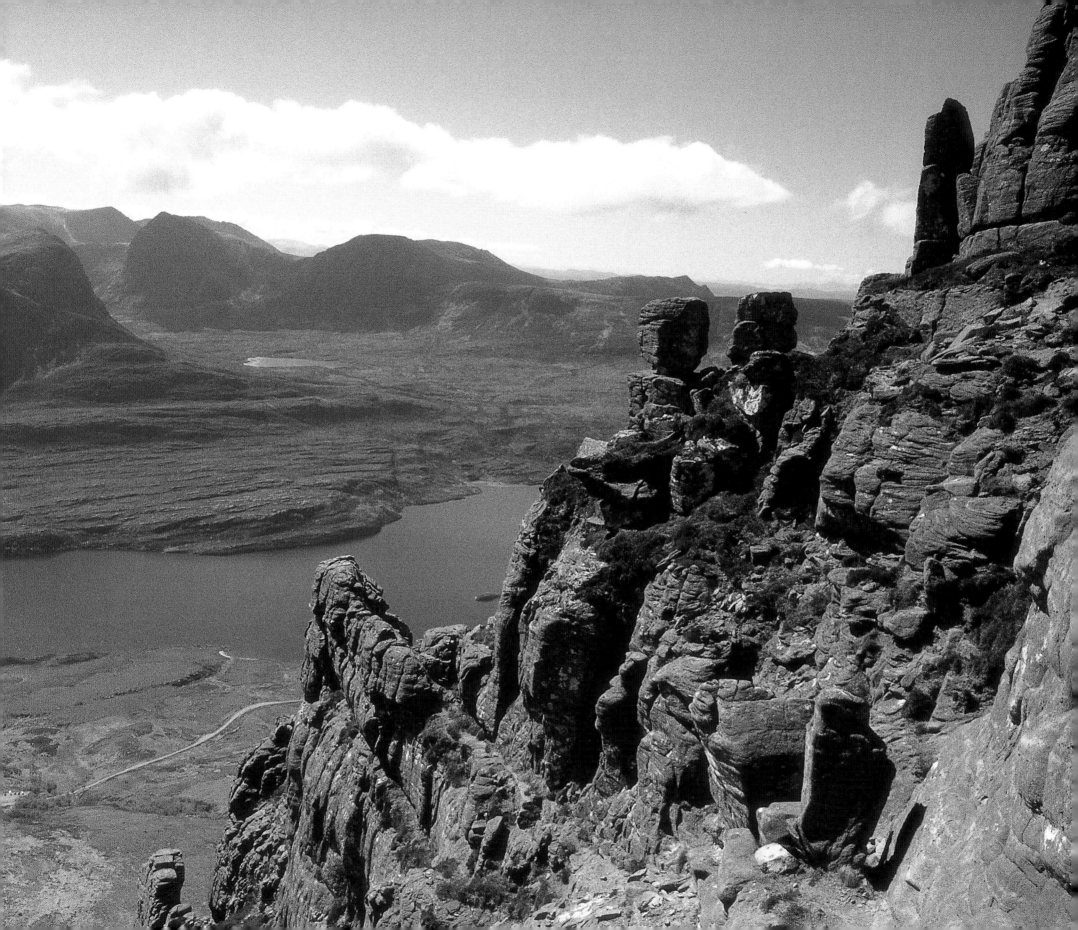

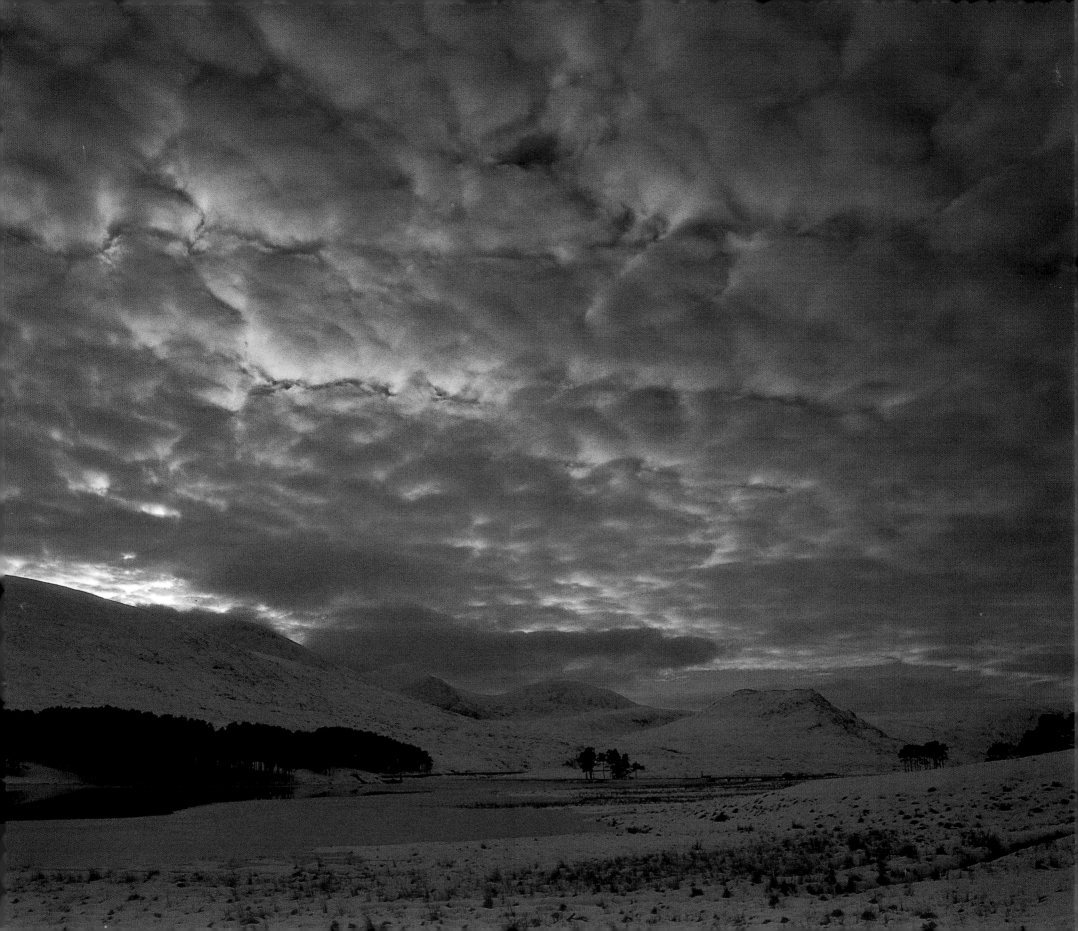

THE GREAT WILDERNESS

Left
Winter sunset over Loch Droma. Here, on the watershed between Glascarnoch and Braemore, one can behold the desolate wastes of the Fannaich and Dundonnell mountains in all their icy glory.

Below
Leaving Easter Ross behind at Lubfearn en route from Garve to Braemore. The last vestiges of farm and woodland are passed here before the 12-mile crossing of the Highland watershed to Braemore. This wind-swept passage rises to over 900ft in altitude and the snow gates at Aultguish are often closed in blizzard conditions.

Above the green straths of Loch Broom and Dundonnell lies a barren swathe of moorland and lofty hills, culminating in the 1,000m summits of Beinn Dearg and Sgurr Mor, the highest points of the Northern Highlands. The 'Destitution Road', built from Braemore to Dundonnell as a famine relief project in the 1850s, adds a bleakness to the scene; yet this wide, lonely landscape refreshes the senses and souls of hillwalkers and travellers alike.

The broad wedge of country to the west between Dundonnell and Loch Maree, much of it occupied by the Letterewe Estate, is regarded by many as Scotland's finest wilderness tract. No public roads penetrate nor is there a single permanent habitation. The most remote Munro, A'Mhaighdean, lies in its centre, 11 miles from the nearest road. This is as grand a piece of mountain country as to be found anywhere in Britain, with the famous peaks of An Teallach and Slioch marking its northern and southern edges.

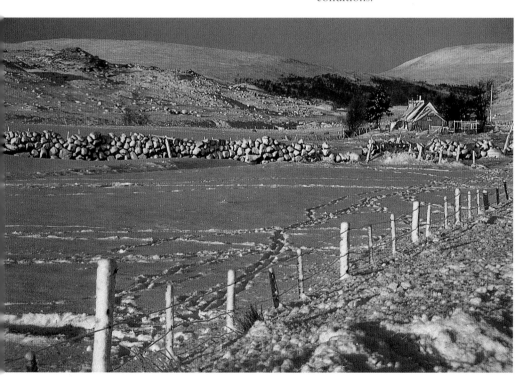

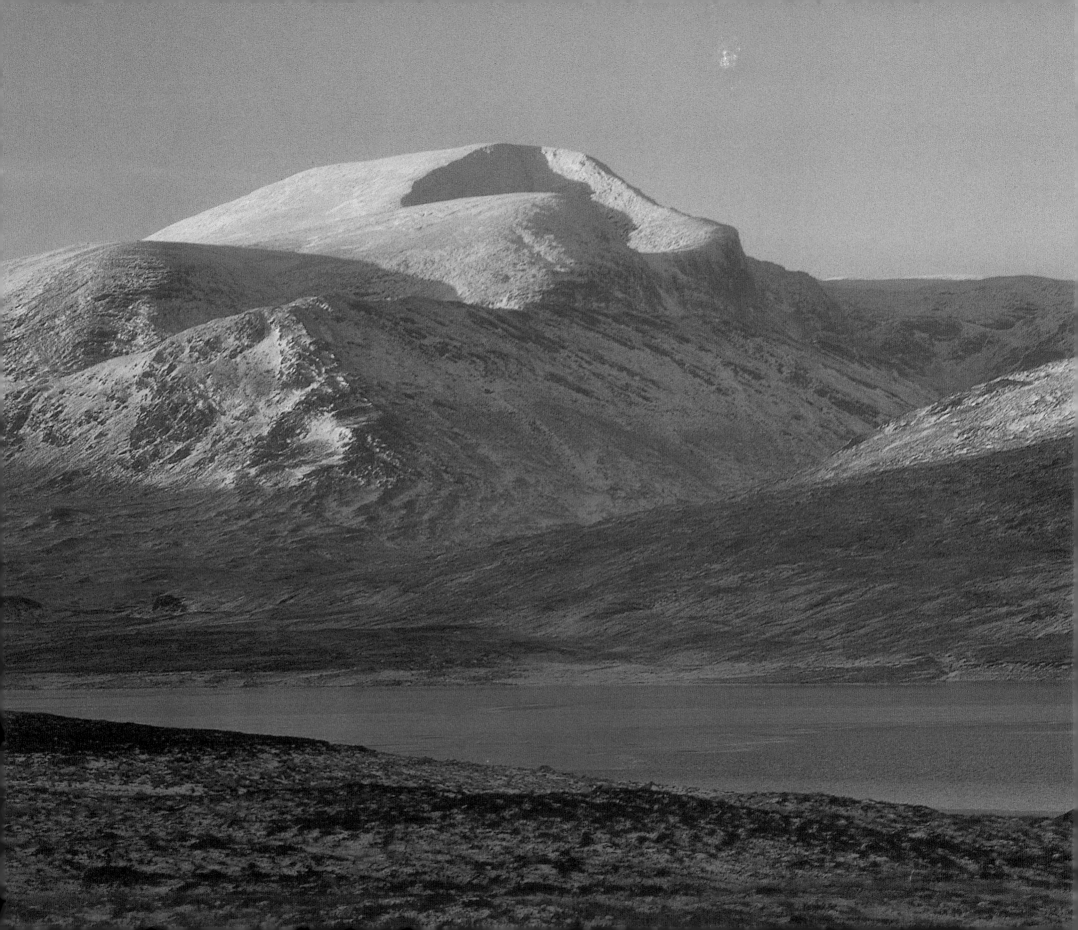

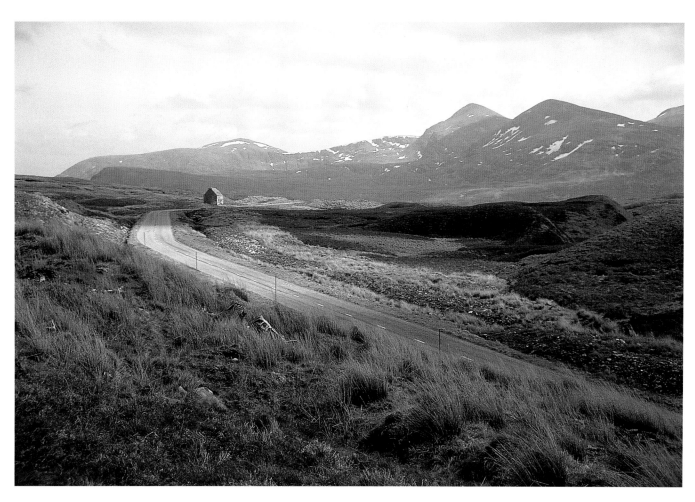

Left
Beinn Dearg (3,556ft/1,084m) from the head of Loch Glascarnoch. These are mica-schist hills in common with much of the West Highlands forming part of the Caledonian mountain massif. The schists rode up against the Torridonian rock strata of the far north west during the Moine thrusting of 400 million years ago. Their smooth outlines have been scalloped by glaciation into striking corries, the shaded bowl under Beinn Dearg's summit providing a fine example.

Above
Looking east to the Fannaich hills from the Braemore–Dundonnell road. The Fannaichs contain nine Munro summits and are penetrated by a remarkable network of stalking paths built in the latter nineteenth century to provide access for deer shooters and their ponies. Several tiny stone shelters can still be found and many of the paths remain intact, giving excellent walking for modern hillgoers.

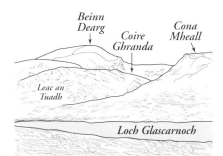

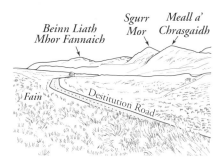

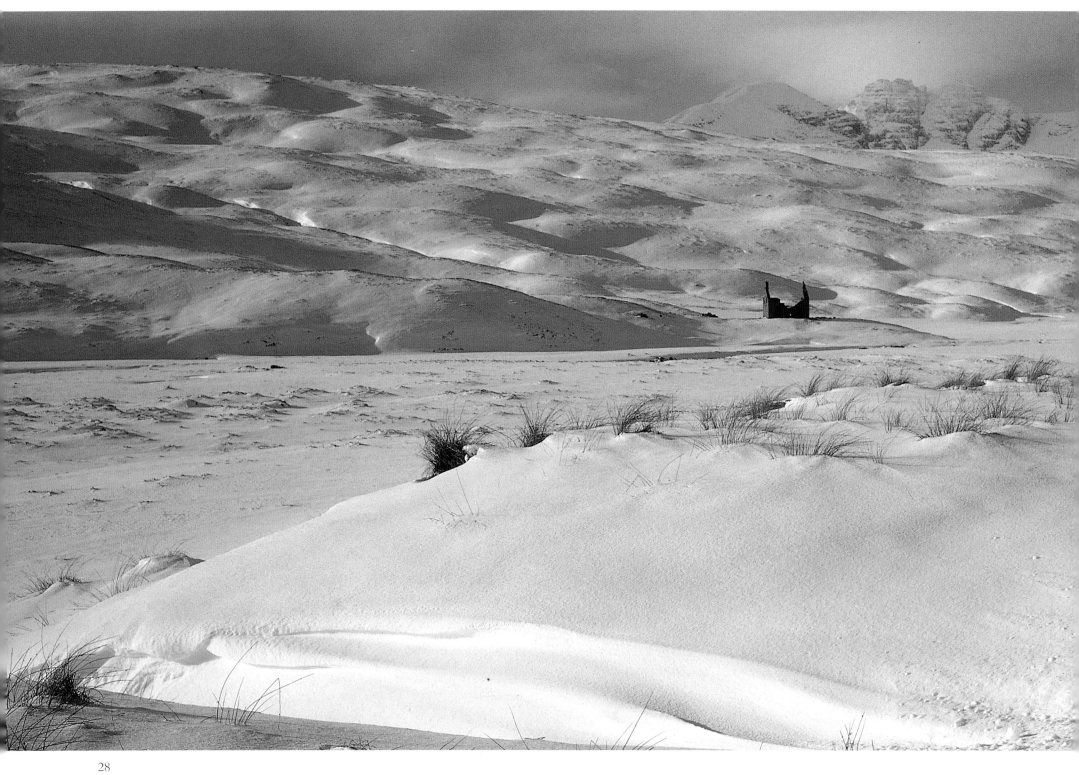

Left

Heavy snow cover on the moors of Dundonnell Forest viewed from the Destitution Road. An Teallach looms behind while in the foreground the winter sun picks out the innumerable hummocks of drumlins deposited by the glaciers as they retreated at the end of the last Ice Age.

Right

Spring arrives on the Dundonnell moors. Meltwater swells the infant Dundonnell River as it swings north to commence its descent to Little Loch Broom.

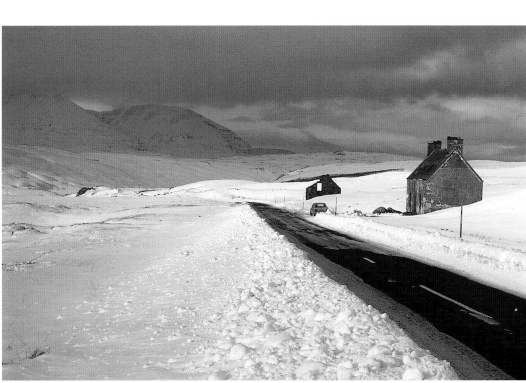

Left

On the A832 at its highest point by the abandoned shieling of Fain with the outer wings of An Teallach behind. Although this stretch has become solely labelled as the Destitution Road, it was actually one of five roads built in the 1850s under a work-creation scheme to relieve the distress of the great potato famine of 1847–51. A Central Relief Board provided half of the capital cost, the local lairds the remainder, and the local men were paid not in cash but in an equivalent value of meal. One critic described the scheme as 'a monstrous malversation of a charitable fund...'. Nevertheless the new roads provided a coastal link between Gairloch and Loch Broom that was to prove vital in the development of tourism 30 years later.

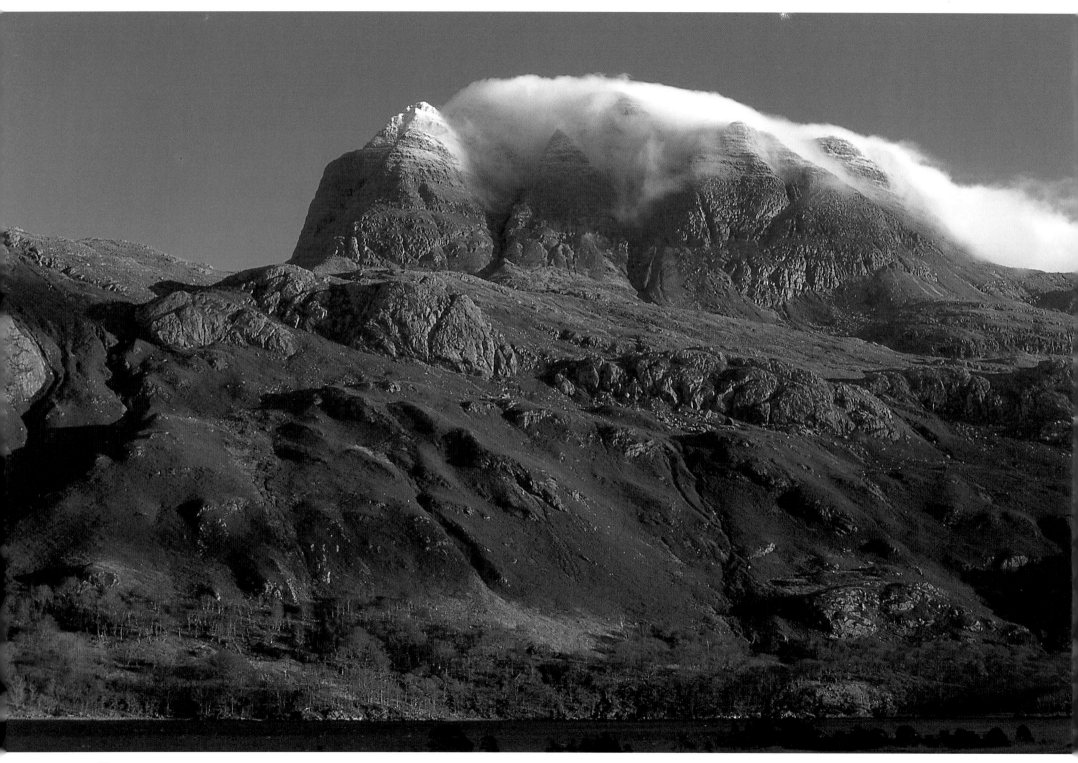

Left

The turretted peak of 3,215ft (980m) Slioch, the spear, dominates the upper reaches of Loch Maree. This is a typical Torridonian mountain, its horizontally bedded sandstone buttresses sitting proudly on top of beds of ancient Lewisian gneiss. A few climbers venture on its northern walls in winter, but for walkers there is a long yet simple route up the south-east flanks from Kinlochewe. Slioch's summit is a superb belvedere from which to view the lower reaches of Loch Maree, which are studded with wooded islands. One of the smaller of this archipelago, Isle Maree, was first a site of pagan worship and sacrifice, then in the late seventh century became a dwelling of St Maelrubha, the first Christian messenger to these regions. Indeed, the name Maree is an English corruption of *maelrubha*.

Below

Loch Tollaidh, on the moors between Gairloch and Poolewe, offers a wide prospect of the northern part of the Great Wilderness with the broad swell of Beinn a'Chaisgein Mor prominent on the right-hand skyline, and An Teallach on the left.

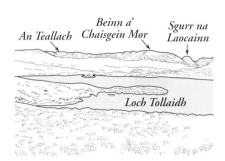

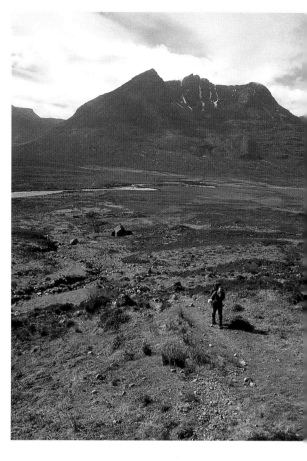

Above

The most popular approach to the interior is by the track from Corrie Hallie near Dundonnell. A 'right of way' signpost here indicates an impressive distance of 24 miles to Poolewe. In 1986 this classic overland crossing was made the route of the Great Wilderness Challenge, an annual charity event during which a running record of 2hr 48min was established. The path leads for 4^1/$_2$ miles round the southern flanks of An Teallach to Shenavall bothy in Strath na Sealga. On its far side the trident-topped peak of 2,978ft (908m) Beinn Dearg Mor throws out an obvious challenge to the mountaineer.

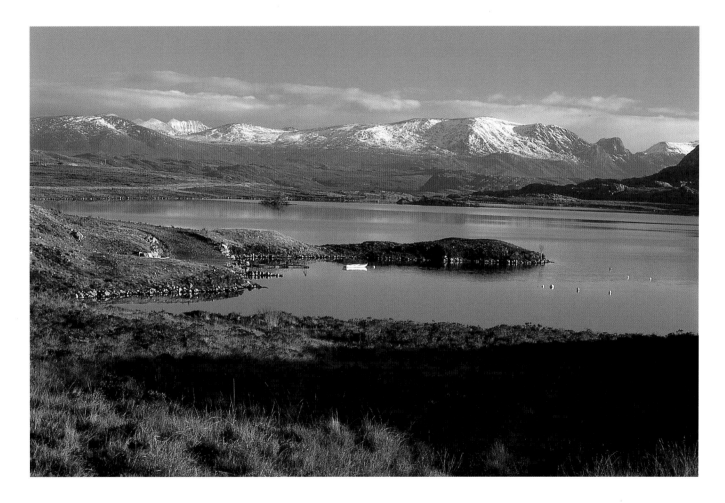

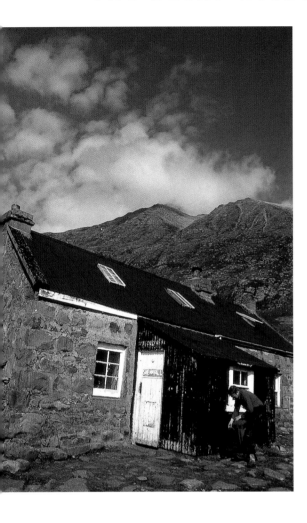

Left

Most famous of all the bothies in the North-West Highlands, Shenavall was formerly a shepherd's cottage but is now maintained by the Mountain Bothies Association with the co-operation of the local Gruinard Estate. Floorboards, a fireplace and a few chairs provide the in-house comforts; trekkers must bring their own food, stoves and sleeping bags. In summer the numbers of visitors here can create problems of over-crowding and not all respect the privilege afforded by its open door. Accumulating rubbish, indiscriminate faecal pollution of surrounding land and occasional cases of vandalism are all problems faced by the MBA in its continuing work of providing open shelters in Scotland's wild places.

Right

The snaking waters of Strath na Sealga and Gleann na Muice, viewed here from the crest of An Teallach, are a signature to the untamed beauty of the wilderness but pose formidable barriers to the traveller after rains. The main river must be forded to continue the crossing to Carnmore and Poolewe.

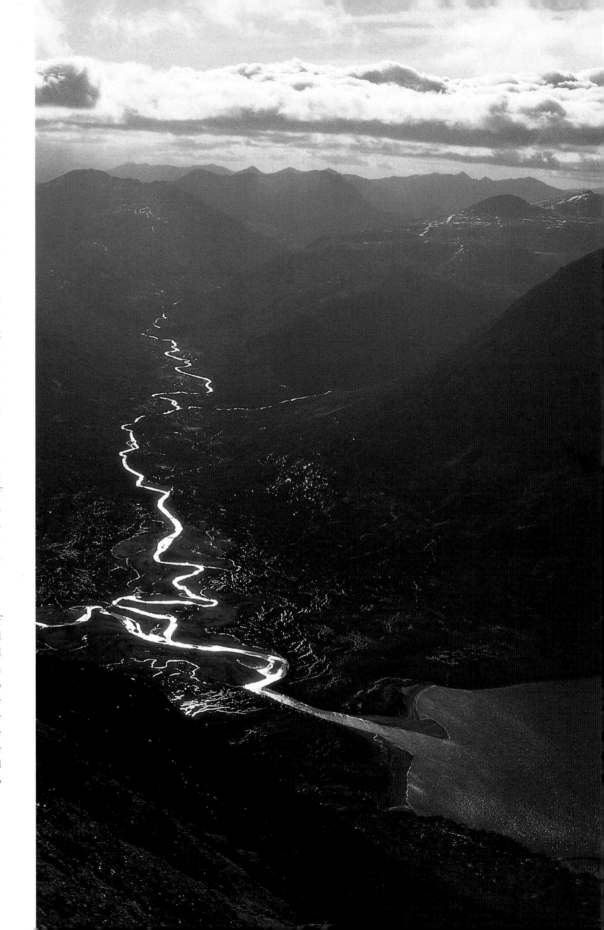

Below

A ring of Munros, known as the 'Fisherfield six', encircle Gleann na Muice, providing a strenuous test for mountain walkers. On Sgurr Ban, second of the summits to be tackled in a clockwise circuit from Shenavall, wide fields of frost-shattered boulders emphasise the loneliness and commitment of this round. The ridge of An Teallach lies away to the north.

Right

River crossings must be treated with great caution in spate conditions. A fully-laden walker has little chance of regaining a footing once swept away. Trekking poles help balance and can probe the depth of water, whilst fixing a rope over a burn can offer security for a group. However, if there is any doubt of passage the wiser course is to seek an easier crossing upstream even if this necessitates a lengthy detour.

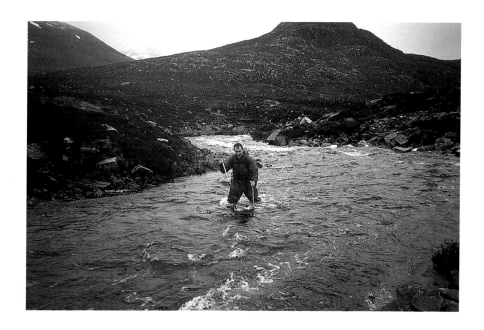

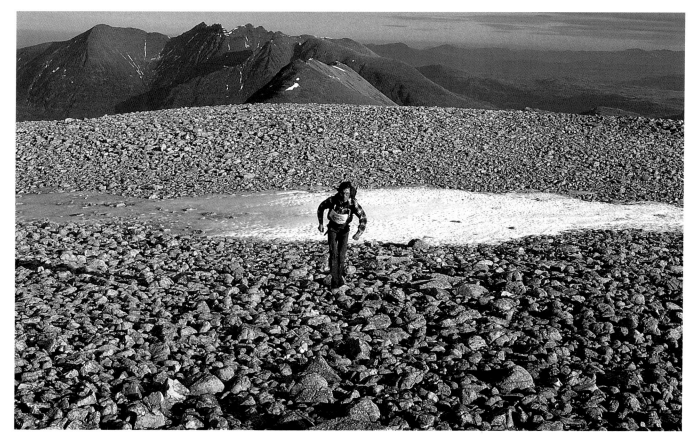

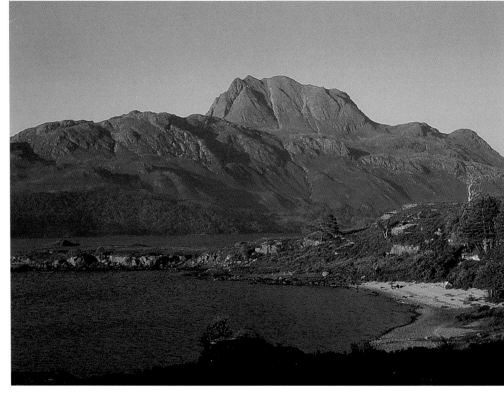

Above left
On a January day by the shores of Lochan Fada the civilised world seems far away. The snow- capped summit of A'Mhaighdean is seen up to the right. Lying behind Slioch in the heart of Letterewe Forest, this 3-mile-long loch was proposed for a large scale hydro-electricity development in the 1960s. Strong protests from conservationists helped defeat the scheme. The guardian of Letterewe Estate from the mid-1980s, Paul van Vlissengen, spoke of the 'balancing act' he had to perform to accommodate all the demands on the land whilst preserving its sanctity. His enlightened attitude has spared the estate the scarring of bulldozed vehicle tracks. In December 1993 van Vlissengen struck the Letterewe Accord with several conservation and access groups. In setting out guidelines for reasonable access the Accord broke new ground and was soon followed by a national Concordat between land-owning and land-using groups.

Above right
Back on the shores of Loch Maree the eternal upthrust of Slioch catches the light of a summer evening. In the words of John Dixon, author of the gazetteer *Gairloch and Guide to Loch Maree* published in 1886: 'This lovely country... is unsurpassed for its combinations of noble mountains, gleaming lochs, wide moorlands, rugged crags, rocky torrents and smiling woods'. However, this land was not always empty. Thousands of acres of rich native forest clothing the slopes above Loch Maree were felled to fuel a local iron-smelting industry in the seventeenth century, leaving only limited remnants. Scrub woodland cover and settlements existed in the interior before it was turned over to deer forest in the nineteenth century, and the last shepherd and his family left only 60 years ago. The 'wilderness' we prize today is partly of Man's own making.

Opposite
Seen from the summit of A'Mhaighdean the Dubh and Fionn Lochs reach out over moorland wastes towards the coast at Aultbea, providing fast boat access for estate workers and stalkers. Carnmore cottage, on the right of the Dubh Loch, offers the only roof. Climbers wishing to tackle the fierce gneiss cliffs above Carnmore must hike the 10 miles from Poolewe, but can use the adjoining barn for an overnight stay. The Fionn Loch has long been renowned for fishing. In the nineteenth century the creator of Inverewe Garden, Osgood MacKenzie, spoke of 'best trout loch' in Scotland after seeing a catch of 12 fish weighing a total of 88lb in a single day.

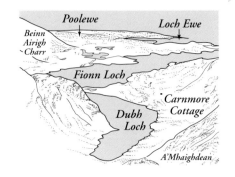

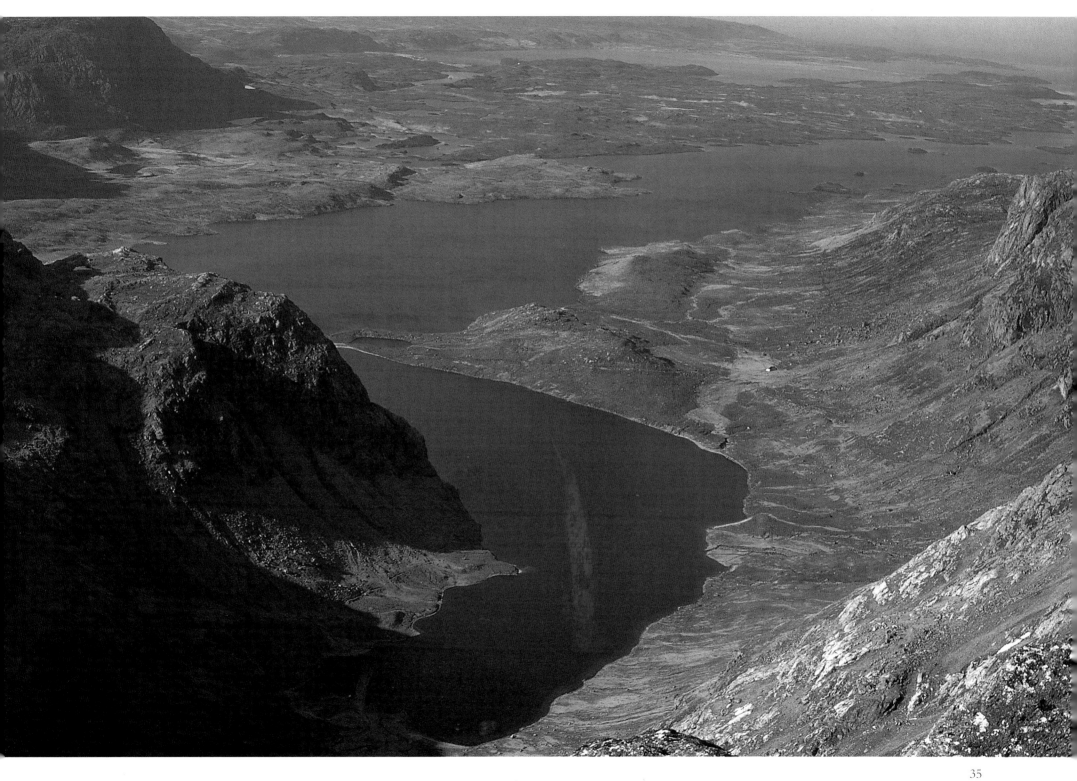

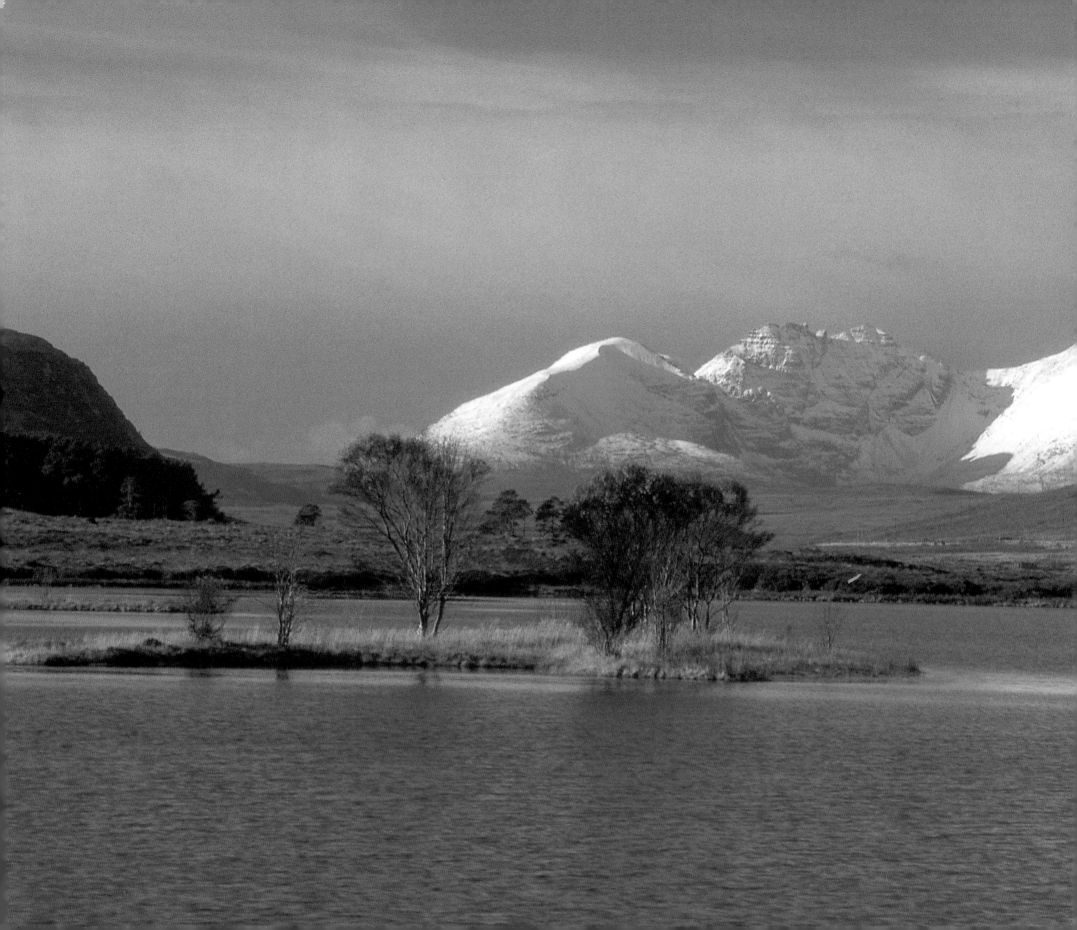

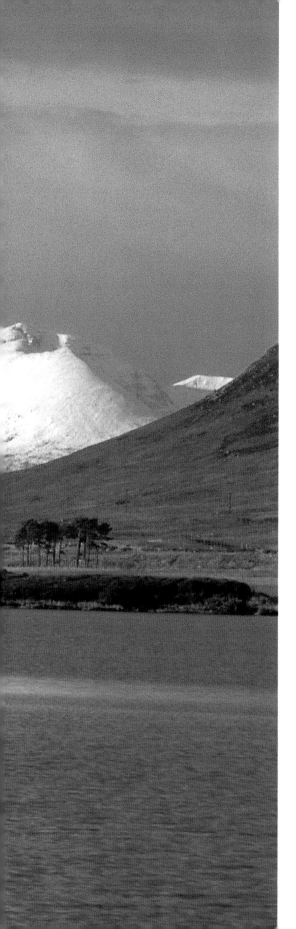

THE MIGHTY FORGE

A few words describing An Teallach's summit ridge had the power to flush me from my roost in the plains and send me winging over the mountain world. – W.H. Murray

An Teallach is both a vast sprawl and a mighty rocky upsurge of mountain. – H.M. Brown

These words, from two distinguished Scottish mountaineers, testify to the power and attraction of An Teallach, the Forge (it has been suggested that the name derives from the smoke–like mists that curl around its summits). For many it is simply the finest mountain in Britain; yet from a strict topographical assessment other Torridonian peaks, like Liathach, might be considered its equal. However, with its isolated position and varied form An Teallach has something of grace and elegance, a romantic beauty that tugs the heartstrings.

Left
Whether seen in summer or winter raiment, as in this classic view from Loch Droma, An Teallach has kindled the passions of countless mountaineers: a mountain of hazy dreams and bold deeds, of icy dawns, fiery sunsets and mellow recollection.

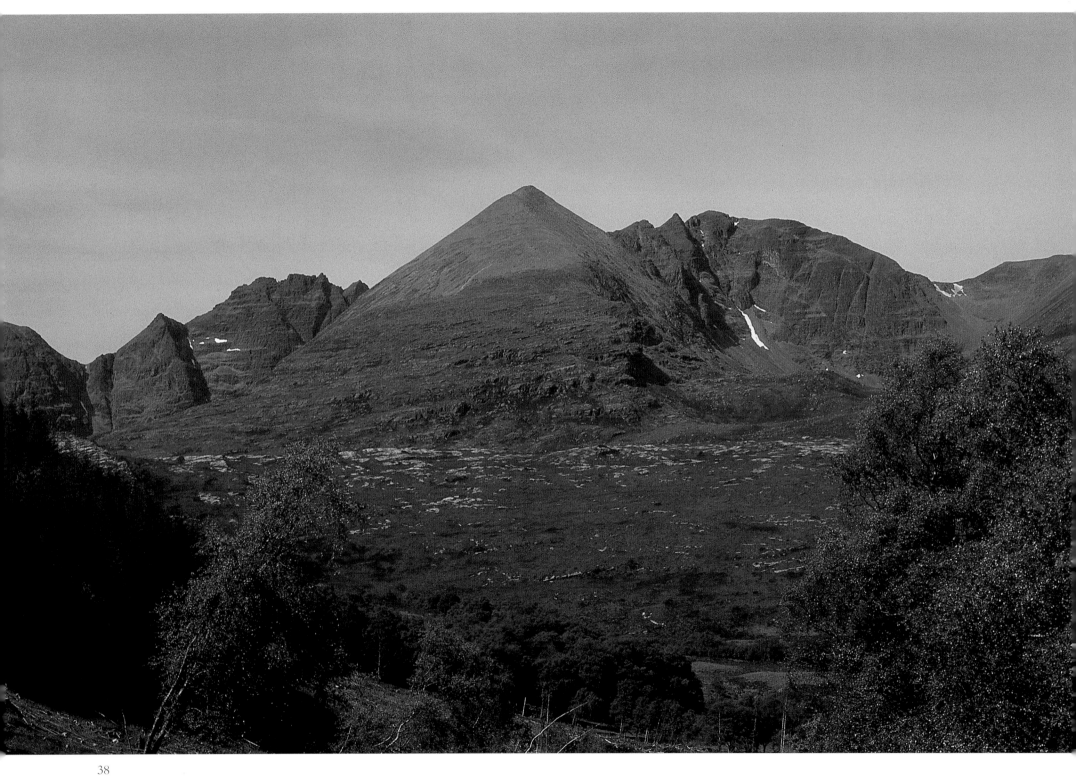

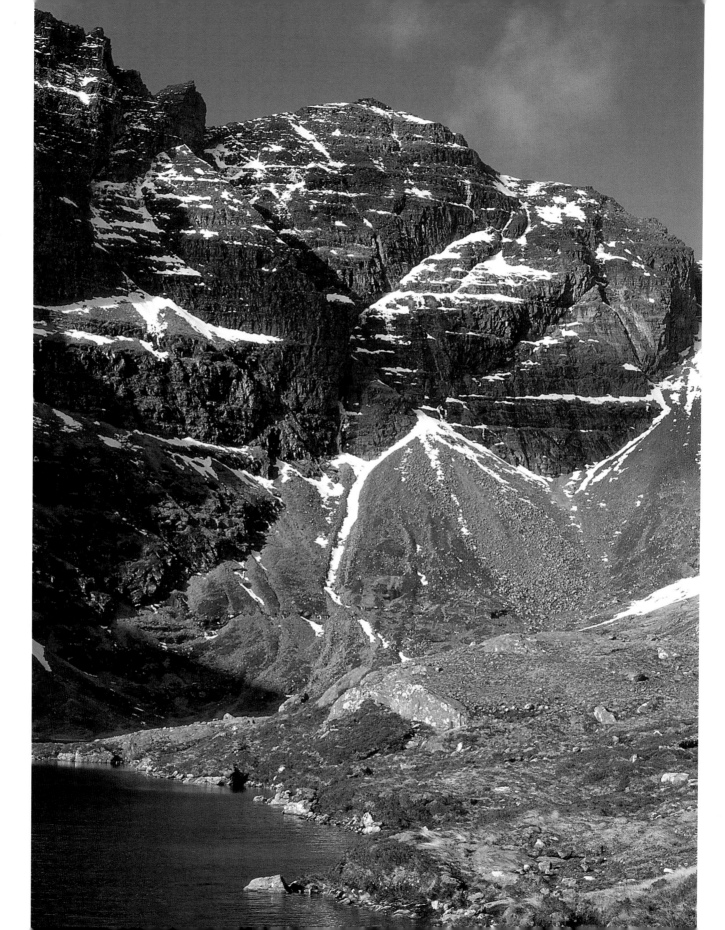

Left

The breadth and excitement of the An Teallach massif can be appreciated from the woods above Dundonnell. The sky-line ridge encloses two deep corries, Toll an Lochain and Glas Tholl, split by the soaring spur of Glas Mheall Liath, whose grey quartzite screes contrast vividly with the brown sandstones of the pinnacled ridges behind.

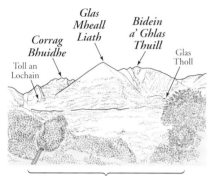

Dundonnell Woods

Right

The best way to admire the vertical grandeur of An Teallach is to walk from Dundonnell up the peat bogs and sandstone pavements of Coir'a Ghiubhsachain into Toll an Lochain, a trek of around two hours. The terraced crags of Sgurr Fiona and Corrag Bhuidhe soar skywards from the shores of the lochan, which is nearly half a mile across and fills the corrie floor.

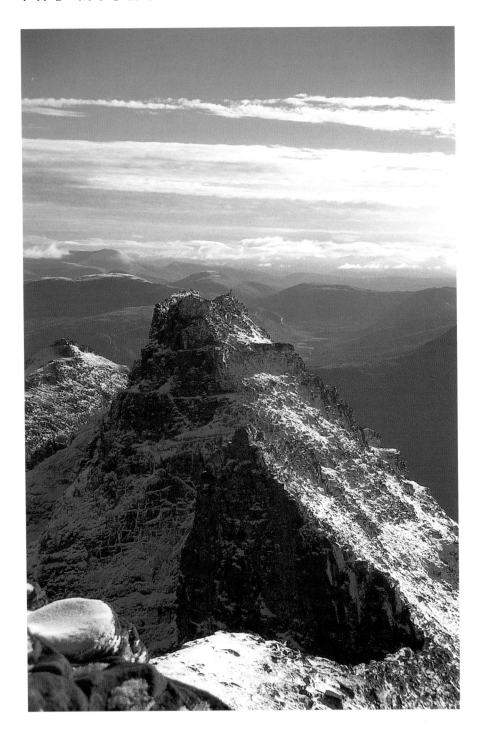

Right

A complete traverse of the bounding ridge might start at the north-eastern top of Glas Mheall Mor, a conical sentinel capped with quartzite. From here the saw-toothed crest of An Teallach's highest summit, the 3,484ft (1,062m) Bidein a'Ghlas Thuill, is viewed across the corrie. A wealth of winter gully climbs can be made in Glas Tholl, some of them over 1,000ft in vertical height.

Left

Sgurr Fiona (3,475ft/1,059m) is An Teallach's second full Munro summit. Up to this point the ridge from Glas Mheall Mor and over Bidein a'Ghlas Thuill has consisted of rough but simple walking, but now the spear-head of Lord Berkeley's Seat and the Corrag Bhuidhe pinnacles come into immediate view, promising more demanding terrain. Many walkers, unsure of their scrambling skill or else facing icy conditions, are wise to turn back here but to do so is to miss the highlight of the traverse.

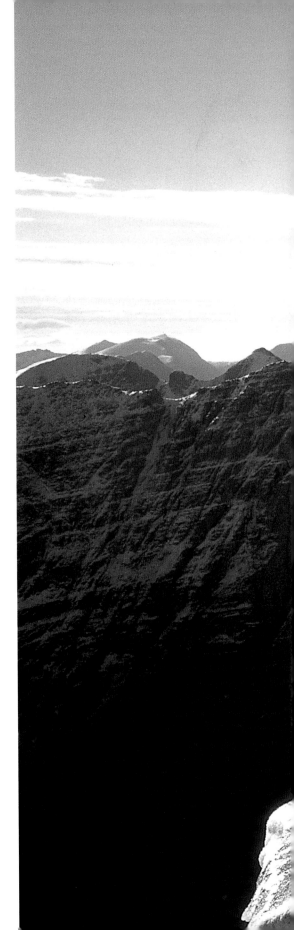

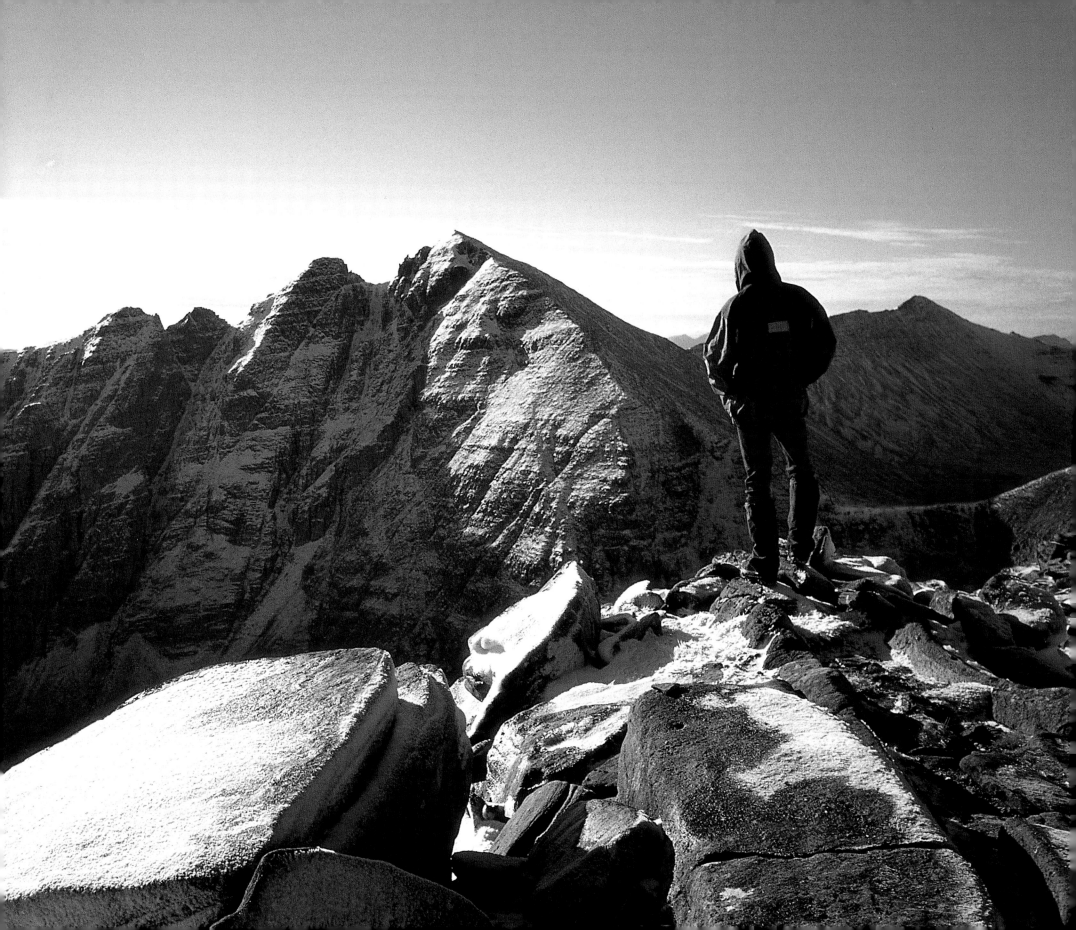

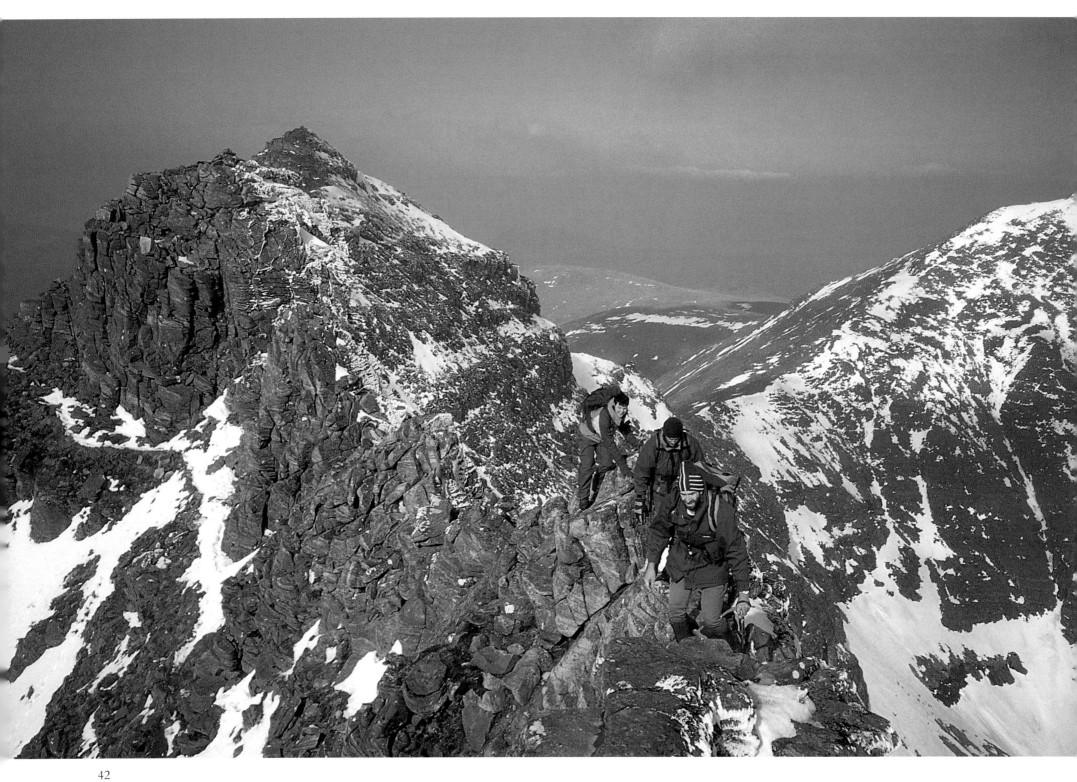

Left

The route along the crest of Corrag Bhuidhe is an exhilarating scramble with sensational exposures down to Toll an Lochain. Several pinnacles, each formed of giant pancakes of weathered sandstone, can be climbed or else bypassed by traversing paths down on the south side. The crest ends at an abrupt buttress of rounded and often wet rock. Many climbers try to descend this 'bad step' direct, and a number of fatal falls have occurred here. It is far safer is to retrace one's steps a little and descend a bouldery gully for more than 300ft down the south flank to gain a narrow but simple traversing path which regains the ridge beyond the step. All of this section becomes serious mountaineering terrain under snow and ice.

Right

With the excitements of the pinnacles over the walker can lengthen stride over the final tops of Stob Cadha Gobhlach and Sail Liath, and then, with luck, can enjoy a regal promenade down to the Corrie Hallie track in afternoon sunshine with the Fannaich hills as a backcloth. The traverse of An Teallach should be reserved for a fine day when both its intimate pleasures and distant views can be savoured to the full.

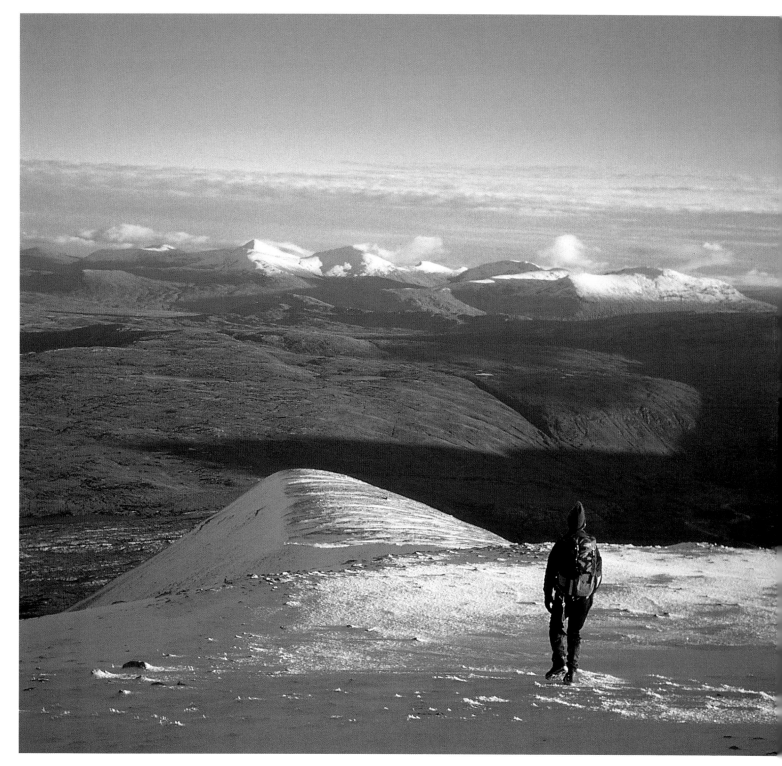

THE MIGHTY FORGE

Retrospect of The Forge from Loch Droma. I remember less about my own first traverse of An Teallach as a 17-year-old boy than the distant view of the mountain as we drove back over the Braemore heights towards Inverness. The sight of her serrated crest rising out of the evening haze prompted the most wondrous disbelief. 'Have I really just climbed that?,' I asked myself. There are only a few special mountains whose aura shines more brightly after close acquaintance. An Teallach is one of them.

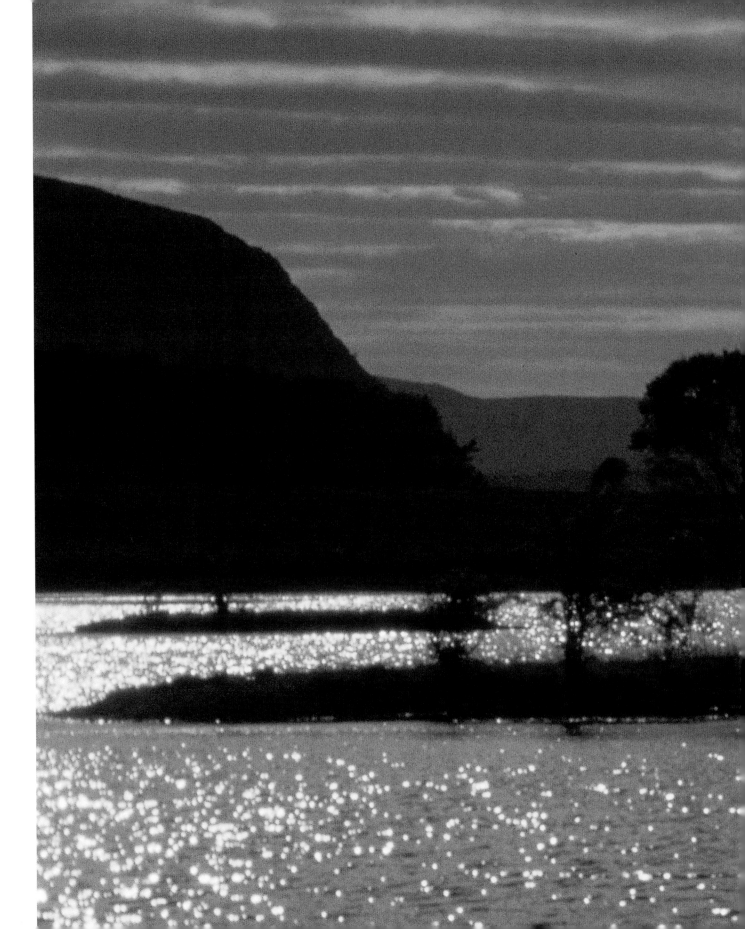

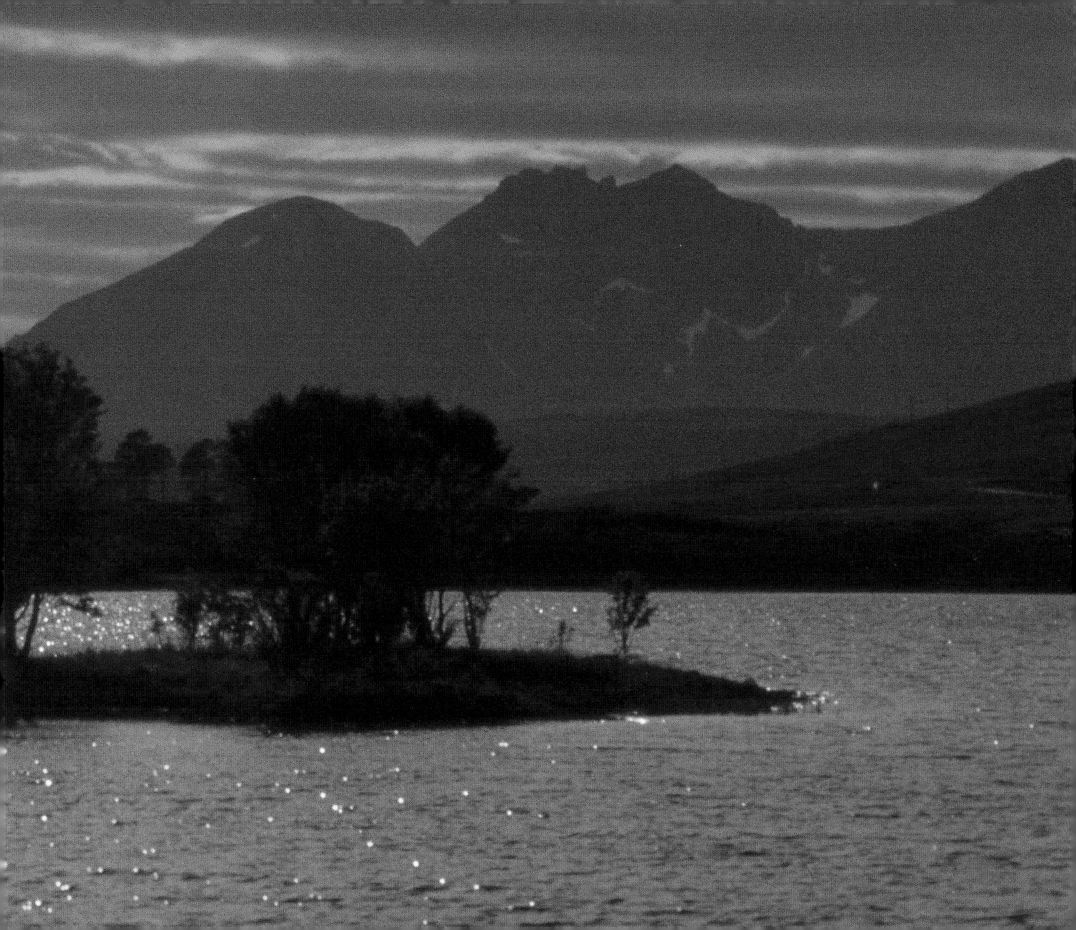

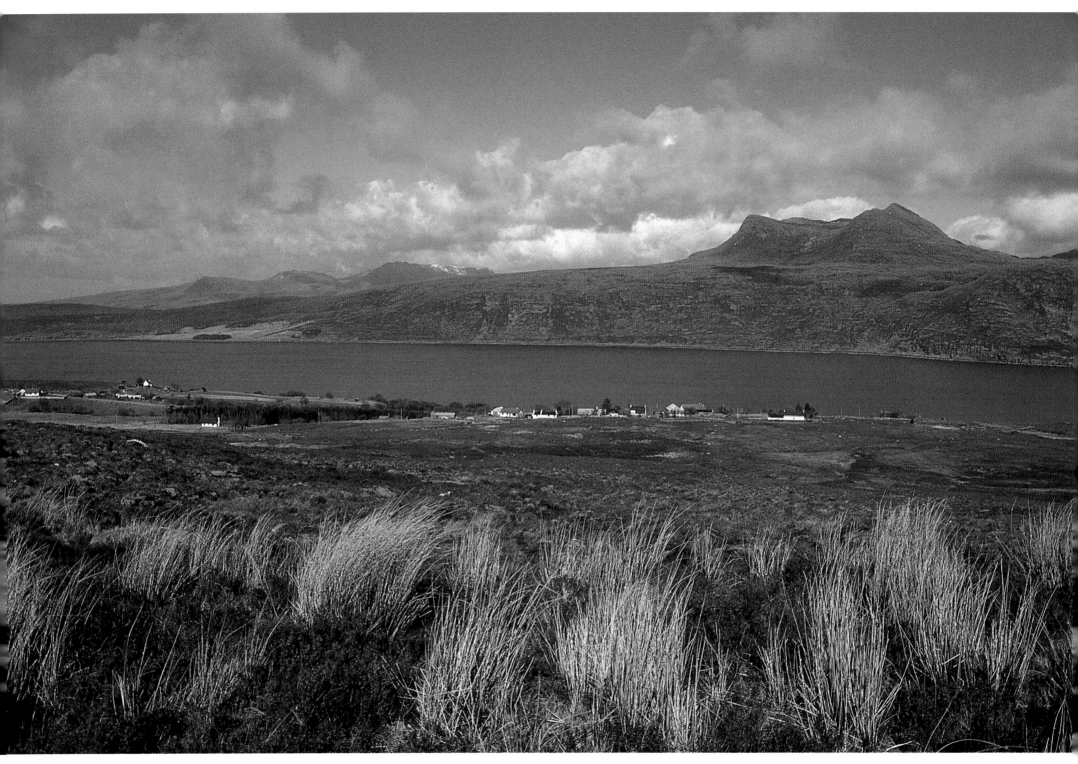

THE ROSS-SHIRE RIVIERA

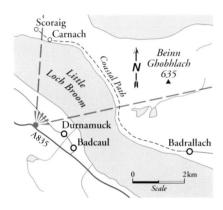

Left
At Badcaul the A832 swings away from Little Loch Broom and climbs over heather-clad moors to Gruinard. The bold outline of Beinn Ghobhlach is seen across Little Loch Broom and to its left the township of Scoraig. Isolated by 3 miles from the nearest road-end, Scoraig's population so dwindled that by 1964 there remained only four incomers who wished to recreate a self-sufficient community by attracting other settlers of like mind and varied talent. Their initiative was so successful that by 1991 the population had risen to 88 supporting a primary school with a roll of 13, and a resource base of windpower, fishing, market gardening and high-quality craftwork. Scoraig is a remarkable example of a community reborn.

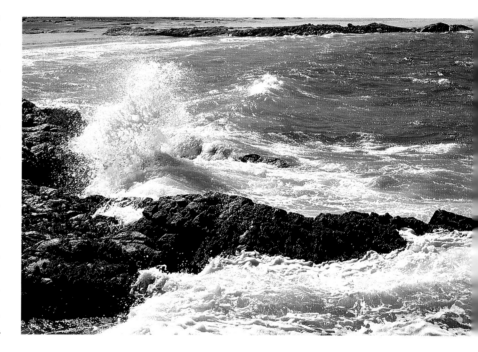

Above
Atlantic rollers crash into the shoreline rocks at Cove, 6 miles north of Poolewe on the Rubha Reidh peninsula.

In delightful contrast to the grandeur of its mountain backbone, Wester Ross possesses a coastline of sandy beaches and rocky coves linked by a necklace of crofting and fishing townships. Though born in the social upheavals of the late eighteenth century, smitten by the hardship of subsistence agriculture and sapped by depopulation, these villages today enjoy a prosperity far beyond what could have been envisaged 50 years ago. With a mix of native and incoming families, a strong sense of community and many small businesses in tourism, fishing and land management, the economy of the area is certainly reaping the rewards both of indigenous industry and publicly-funded improvements to roads and harbours. Whether surfing alone on the Atlantic waves, pottering around the inlets in a kayak, rock climbing or just strolling along empty sandy beaches, there is no doubt that here is paradise for the discerning holidaymaker.

47

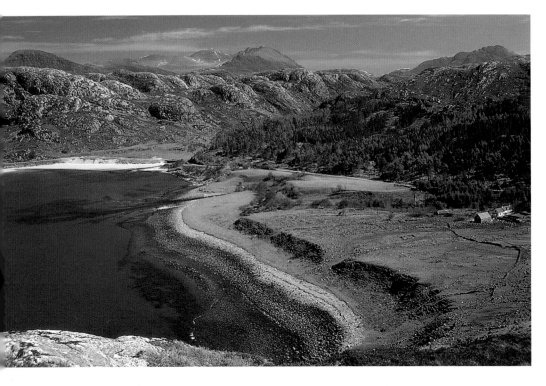

Above

Gruinard is the first sandy bay encountered on the journey from Dundonnell to Gairloch. Its name is derived from the Norse *grunna-fjordr* meaning shallow firth. The sands are tinged with the distinctive pink of their parent sandstones. A succession of domes of Lewisian gneiss, scraped bare by the ice sheets of 20,000 years ago, rise behind the beaches. All three major rivers of the Great Wilderness – Gruinard, Inverianvie, and Little Gruinard – empty their waters into Gruinard Bay. Just over a mile north of the bay lies Gruinard Island which was deliberately infected with anthrax as part of a wartime experiment into the effects of biological weapons. Only in 1990 was the island finally declared safe to visit.

Right

Rubha Reidh lighthouse was built in 1912 by David Stevenson, cousin of author Robert Louis. Its beam of 295,000 candle power has a range of 23 miles. Save for the wrecking of an American Liberty ship with the loss of 62 lives in 1944, the light has successfully protected all shipping passing through this part of the Minch. When automatic operation was installed in 1985 the keepers' house became a centre for activity and exploration holidays.

Sail Mhor *An Teallach* *Beinn Dearg Bheag*

Gruinard Bay Little Gruinard

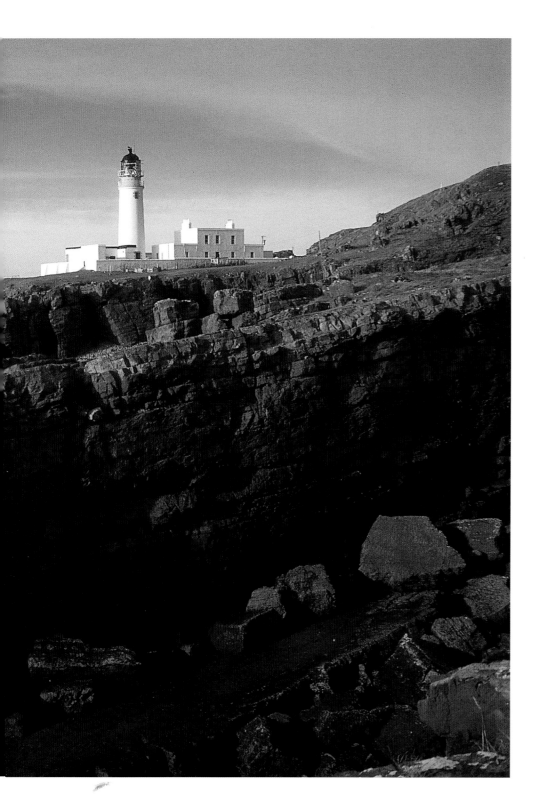

Above

Gateway to 100,000 visitors every year, Inverewe Garden is one of Scotland's man-made wonders. Prior to Mr Osgood MacKenzie's acquisition in 1862 Inverewe Estate was an acidified wilderness of raw peat, but over the next 60 years he propagated a sub-tropical garden of exceptional luxuriance on this ground. Once initial shelter was created by enclosing trees, the mild and humid sea-level climate produced by the Gulf Stream allowed increasingly exotic shrubs, plants and flowers to flourish. Since 1952 the garden has been owned and maintained by the National Trust for Scotland.

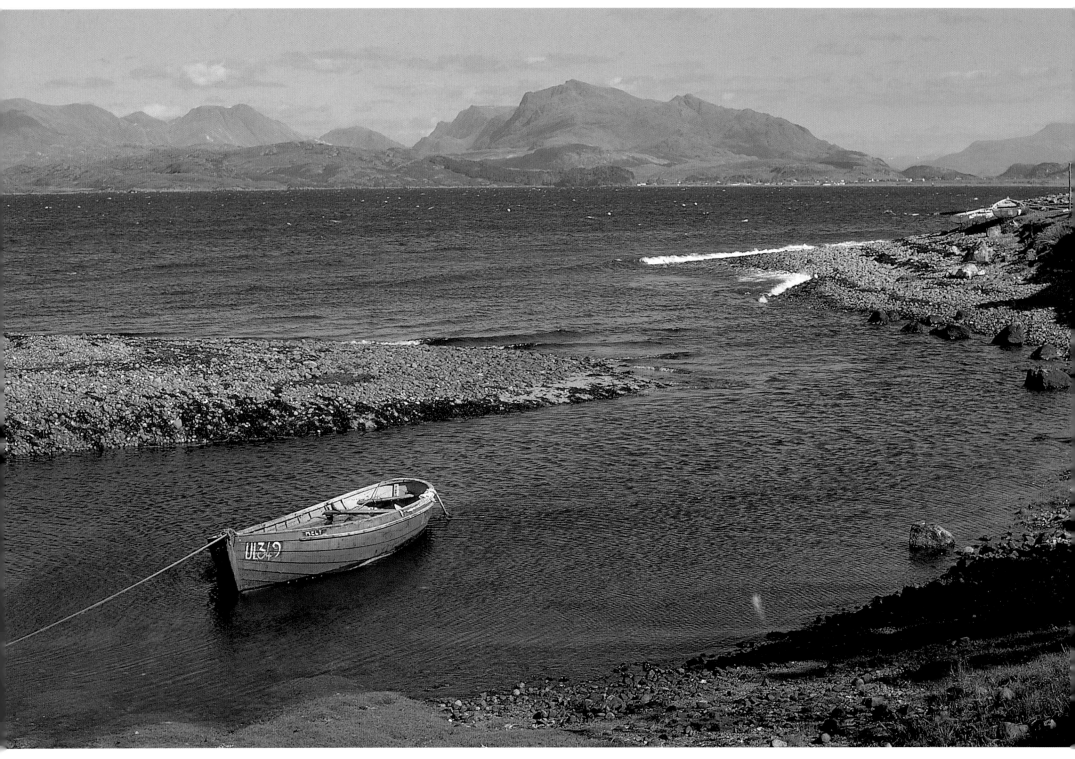

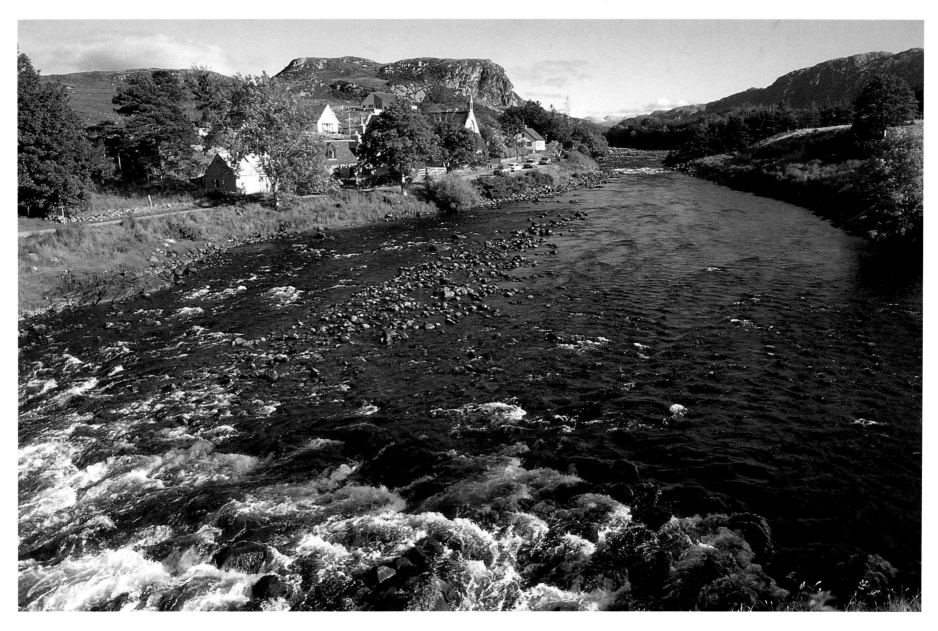

Left

With a deep broad inner reach and narrow entrance Loch Ewe was an ideal site for naval operations during the Second World War. Despite the mining of the Home Fleet flagship, HMS *Nelson*, in December 1939, the loch later became the assembly point for convoys on the notorious Arctic run to Russia. From 1941–44 a total of 19 convoys with 481 merchant ships and 100 naval escorts sailed from here. Many were never again to see British waters once they left Loch Ewe.

Above

Poolewe village stands at the outlet of the River Ewe which drains Loch Maree and its basin, and was the focus of the local iron-smelting industry in the seventeenth century. An estimated 740 acres of prime forest around Loch Maree were felled annually to provide charcoal fuel. Haematite ores from England were landed here, finished cast and wrought iron shipped out, and a furnace known as A'Cheardach Ruadh, the Red Smiddy, stood on the banks of the river. Piles of red slag can still be unearthed in the vicinity.

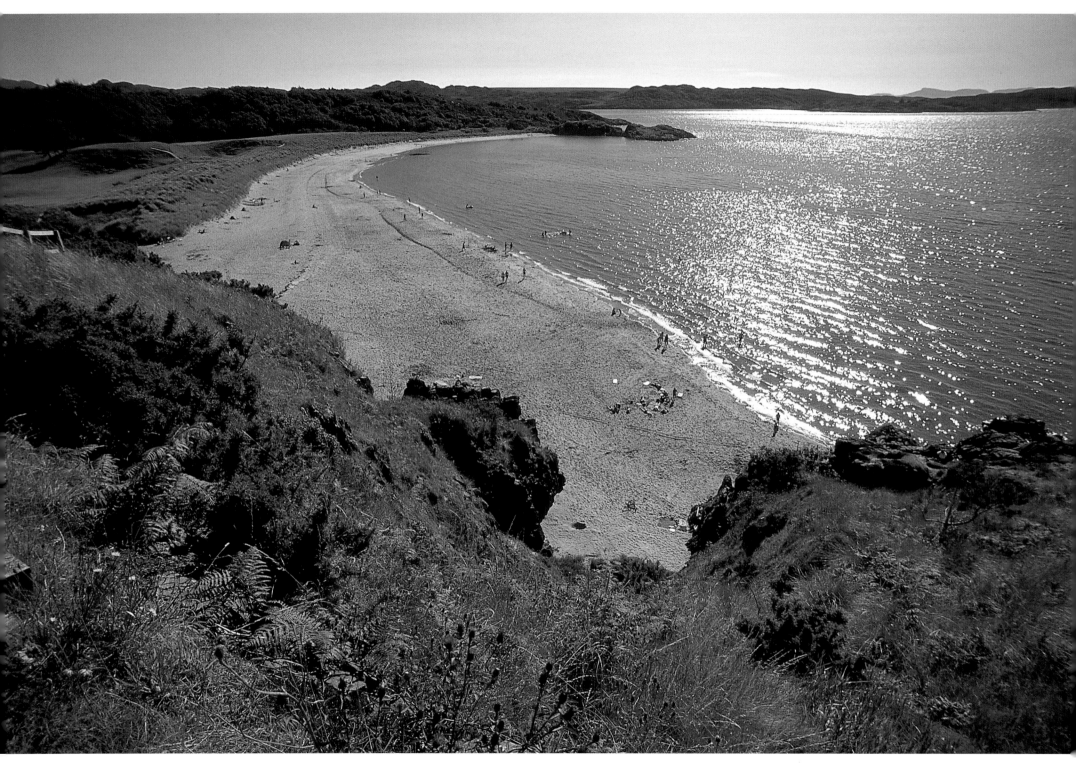

Left

Gairloch's sandy beaches have attracted tourists since 1872 when the hotel was opened on the shore front, its imposing portals still welcoming thousands of tourists each year. Gairloch derives from the Gaelic, *An Gearr-loch*, meaning the short loch. The town, with a population of just over a thousand, is an amalgamation of the five crofting townships scattered round the bay. Auchtercairn is the main social focus with shops, a modern high school and museum. Were it not for the chilly sea temperature, an unjust reputation for wet summer weather and the predations of the dreaded midge, this whole coastline could be a prime destination for mass tourism.

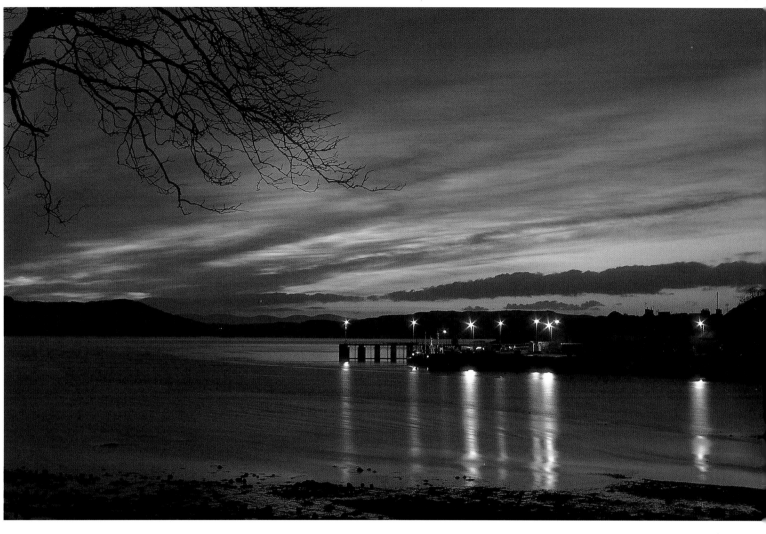

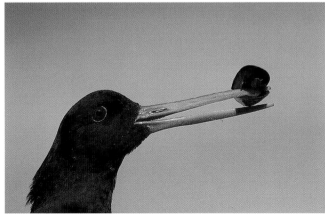

Left

An oystercatcher enjoys a tasty bite of mussel. Visually the most distinctive and one of the most common of the many wading birds to be seen in the estuaries of Wester Ross, the oystercatcher is a ground nesting bird with a long flattened bill especially adapted to prising open the shells of its prey. Its shrill piping *pic-pic* call is as easily recognised as its black-and-white plumage, red bill and legs.

Above

The pier and commercial centre of Gairloch lies at Charlestown, a mile south of Auchtercairn. Here an expanding trade in landing and processing shellfish – prawns, scallops and lobsters – has provided jobs and prosperity outside the tourist sector in recent years.

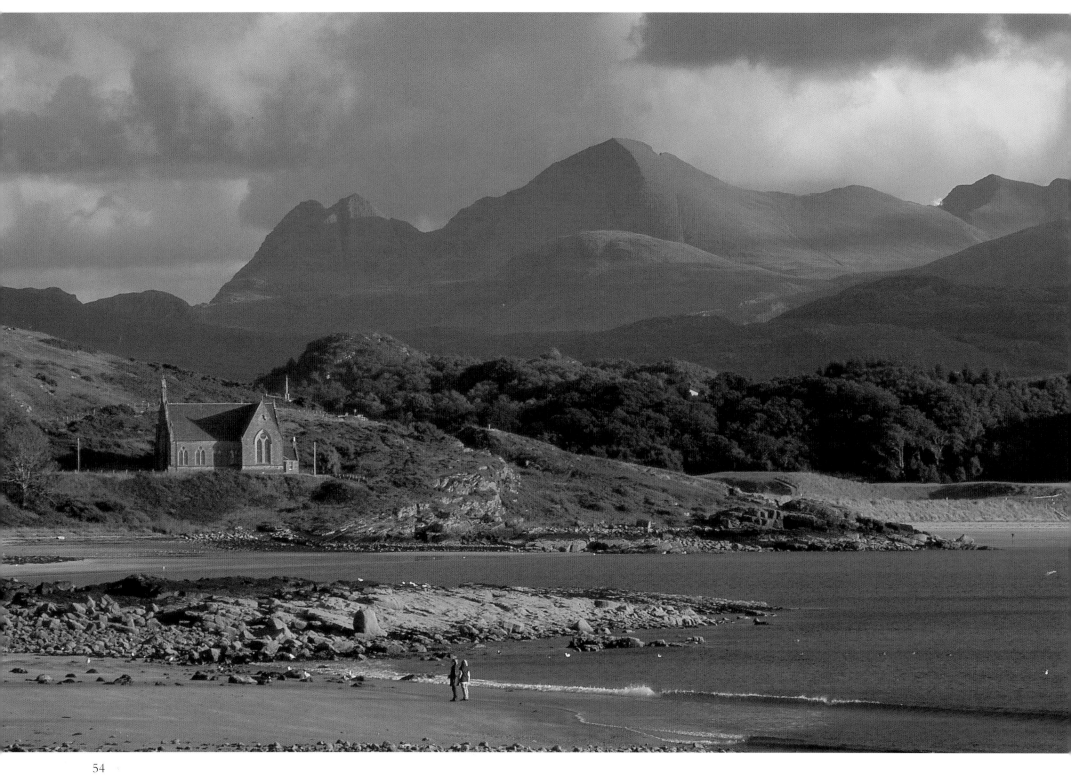

Left
Gairloch is one of the largest parishes in Scotland, some 18 by 31 miles in area. The view from Strath Bay past Gairloch Free Church stretches over Flowerdale deer forest to Beinn Alligin and the Torridon hills. The lands of Gairloch have, since a Royal Charter of 1494, been owned by the MacKenzie family, who successfully introduced the crofting system to the townships after 1845 without resort to forced clearances, as were occurring elsewhere in the region.

Right
The Victoria Falls at Slattadale above the side of Loch Maree were named in honour of the Queen's visit during her famous tour of the Gairloch area in September 1877.

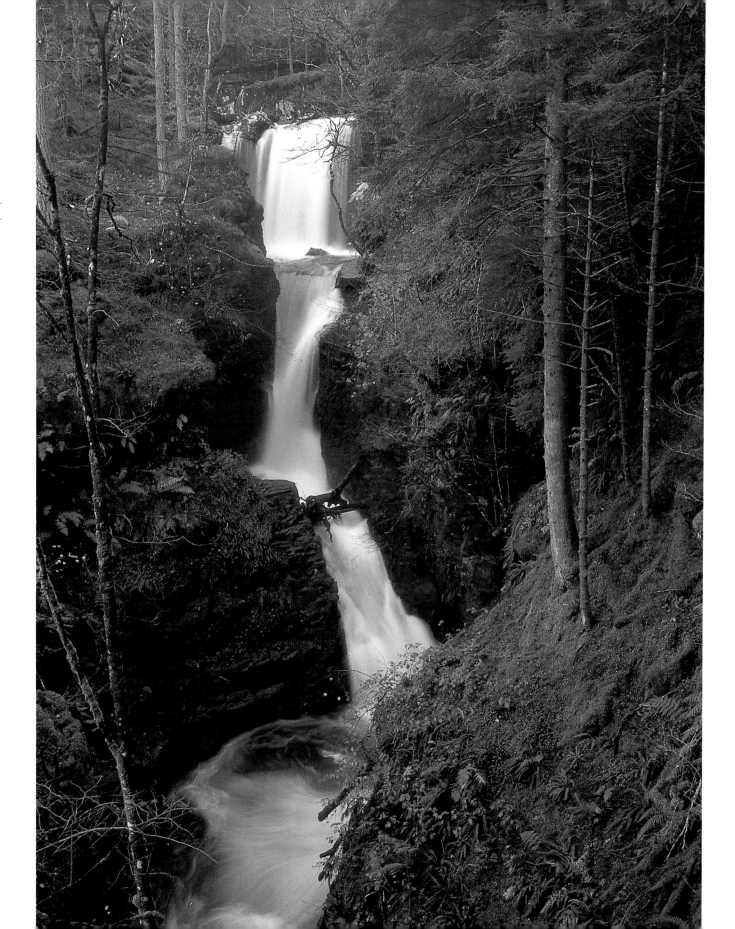

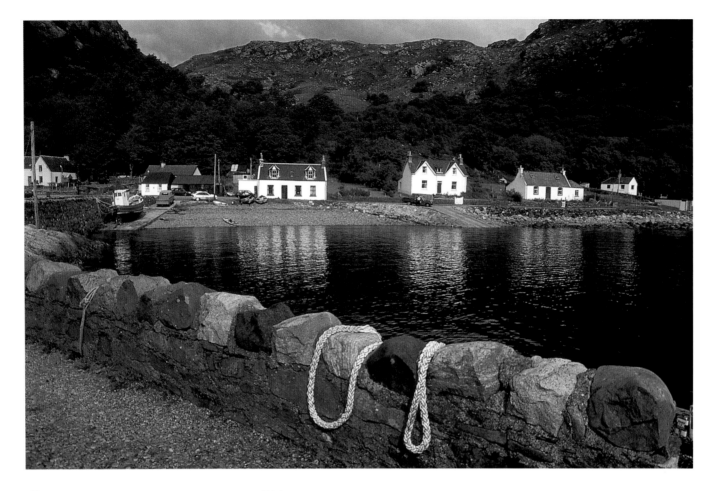

Right
Torridon village nestles at the head of upper Loch Torridon close under the mighty bulk of Liathach, guaranteeing copious rainfall as moist air condenses on being driven up over the mountain mass. The Munro summits of Beinn Liath Mhor (left) and Sgorr Ruadh (right) dominate the skyline to the south.

Above
Diabaig harbour lies in a peaceful cove girt by gneiss crags on the north side of Loch Torridon. In smuggling days there was a local saying *Is fada Diabaig bho lagh*, 'Diabaig is far from law'. Though now linked by road, the village is still a tortuous 7¹/2-mile drive from Torridon. A large fish-farm enterprise now uses the cove, yet Diabaig retains its appeal as one of the most delectable spots on the north-west coast.

Right
Lewisian gneiss boulders are washed clean by the Atlantic waves on Diabaig shore. Some 2,000 million years in age, and folded and gnarled by massive forces of crushing and buckling in the Earth's crust, this is the oldest surface rock found in Western Europe.

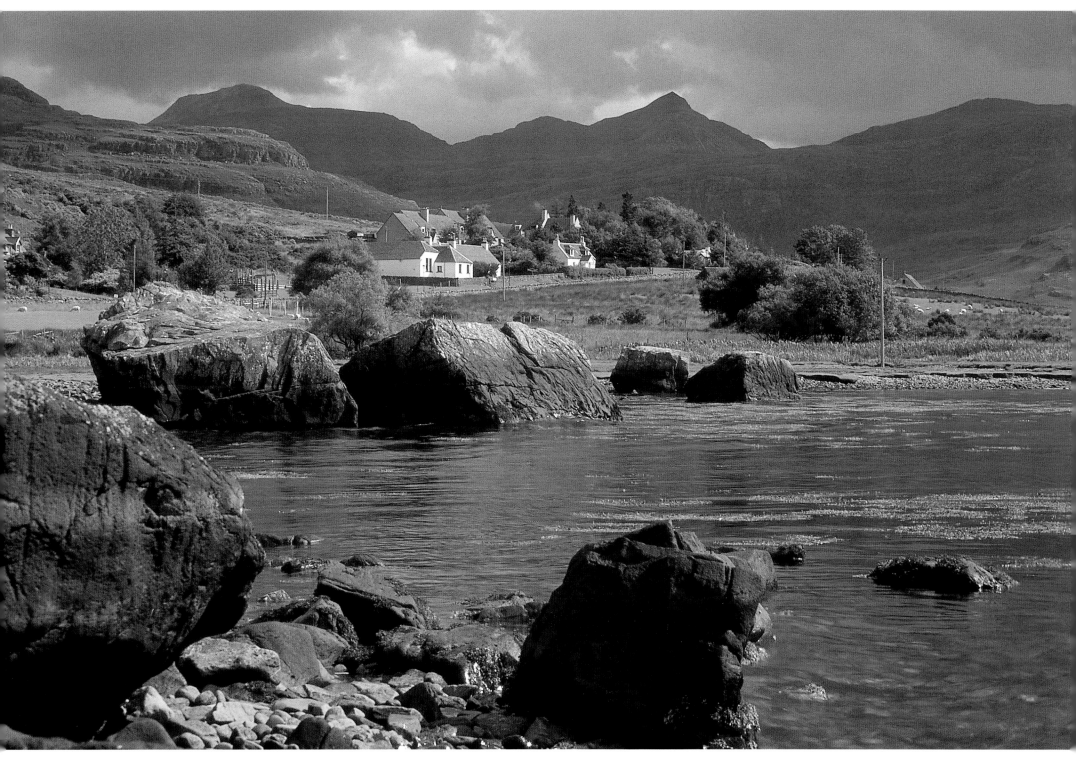

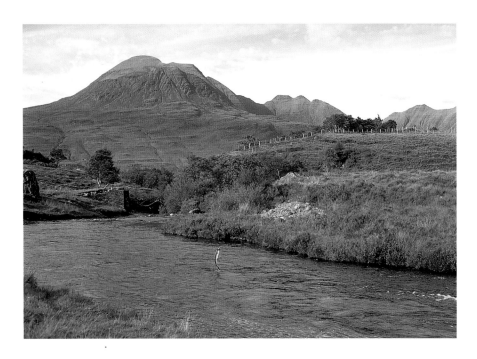

Below
Framed by a remnant of the Scots pines which still clothe the hillside, Shieldaig village has an enviable west-facing aspect in the crook of a bay on the south side of Loch Torridon. Like Ullapool, the settlement was created as a planned fishing village in the early 1800s. Its name *Sild-vig* is the Norse for herring bay, and the herring provided much of its early trade. As recently as 1953 white fish were numerous and a magazine could write, 'Shieldaig is famous for its whiting, coalfish, cod, gurnard and haddock'. Sadly, overfishing, particularly trawling, in the loch has depleted such stocks to danger levels in the 50 years.

Right
A summer sunset can be viewed here sinking to its final dramatic plunge from Shieldaig shore.

Above
The sight of salmon jumping in the rivers of Wester Ross is one that has become increasingly precious in the last 20 years. Diminution, and in some cases complete disappearance, of wild salmon stocks from many rivers has been a cause of major concern and investigation to environmentalists and fishermen alike. The River Balgy on the south shore of Loch Torridon was one of the prime sites to see the fish leap.

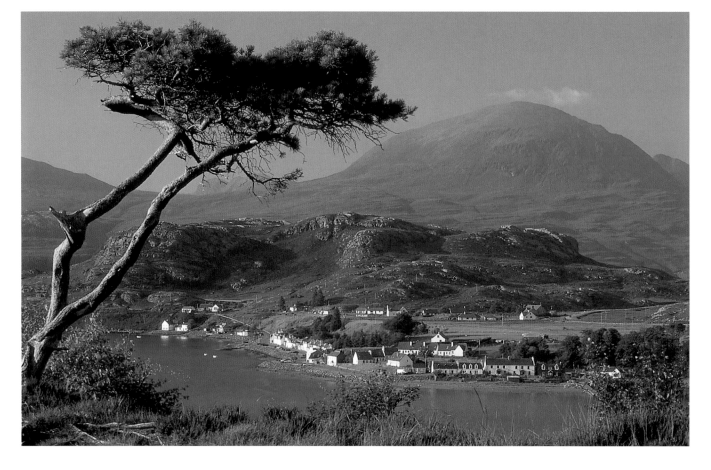

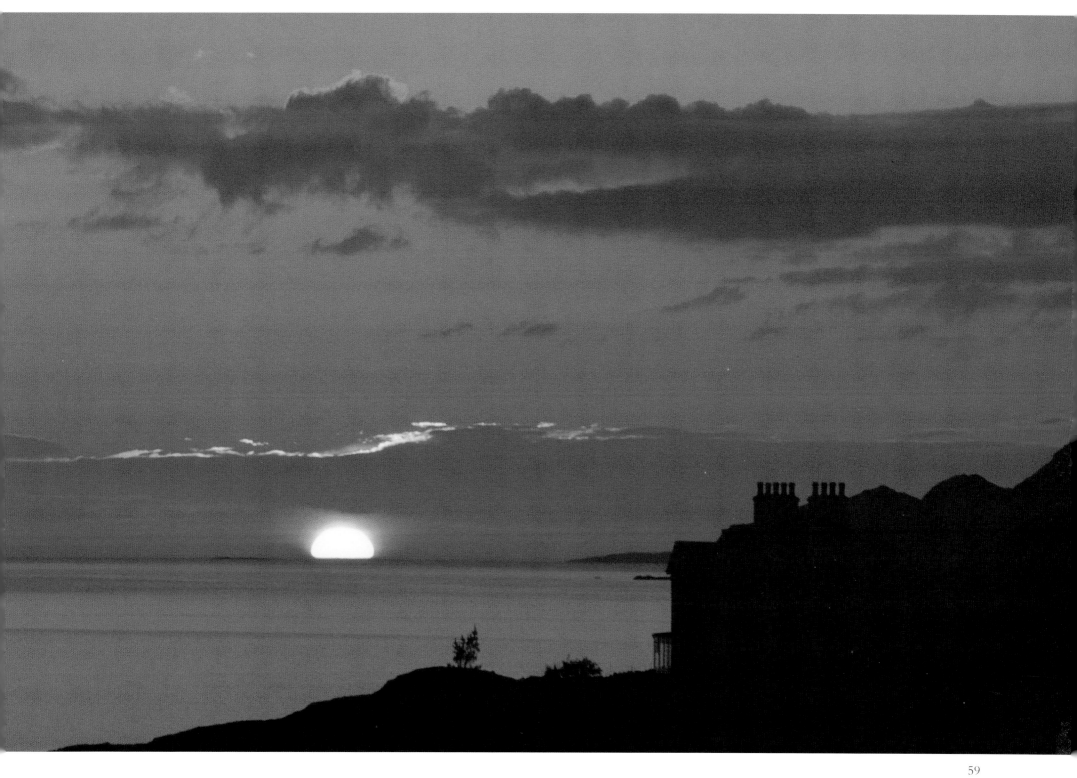

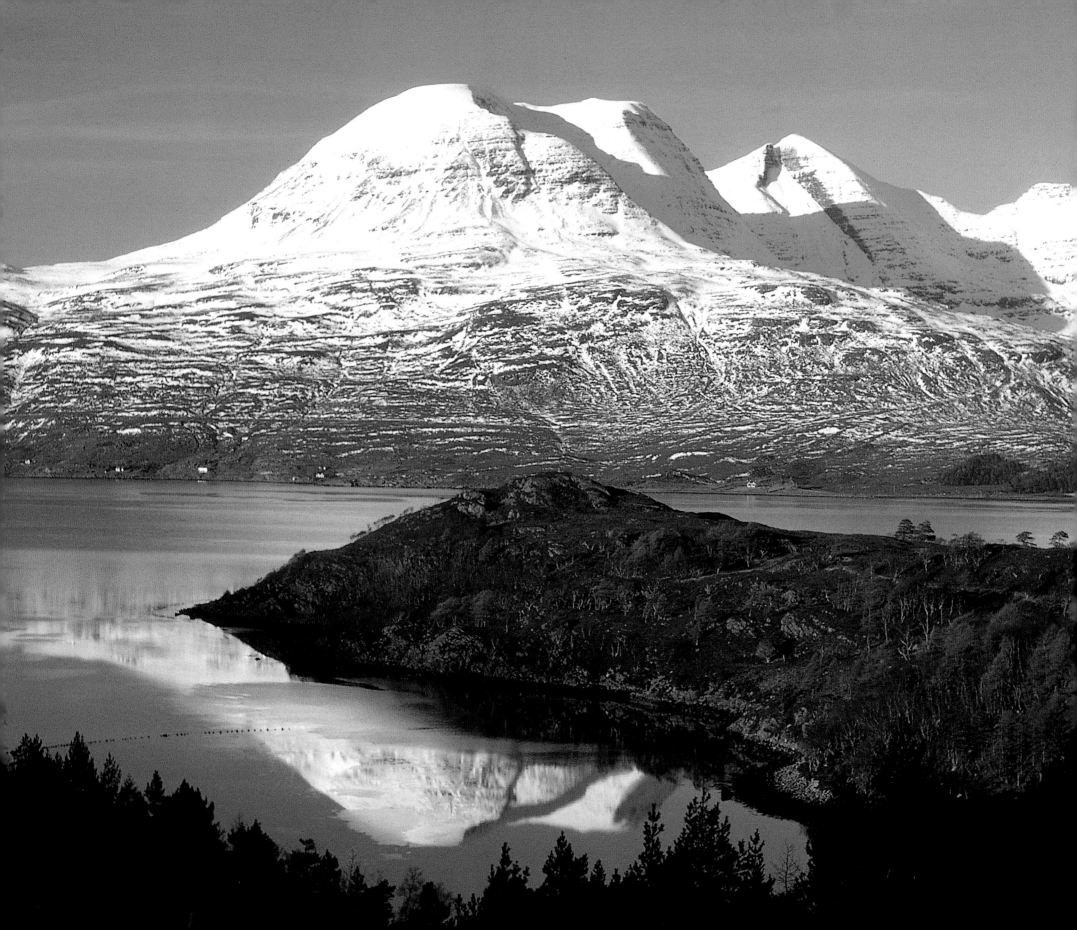

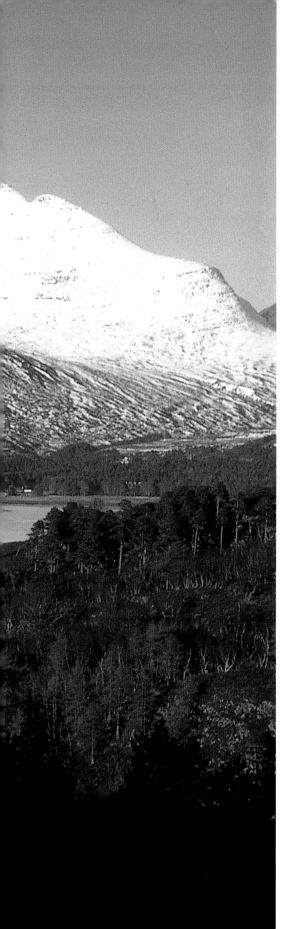

TORRIDON'S FORTRESSES

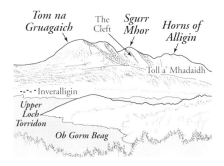

Tom na Gruagaich • The Cleft • Sgurr Mhor • Horns of Alligin • Toll a' Mhadaidh • Inveralligin • Upper Loch Torridon • Ob Gorm Beag

Left
Beinn Alligin is thought to mean the jewelled hill. The horseshoe of its main ridge runs clockwise over the western summit of Tom na Gruagaich, the knoll of the maiden, then round to the highest top, 3,232ft (985m) Sgurr Mhor, and finally over the triple-topped Horns of Alligin. The ridge traverse is regarded as good training for the sterner test of Liathach, and the Horns can be tricky in icy conditions. The southern and eastern flanks are seamed with long gullies formed from vertical joint lines in the sandstone. Although Alligin's westerly exposure to mild maritime airflows does not favour the build-up of snow and ice, good winter climbing can nevertheless be enjoyed for a few weeks each season.

Beinn Eighe, Liathach and Beinn Alligin, ancient remnants from hundreds of millions of years of erosion and more recent glaciations, together form the holy trinity of the Torridon mountains. Highest in altitude and centrepiece of the range, Liathach vies with An Teallach for the title of 'king of the Torridons'. Deep valleys dissect the trio, and a wild plateau stretches away to their north. No other hills in Britain possess their gaunt, chiselled beauty – and it is in winter that they assume their greatest majesty.

But equally there is a tangible brightness and refreshment here during the spring and summer. The last snows cling to the higher hollows on Liathach. Sunlight dances on the multitude of hill lochs, which sparkle like jewels set in the ancient mountain stone. Clouds may decorate the horizon but only rarely gather forces to truly drench the hills, for this is the driest spell of the year and the days are long, affording ample opportunities for exploration.

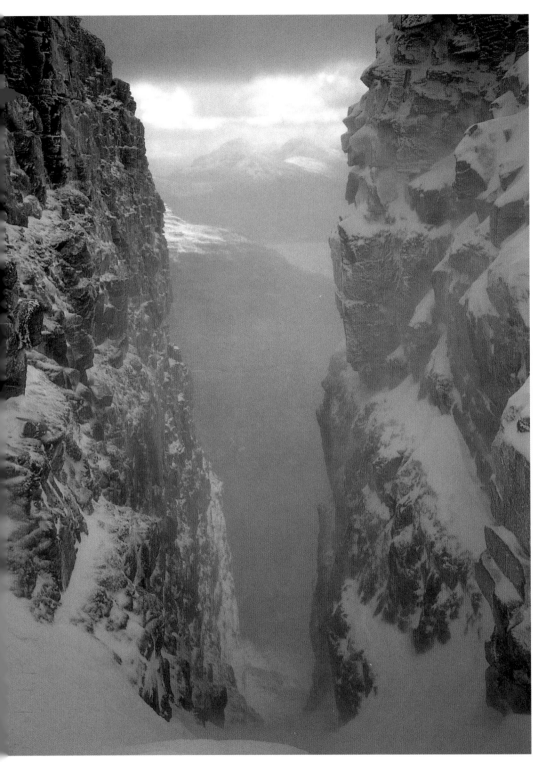

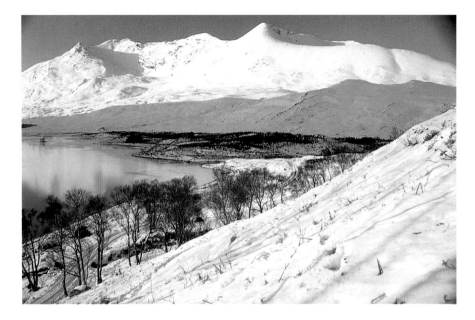

Left

The Eag Dhubh na h-Eigheachd, or Black Cleft of the Outcry, is one of the most spectacular natural features on the Scottish mountains. Standing in the notch at the head of the cleft on a blustery winter's day, great updraughts of spindrift funnel upwards. The sheer left wall drops over 1,300ft in a single slash down Alligin's southern face. The name Outcry derives from an old legend that a voice, presumably the wind, could often be heard moaning in the gully until the day when a man fell over the cliff to his death, whenceforth it was heard no more! Opinions vary as to how the Cleft was created; some say a single cataclysmic landslide created the feature, others favour prolonged glacial erosion along the joint line. The resultant debris now litters the corrie below in a huge boulder fan.

Above

The central ridge of Beinn Eighe looks supremely alluring in the view from Loch Clair when heavily plastered with snow. However, these conditions demand a purgatorial effort from the mountaineer who must break the trail in the fresh drifts. Summer walking times can be doubled in deep snow and there is barely sufficient light in a short winter day to reach the tops. By recompense the descent down steep slopes of soft snow can be swift and furious, especially if the sitting glissade position is adopted, but the risk of avalanche must always be assessed before embarking on steeper terrain in these conditions.

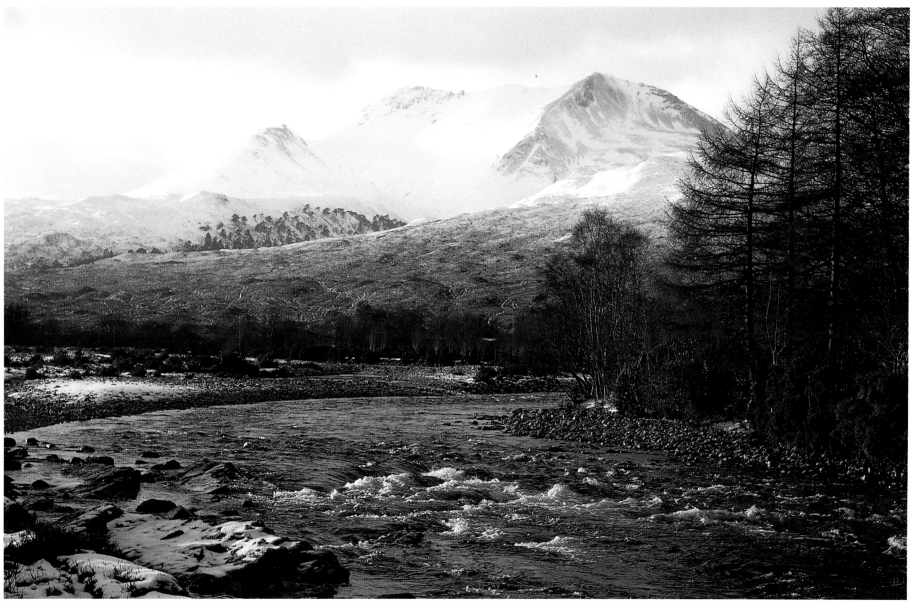

Above

The eastern end of Beinn Eighe makes an elegant portrait when viewed from the riverside at Kinlochewe. Remnants of Scots pines straggle up the lower slopes of Coire Domhain. This part of Beinn Eighe became Britain's first National Nature Reserve, when it was purchased by the Nature Conservancy Council in 1951. The first priority in management was the protection and regeneration of the mountain's surviving patches of native woodland, particularly the Coille na Glas-leitire above the shores of Loch Maree.

Although the lower slopes are now fenced off to prevent the ingress of deer, who would browse and kill off young trees, there are gates and stiles on all the main approach routes to facilitate human access to the mountain.

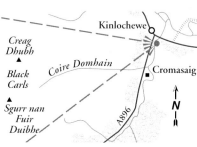

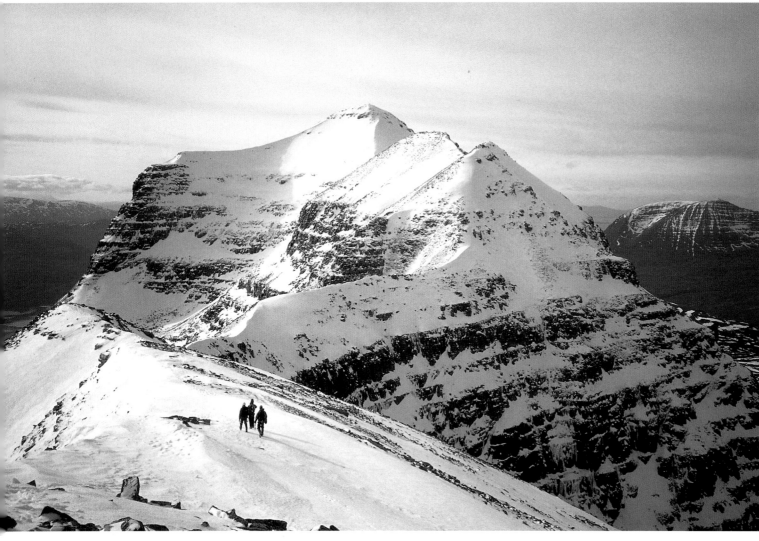

Right
Liathach, the grey one (locally pronounced leeagchach), is viewed in full winter raiment from the northern shore of Loch Clair. From here as nowhere else the mountain resembles the upturned keel of a beached galleon. Most climbers commence the traverse of the ridge at this eastern end.

Below
Few mountains in Scotland rise so steeply from sea level to summit as Liathach. In less than a mile terraced crags rise nearly 3,000ft from the foot of Glen Torridon to the Fasarinen pinnacles, an average angle of over 40 degrees. The pinnacles lie between Spidean a'Choire Leith and the second Munro, Mullach an Rathain. They form the crux of the traverse. In summer most can be bypassed by trods on the south side but a steep banking of snow forces the winter climber to traverse their crest.

Above
The easternmost top of Liathach, Stuc a'Choire Dhuibh Bhig, can be bypassed at the start of the traverse but is worth visiting to see the angular profiles of the main ridge, which appear as a row of superimposed pyramids. These culminate in the mountain's main summit, the 3,456ft (1,054m) Spidean a'Choire Leith. The banded

cliffs on either side of the crest leave no illusion as to the seriousness of the traverse in winter conditions, for escape routes are not easy to find.

Right
Smothered by fresh snowfall and tinted with hoar-frost crystals, a bog myrtle bush lies dormant in Glen Torridon.

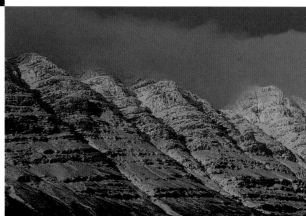

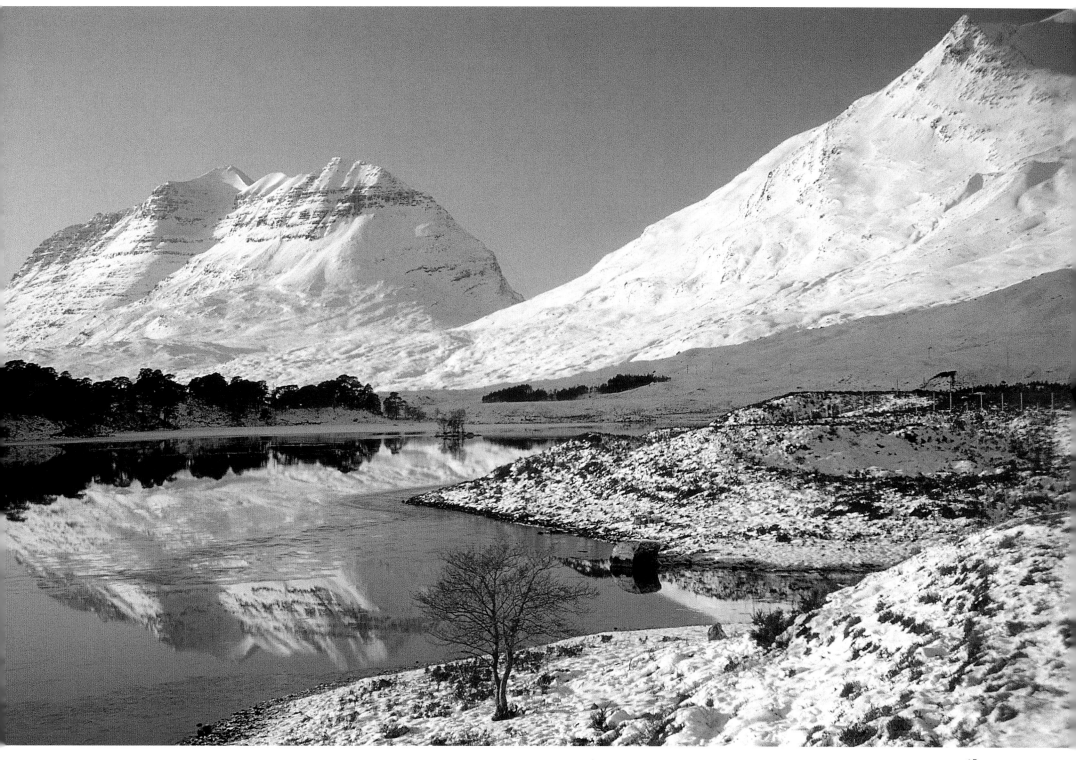

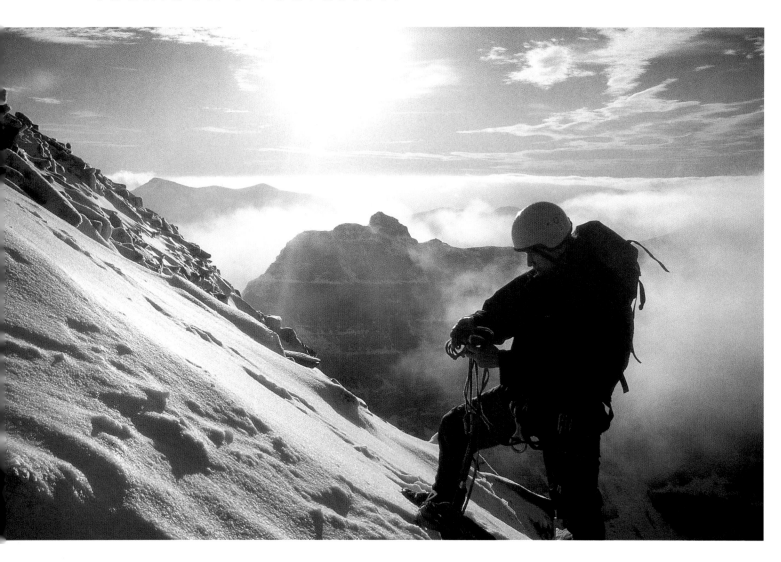

Above
A climber coils the ropes on a January afternoon after an ice climb on the north side of Liathach.

Left
In sub-zero conditions moist air deposits exquisitely feathered crystals of rime as it rises over the mountain crests, creating a fragile coating of ice on every windward rock face. As the summit of Liathach is approached, the clouds sink to reveal the spearhead of Sail Mhor, the north-western spur of Beinn Eighe.

Opposite
In the deepening shades of a winter's afternoon the central ridge of Beinn Eighe is seen longtitudinally from the summit of Liathach across the depths of Coire Dubh Mor, the deep valley which separates the two mountains.

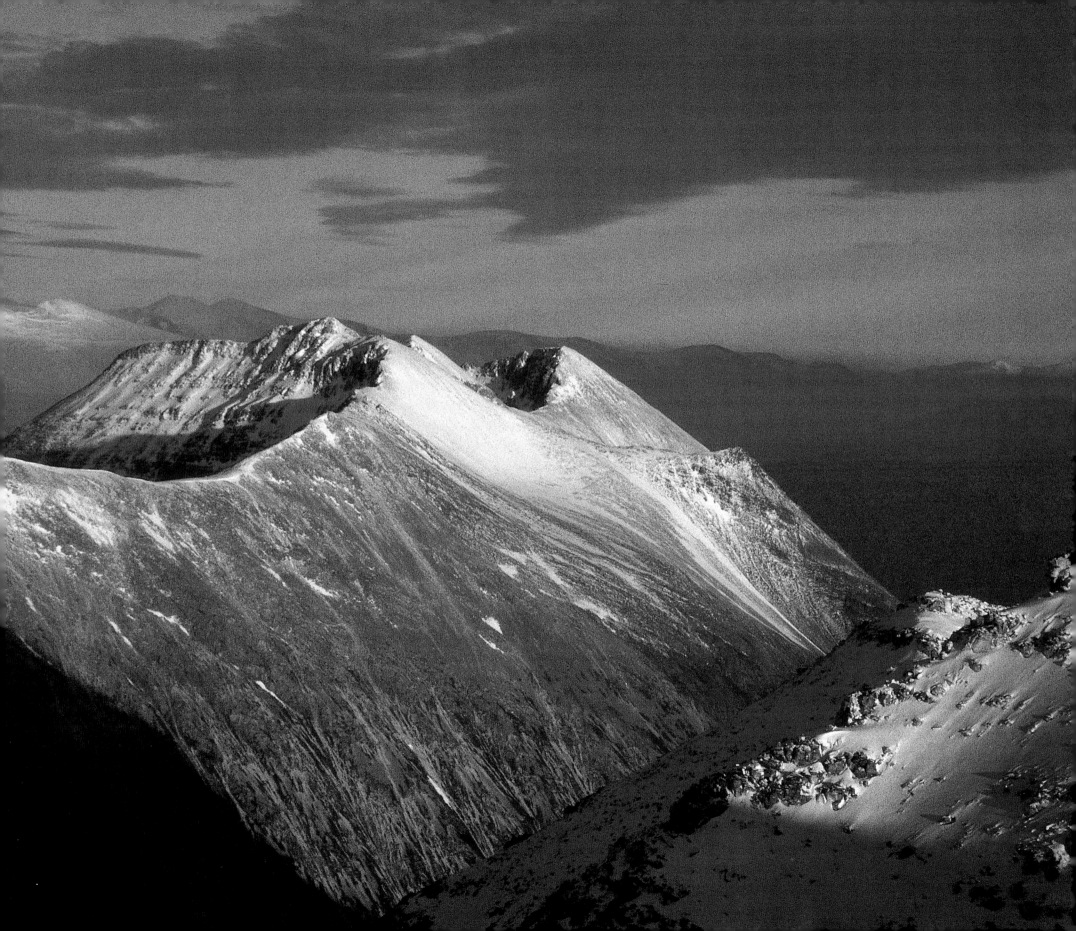

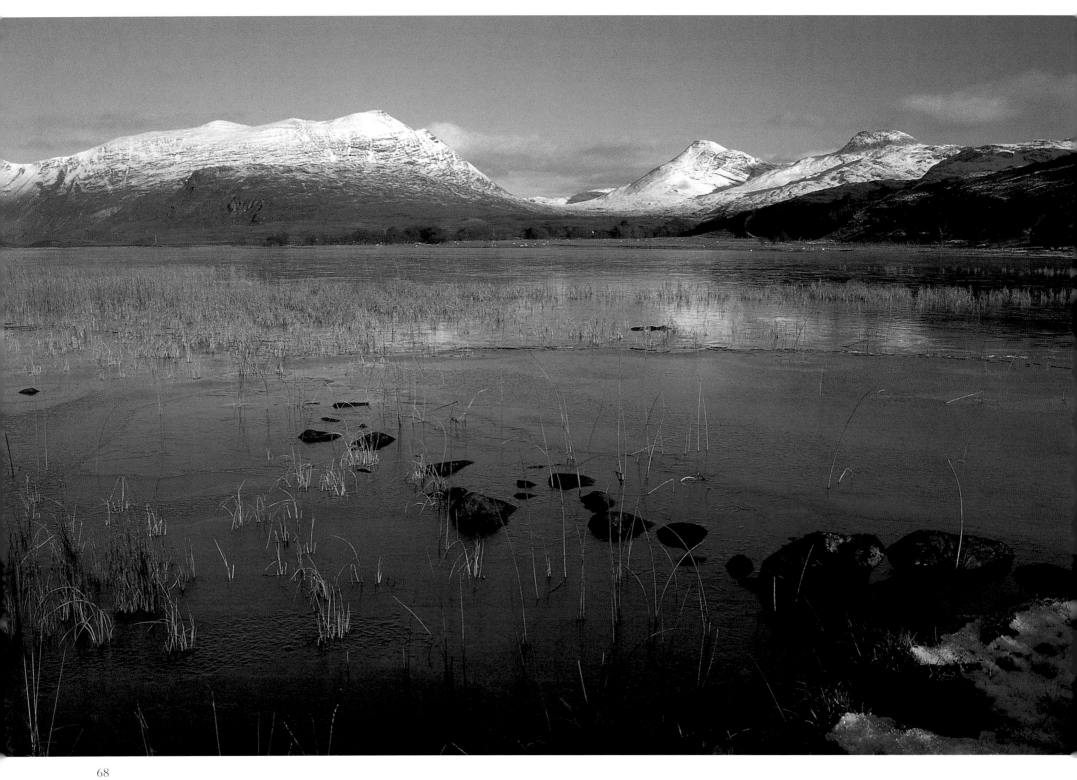

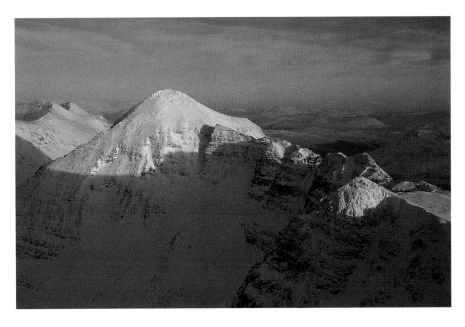

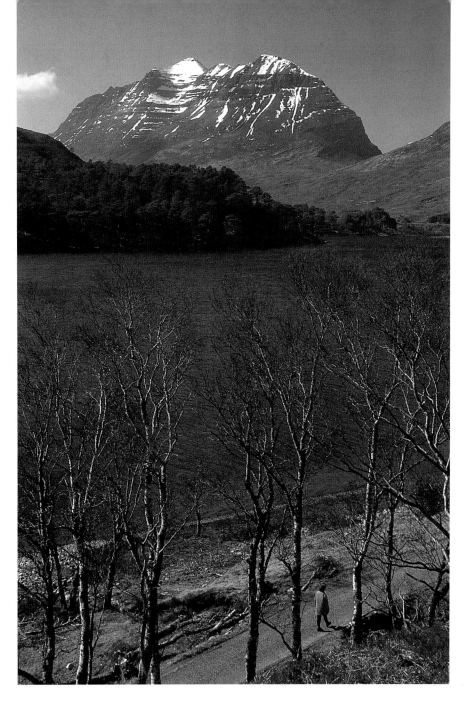

Left

The winter scenes in Torridon can be enjoyed without climbing the mountains and nor are the wonders confined to the famous trio of peaks. In this view we stand below the road between Kishorn and Shieldaig and look across Loch an Loin to the hills south of Glen Torridon. For long periods in winter the Atlantic depressions and westerly winds dominate the weather with little respite, and yet whenever air pressure rises to a temporary ridge or else settles to create a stable mass of air over Scotland, yesterday's storms can be instantly forgotten as one wakes to a scene of frost and calm over Torridon's hills and lochs.

Above

In midwinter the traverse of Liathach is a race against time. The pinnacles must be crossed while the light holds, yet iced rocks and route-finding difficulties can often delay parties by up to two hours. Many groups will wish to rope up for this section. Thankfully, the technical difficulties are over once the upper ridge of Mullach an Rathain is reached. One can then look back on the pinnacles and Spidean a'Choire Leith in the alpenglow of sunset knowing that the way home is assured. This brief hour of sunset and twilight on the winter mountains is undoubtedly the most magical of all.

Above

An April stroll by the side of Loch Clair. To the west the rump of Liathach is steadily shedding its winter mantle. By mid-April the snow has usually retreated to the deeper gullies and higher corries, but walkers are wise still to carry axe and crampons, for icy stretches may yet be encountered. Sitting under the pyramidal cap of the Liathach the east-facing Coire Liath Mhor collects large volumes of snow borne on the winter westerlies and thick drifts can last through to June.

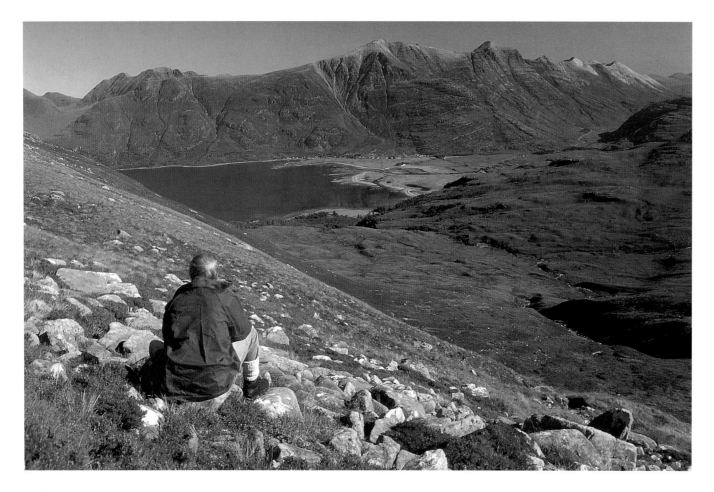

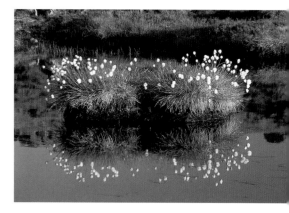

Above
An island of bog cotton grass in summer bloom on the peat moors above Shieldaig.

Left
The classic ascent of 2,957ft (902m) Beinn Damh climbs through the pinewoods above the Loch Torridon Hotel on to the open slopes of Coire Roill, from where a wide vista can be enjoyed across the head of the loch. The heavily vegetated sandstone flanks of Liathach contrast with the stony quartzite screes on Beinn Eighe to its right. Liathach's rocks are horizontally bedded and only the summit cappings on the two Munros are composed of quartzite, whereas the strata on Beinn Eighe dip south-eastwards so that the younger quartzite outcrops down to the lower slopes.

Right
Beinn Eighe's sprawling ridge line is nearly 4 miles long and contains six distinct summits. Traditionally, only one of these, Ruadh-stac Mor, was classed as a full Munro, but in 1997 the anomaly was corrected and the central summit, 3,258ft Spidean Coire nan Clach, was added to the list. Looking west from its summit the quartzite ridge makes a switchback traverse to the next top, Coinneach Mhor.

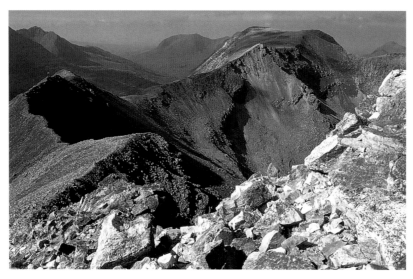

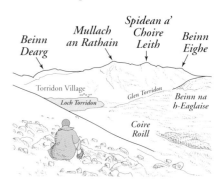

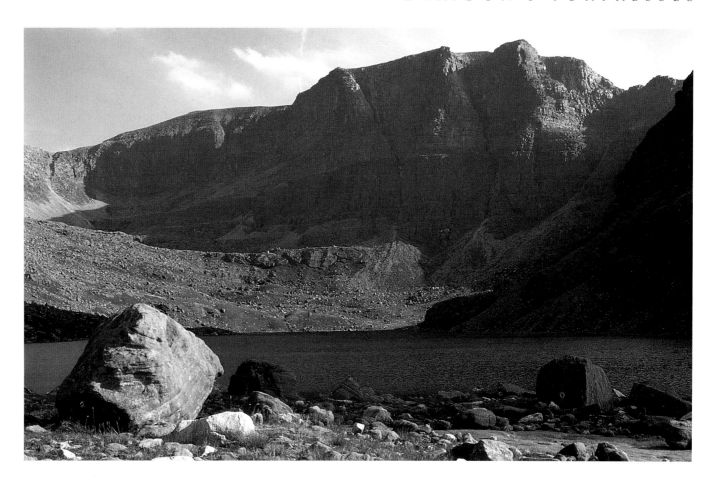

Below
On the edge of 'the File'; the traverse of Beinn Eighe is an exciting ridge walk without posing severe scrambling difficulty, so that the airy situations can be enjoyed by any fit walker. A full traverse usually takes around eight hours. Climbers are seen approaching the central summit, Spidean Coire nan Clach, with Sgurr Ban and the eastern end of the ridge behind. Along the traverse one sees many boulders covered in millions of tiny tubes, known as 'pipe-rock'. These are the casts of worms which lived in marine deposits some 400 million years ago which were later crushed and compacted into the quartzite rock. By contrast, the Torridonian sandstone which is twice as old predates such life forms and has no fossils.

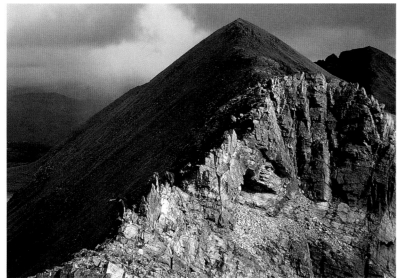

Above
Coire Mhic Fhearchair, the finest in Torridon, is cradled between Beinn Eighe's two north-western spurs and has been sculpted by successive glaciations into the magnificent Triple Buttress. After the effort of a 4-mile walk on a reconstructed path from Coire Dubh on the south side of the mountain, the view at the corrie lip is a sudden and exciting revelation. On the east side of the lochan there is a vivid lateral moraine of white quartzite boulders lying on top of sandstone bedrock, proving the role of the glaciers in plucking and transporting rocks away from the back walls. But it is the elegant asymmetry of the buttress which draws the eye and holds the gaze. At its base the propellers, engines and wheels of a Lancaster TX264 bomber can be found. Commencing a flight from RAF Kinloss on 13 March 1951, the plane clipped the mountain's crest and plunged over the buttress with the loss of its entire crew of nine.

Right above

The country to the south of Glen Torridon is peppered with lochans, criss-crossed by deer stalking paths and capped by attractive peaks. Though none of these match the grandeur of the 'Torridon trio' three are Munros and five attain Corbett status (between 2,500 and 3,000ft in altitude), including Beinn Damh which is seen here from the south east. The foreground is provided by Loch a'Mhadaidh Ruadh, the lochan of the red fox, highest of a string of lakes in the valley between An Ruadh-stac and Maol Chean-dearg.

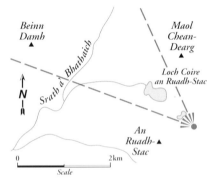

Right below

Silver birch and Scots pines at the foot of Coire Mhic Nobuil make a lovely frame by which to approach Beinn Alligin. These woodlands were severely damaged by a north-westerly gale in February 1989, but recovery is now well progressed. Elsewhere in Torridon large areas have been fenced by the National Trust to allow regeneration of a natural mixed forest on the lower slopes. In half a century one can envisage a rich forest throughout the Torridon glens similar to the pinewoods on the Beinn Eighe Nature Reserve above Loch Maree.

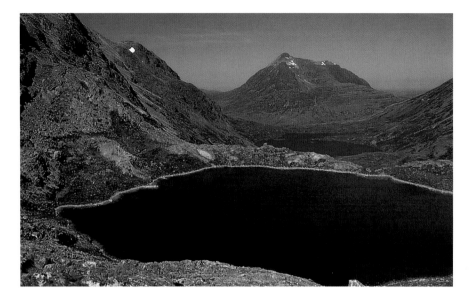

Right

Liathach's western summit, Mullach an Rathain, is picked out by the evening sunlight in this view from Ob Mheallaidh, the prominent bay on Upper Loch Torridon, $^1/2$ mile east of Shieldaig.

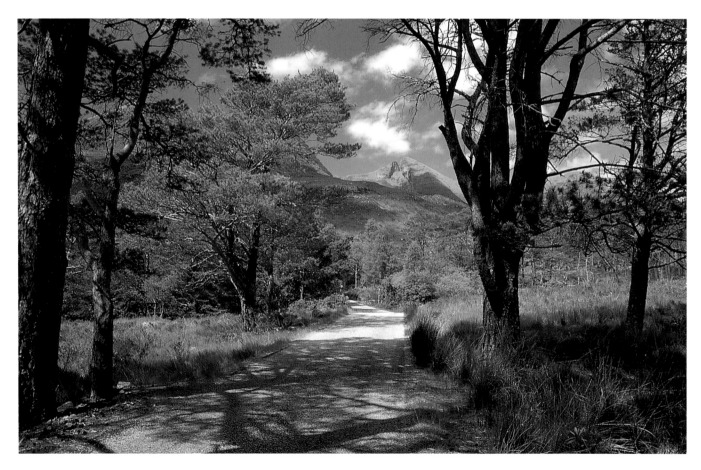

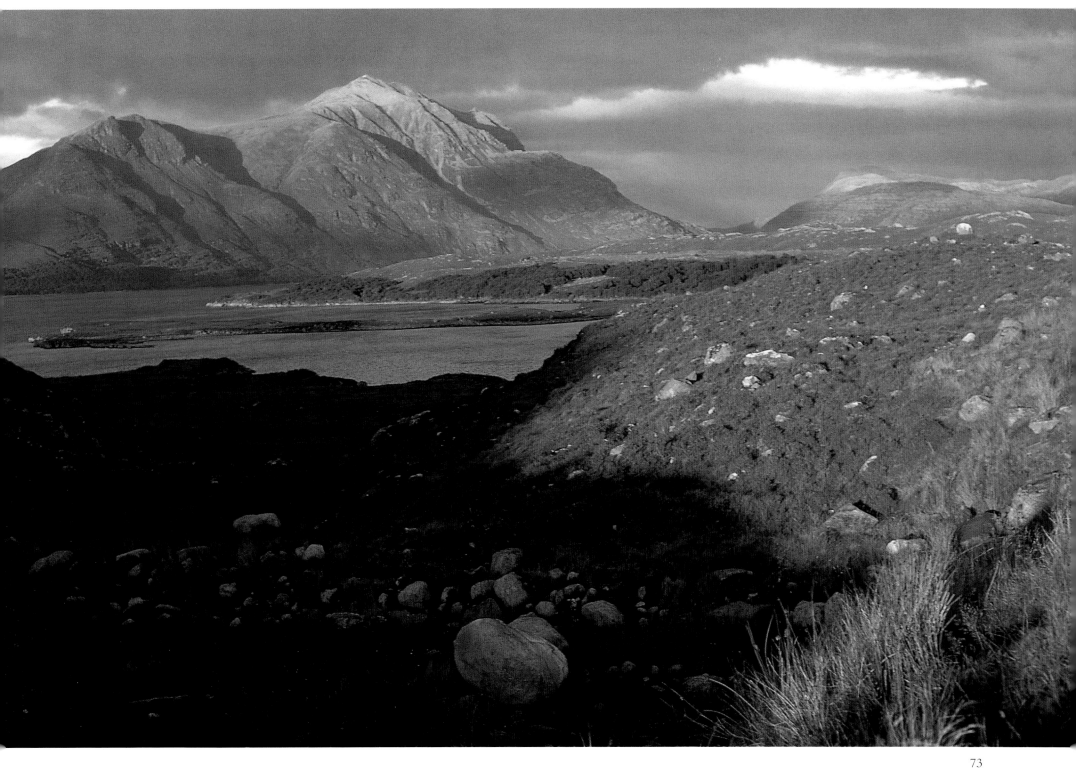

Below

Red deer stags stand alert among sandstone boulders on the slopes of Glen Torridon. In 2000 it was estimated that there were a total of 350,000 red deer in Scotland, some 100,000 too many for the carrying capacity of the land and for the protection of young woodland. Increased culls have been recommended in many areas by the Deer Commission for Scotland, particularly of hinds. Stags are shot for sport in the main shooting season from August to mid-October, but the hinds are largely culled by the professional estate stalkers between November and early February.

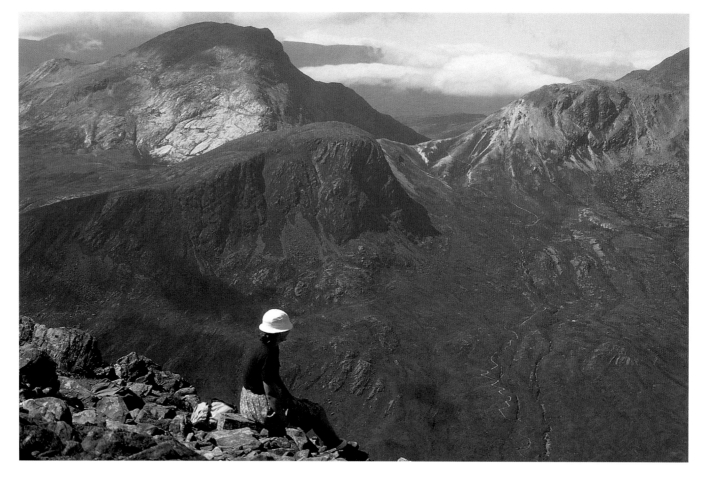

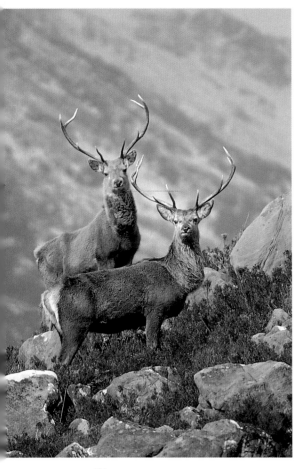

Above

June and July are the green months on the Scottish hills. Growth of sedge grasses is at its maximum while the pink heather is not yet in flower. Even the rocky Torridon hills look to offer luxuriant grazing for sheep and deer. Temperatures are mild enough to allow a prolonged sojourn on the hill tops. This scene from the top of 2,975ft (907m) Fuar Tholl above Glen Carron looks across Coire Fionnaraich to the bare quartzite dome of An Ruadh-stac, where a stalking path zigzags up the lower slopes. Glen Carron marks the south-eastern edge of the Torridonian rock massif; to its south the schistose hills of Monar and Attadale are more rounded and yet greener in their summer hue.

Right

Autumn gathers its rich harvest of colours over Loch Torridon. The ranges of the Beinn Damh and Coulin Forests are arrayed to the south. In October the eerie roaring of rutting stags provides an unforgettable accompaniment to a mountain walk. The stag stalking season is in full swing, but there are no restrictions on access to the hills of the National Trust Torridon estate and Beinn Eighe Nature Reserve. On private estates advice should be sought from the stalkers before embarking on the hills. Walkers can unwittingly shift the deer from their normal grazings and disturb an activity which is worth thousands of pounds in revenue to an estate every day.

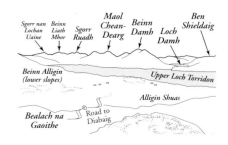

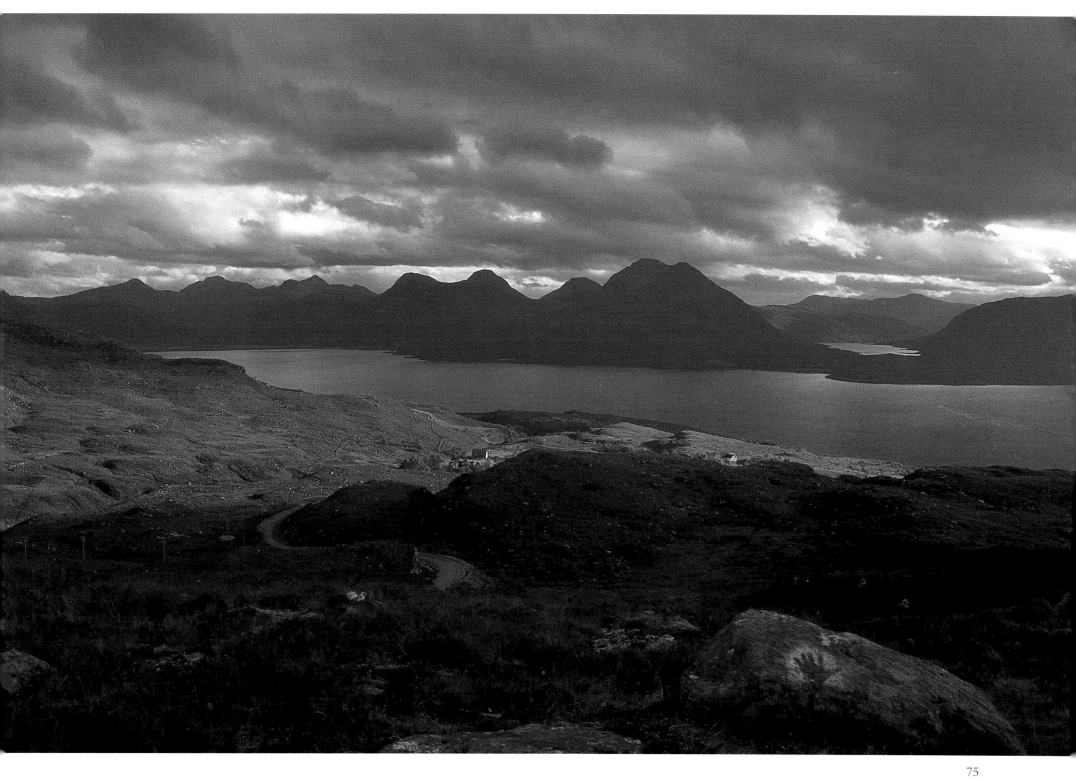

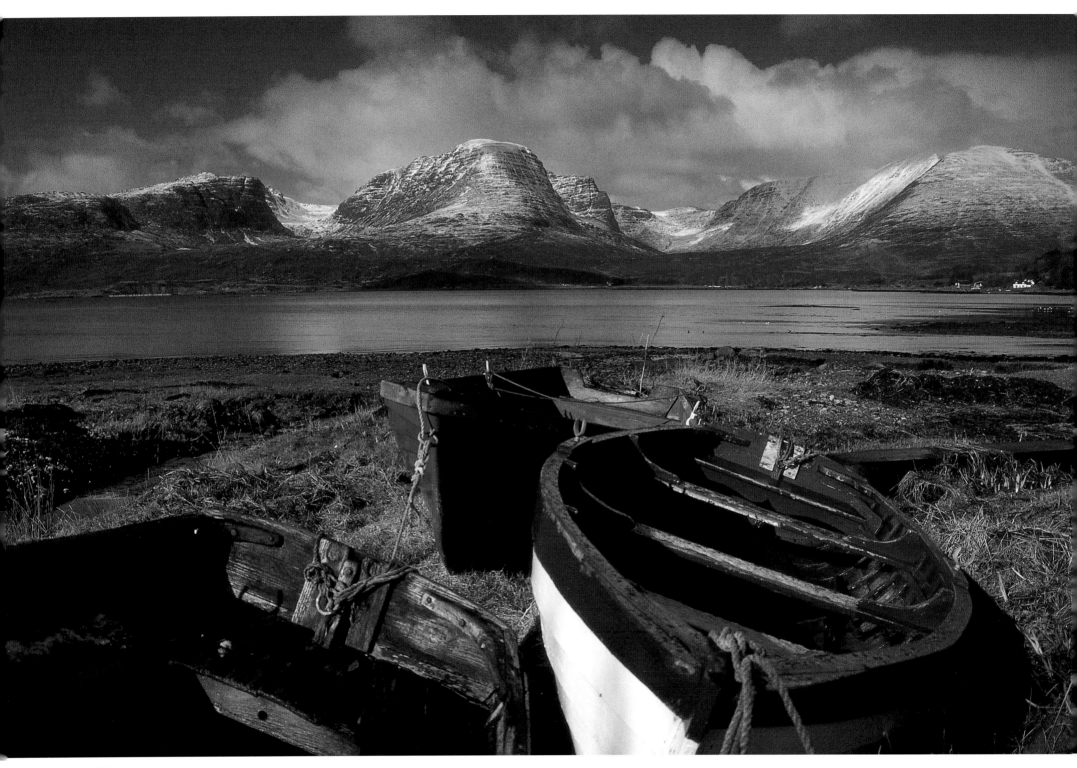

THE APPLECROSS PENINSULA

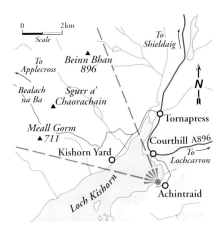

Left
Achintraid shore offers a glorious panorama over Loch Kishorn to the Applecross hills: viewed right to left the three main tops are Meall Gorm, Sgurr a'Chaorachain and Beinn Bhan. The Bealach na Ba road over to Applecross village follows the left-hand corrie.

T he name Applecross evokes all that is special in the landscape and social fabric of the North-West Highlands. The seclusion of the peninsula has ensured a romantic modern appeal yet its inaccessibility has exacted a heavy price in hardship for the local people over the centuries. Until the opening of a reliable coastal access road Applecross was effectively an island community, cut off from the mainland save for the 2,000ft road crossing of the Bealach na Ba and the visits of the Kyle of Lochalsh-to-Stornoway steamer with supplies and mail. The visitor can here discover close-knit coastal townships, sheltered harbours, a thriving pub and campsite, derelict crofts on wild headlands, sandy beaches and even a limestone cave. Applecross remains a sanctuary of peace and solitude.

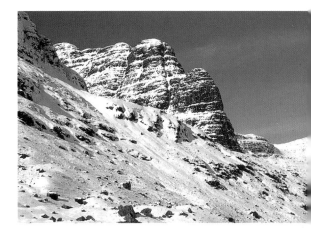

Above
On the lower part of the road from Tornapress over the Bealach na Ba the most striking sight is the 1,000ft vertical buttress of the Cioch Nose. The classic rock climbing route of the district follows the edge of the buttress and was pioneered by Tom Patey and Chris Bonington in 1960. Despite its sensational aspect the route is only Mild Severe in standard and is a popular ascent. A raiment of winter snow shows the geological symmetry of the serried buttresses of the spur, split by horizontal terraces and cleaved by vertical gullies at regular intervals.

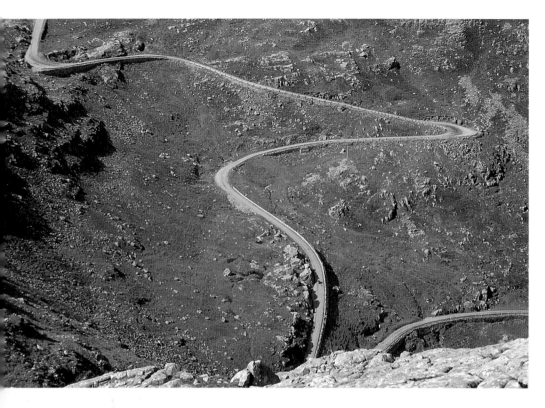

Above left

Looking down on the final hairpins from the summit cliffs of Meall Gorm. After crossing the pass in 1844 Reverend James Begg was profoundly impressed by the scenic ambience, writing, 'the road steals along the impending precipices on the north side of the corry, and as it attains the upper rocky barriers which stretch across the summit of the pass, it winds and twists along their crevices like a corkscrew and is upheld by enormous buttresses and breastworks of stone. The cliffs opposite are fully six or eight hundred feet high, quite perpendicular, yet disposed in great horizontal ledges, like the courses of gigantic masonry, while being formed of bare dark red sand-stone, and almost constantly shrouded in mist and rain, the scene is to many quite appalling.' Such sentiments may well be shared by modern travellers crossing the Bealach on a wild day.

Above right

The summit of the Bealach na Ba is a barren wilderness of sandstone platforms, perched boulders and thick heathery hollows, gently sloping up from south west to north east to provide an open vantage across to the Island of Rassay, and to the mountains of Skye. This evening picture evokes the spaciousness of the scene with a swathe of alto-stratus clouds leading the eye inexorably to the Cuillin and the sunset glow.

Right

The Bealach na Ba (pass of the cattle) was until 1976 the only road link to Applecross. With a summit altitude of 2,053ft this is the second-highest public highway in Britain, and in clear weather the most scenic. This classic summer view from the summit of the pass looks down the Allt a'Chumhaing corrie to Loch Kishorn. Construction of the road commenced on 4 May 1818 with 75 per cent financial support from the Government. However, it was difficult to find a reliable contractor who would complete the job; the first lasted but three months before reportedly going insane! The road was finally completed in September 1822 at a total cost of £4,000 and a labouring pay rate of one shilling per day. Some of the culverts and drystone masonry of the road supports are among the finest examples of their kind, and have required no reinforcement despite the metalling of the road and the increasing volume of motor traffic in the past half century.

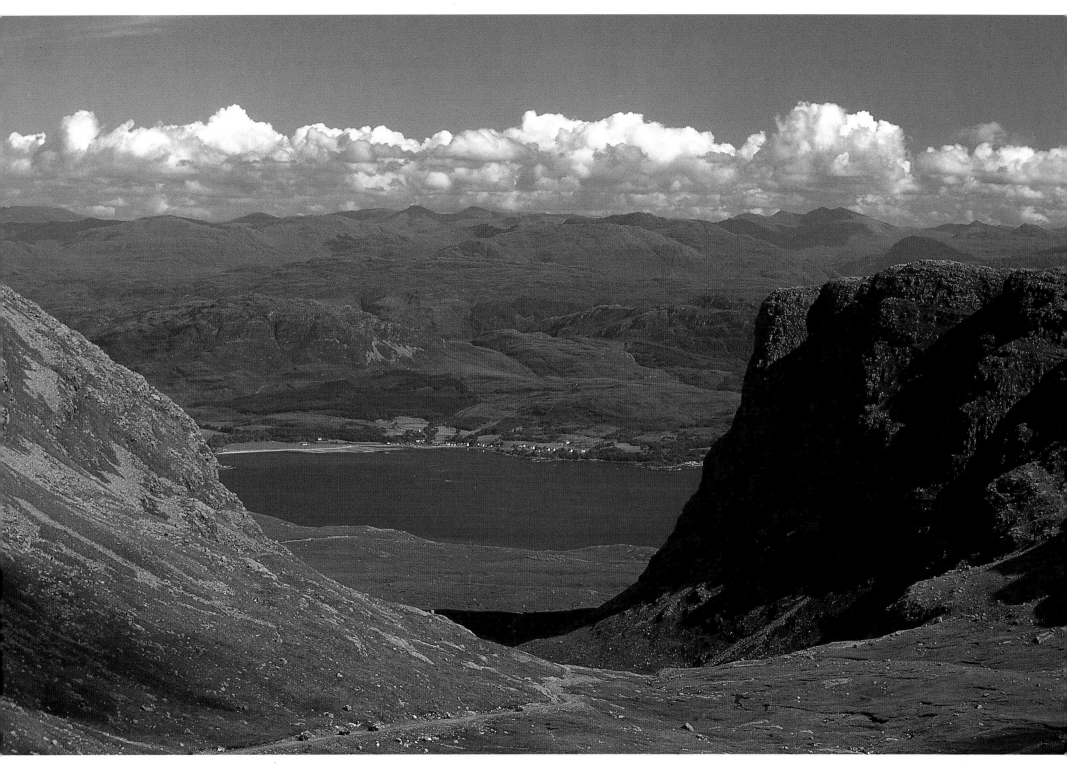

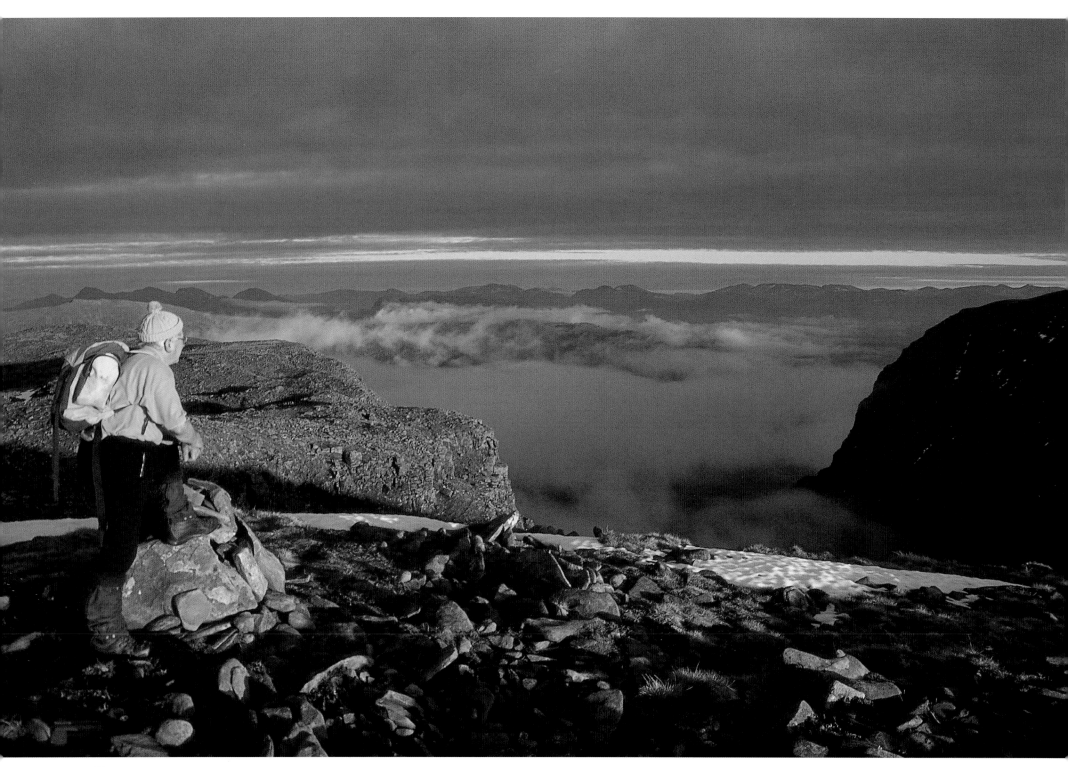

Left

The hills immediately north and south of the Bealach na Ba, Sgurr a'Chaorachain (2,599ft/792m) and Meall Gorm (2,328ft/710m), offer accessible summits to stretch the motorist's legs. Many people walk up the Land Rover track above the pass to the TV relay mast at 2,547ft, a 20-minute stroll. A further 40 minutes of rough tramping south then east along the broad undulating ridge leads to the highest point of Sgurr a'Chaorachain. En route there are exciting views down narrow gully clefts on the south side to the road over 1,000ft below. In this scene Clarrie Pashley surveys the east-ward view from the ridge over the evening mists towards the distant hills of Affric, Cannich and Monar.

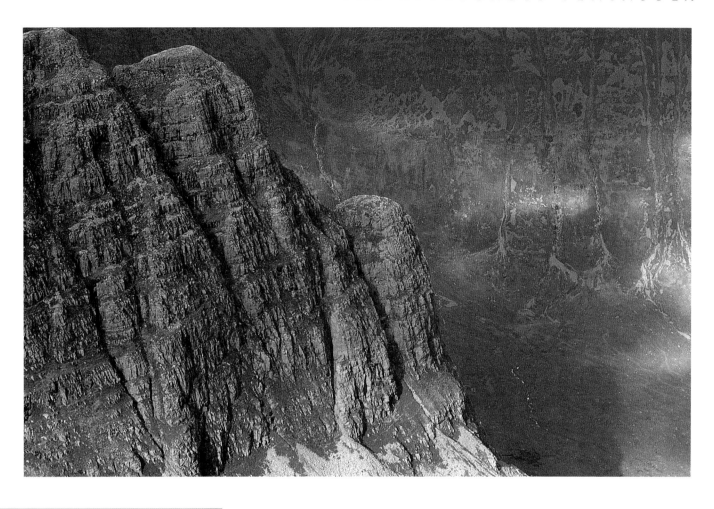

Left

A view of Applecross river, bay and village with the hills of Skye over 12 miles beyond. In AD672 a monastery was founded here by Maelrubha, a Celtic saint, who declared that all land within 6 miles of the site was holy ground, in which any fugitive would be safe from capture. For many centuries the alternative name for Applecross was 'A'Chomraich', meaning 'The Sanctuary'. The name Applecross derives from the Gaelic *Abair Crossain* meaning the mouth of the River Crossan. St Maelrubha lies in the ancient burial ground under a green mound in a grave identified only by two large stones which lie nearby. Applecross is still a sanctuary from the whirlwind pace of modern society, much sought by those who seek an alternative way of life, and much-loved by its close-knit community.

Above

Looking north from the ridge of Sgurr a'Chaorachain one looks down on the mighty buttress of the Cioch Nose which plunges into the empty depths of Coire nan Arr.

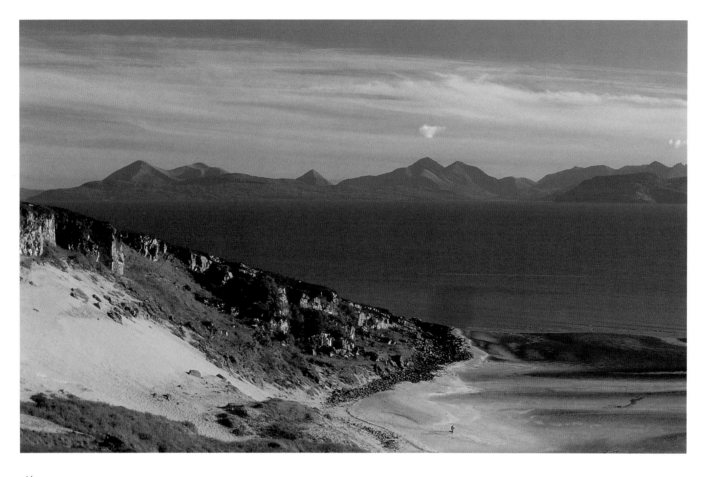

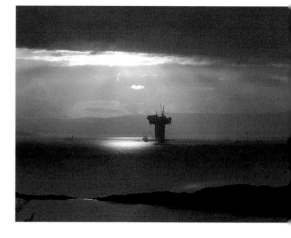

Above

The giant Ninian Central oil-drilling platform was built on Loch Kishorn in the 1970s. On completion the rig was towed round the southern shore of the peninsula and through the Inner Sound to begin its journey to the Ninian field east of Shetland. In this evening shot it is silhouetted against the impassive backcloth of the Island of Raasay. The Kishorn base employed over 4,000 people at the height of construction, and closed in 1986.

Left

Beinn Bhan (2,938ft/896m) is the culminating point of the Applecross massif. On its northern edge massive forces of ancient faulting, cataclysmic landslip and glaciation have created a series of amphitheatres unmatched for stark grandeur. The nested corries are magnificently arrayed across the skyline in the westward view from the A896 between Kishorn and Shieldaig, and dwarf the estate house at Couldoran. The three central corries are the most impressive: (left to right) Coire na Feola (corrie of the flesh), Coire na Poite (corrie of the pot) and Coir'an Fhamhair (the giant's corrie). Beinn Bhan is reserved for the connoisseur of wild places and the determined winter climber.

Above

The first settlement north of Applecross Bay is the coastguard station at Sand which supports submarine testing and training operations out in the Inner Sound. The splendid beach here sports a remarkable dune, over 80ft high, which is regularly replenished by sou'westerly storms. This view looks south over the Sound to the Red Cuillin of Skye.

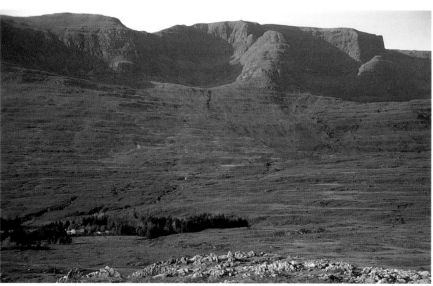

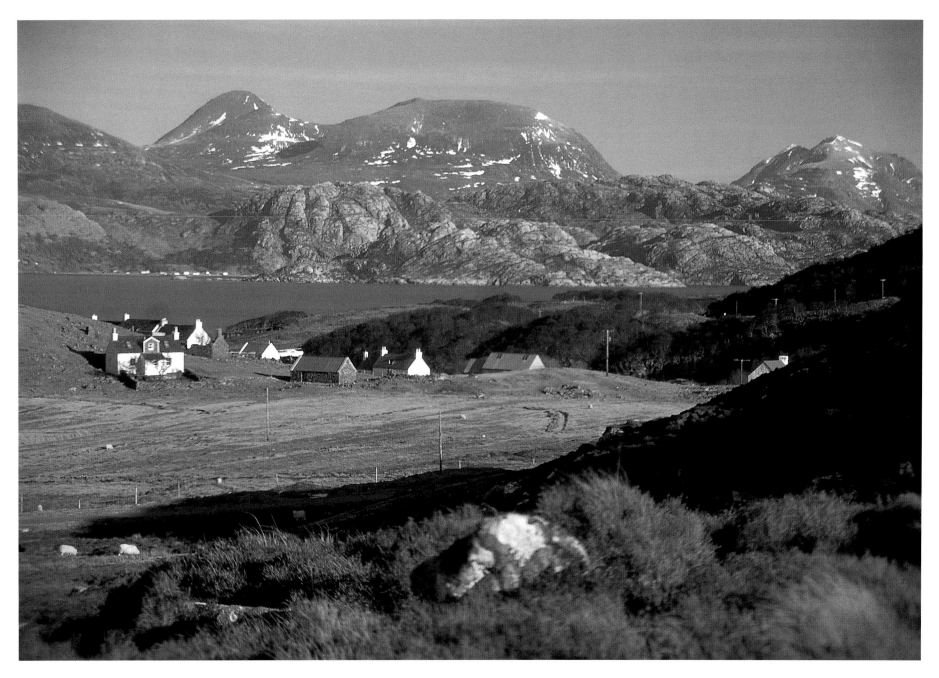

Above

The peninsula's 25-mile coastal road was opened in 1976 and links remote townships which previously could only be accessed on foot or by boat. From Applecross village the road heads along the barren and windswept coastal fringe for over 9 miles, then turns sharply to the south east into Loch Torridon at the peninsula's northern tip. Fearnmore is the first of several settlements which profit from the shelter of the lower loch's bays and inlets, and offers a wonderful panorama of Diabaig and Beinn Alligin across the loch. In this photo Liathach is also seen on the right. From here the road wends a delightful though tortuous route up the loch to Shieldaig, and there are many more exceptional viewpoints en route.

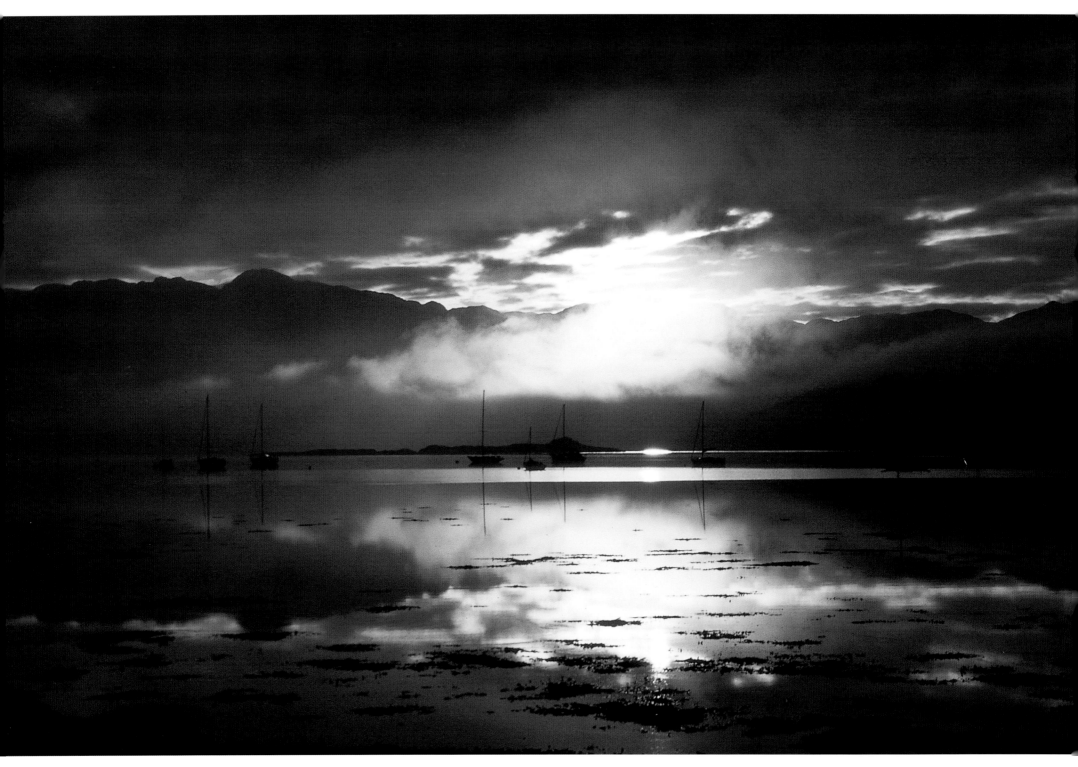

LOCHCARRON'S SEASONS

Left
A golden dawn rising over Attadale viewed from the shorefront of Lochcarron village.

Below
Snowdrops in the graveyard at the old church at Kirkton at the east end of Lochcarron.

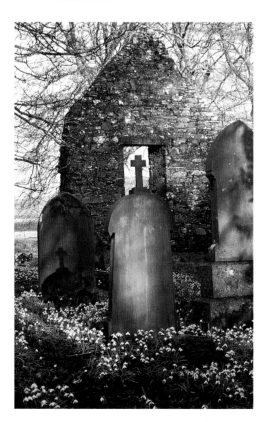

Lochcarron lies in the heart of Wester Ross and is the area's fourth largest settlement after Ullapool, Gairloch and Kyle of Lochalsh. The village grew in the late eighteenth century as the nearby hills and inland glens were cleared of settlement. Though the siting owes more to necessity than choice, its south-east aspect ensures that the inhabitants enjoy every available hour of sunlight, a precious commodity in the dark months of the year. There is no better a base for exploring the district or for making raiding visits over the bridge to Skye. Every part of Wester Ross from Kintail to Ullapool lies comfortably within an hour-and-a-half's drive; and for the hillclimber that includes access to 170 Munros plus countless other summits. However, Lochcarron is more than just a good centre from which to travel. The local district, whilst lacking the spectacular attractions of Torridon or Applecross, has a peaceful beauty that is appreciated the whole year round by those who live and work there.

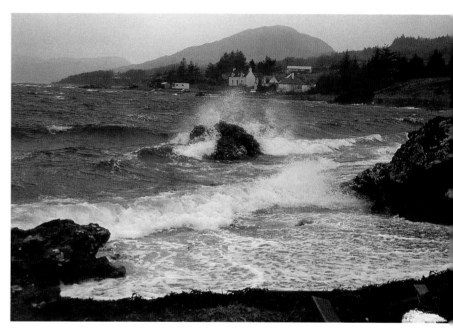

Above
March storms lash the west coast sending wave surges crashing over the shore at Slumbay Island, a craggy knoll of solid rock connected to the mainland by a narrow isthmus. For people born and bred in the area the weather is simply a part of life, to be endured with a wry stoicism.

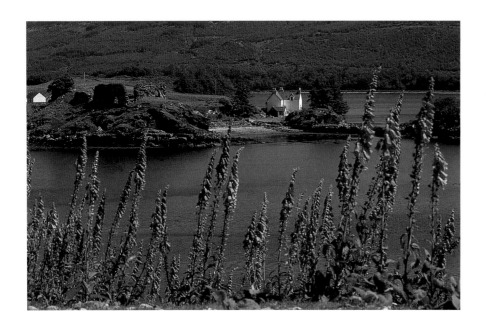

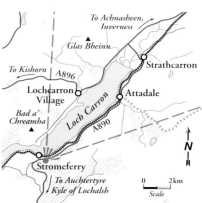

Right

A glorious vista awaits motorists driving north on the A890 as they enter South Strome Forest and breast the rise beyond Stromeferry junction. The whole expanse of Upper Loch Carron is displayed with its shoreline village and backcloth of mountains in a scene that only a wide-angle lens can fully capture. Viewed from here the geomorphic origins of the loch as a fjord become clear, its sides gouged out and overdeepened by the successive ice sheets of the Pleistocene era, then flooded by the sea as the ice melted. At the height of the last Ice Age 20,000 years ago a glacier estimated at 3,000ft in thickness forced its path down the glen. In the present day the middle of the loch reaches a depth of 525ft, yet yachts passing through its mouth at Strome narrows draw only 30ft of water at low tide.

Above

A strong tidal race flows through Strome narrows 3 miles south west from Lochcarron village. Here the upper loch links with the wider firth between Plockton and the Applecross peninsula. The ruins of Strome Castle stand alongside the defunct jetty for the Strome ferry which linked Lochcarron to Lochalsh before the south shore road was built in 1971. On a clear day the outlook to Skye is quite exceptional, and with a foreground fringe of foxgloves the scene possesses a rich beauty in early summer.

Right

Attadale House, owned by the Macpherson family, together with its gardens, woodlands and farm, form a delightful enclave on the south shore of Loch Carron and hosts the local Highland Games in mid-July each year. The gardens are open to the public in summer and are sheltered by giant Wellingtonia trees which are over 120 years in age.

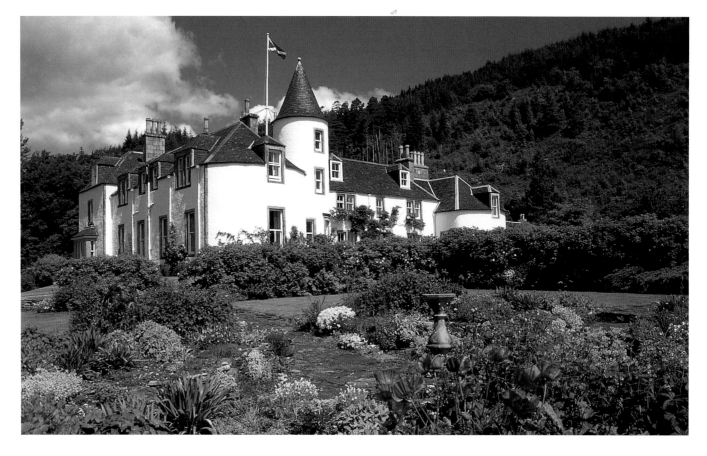

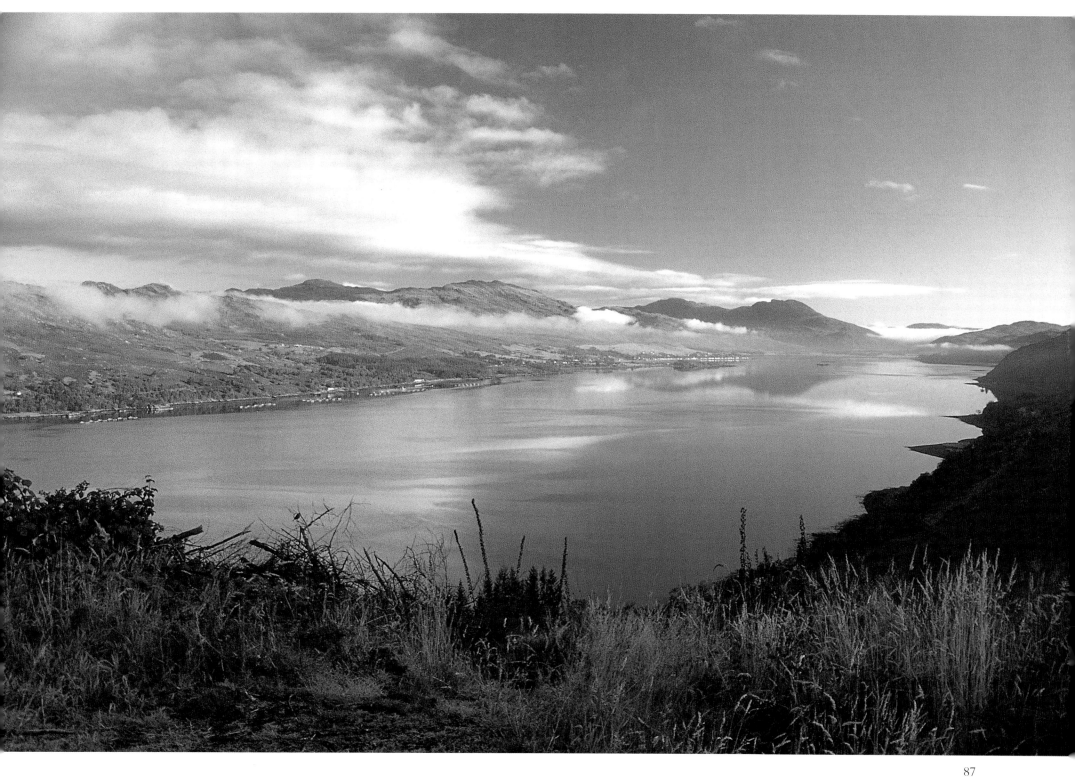

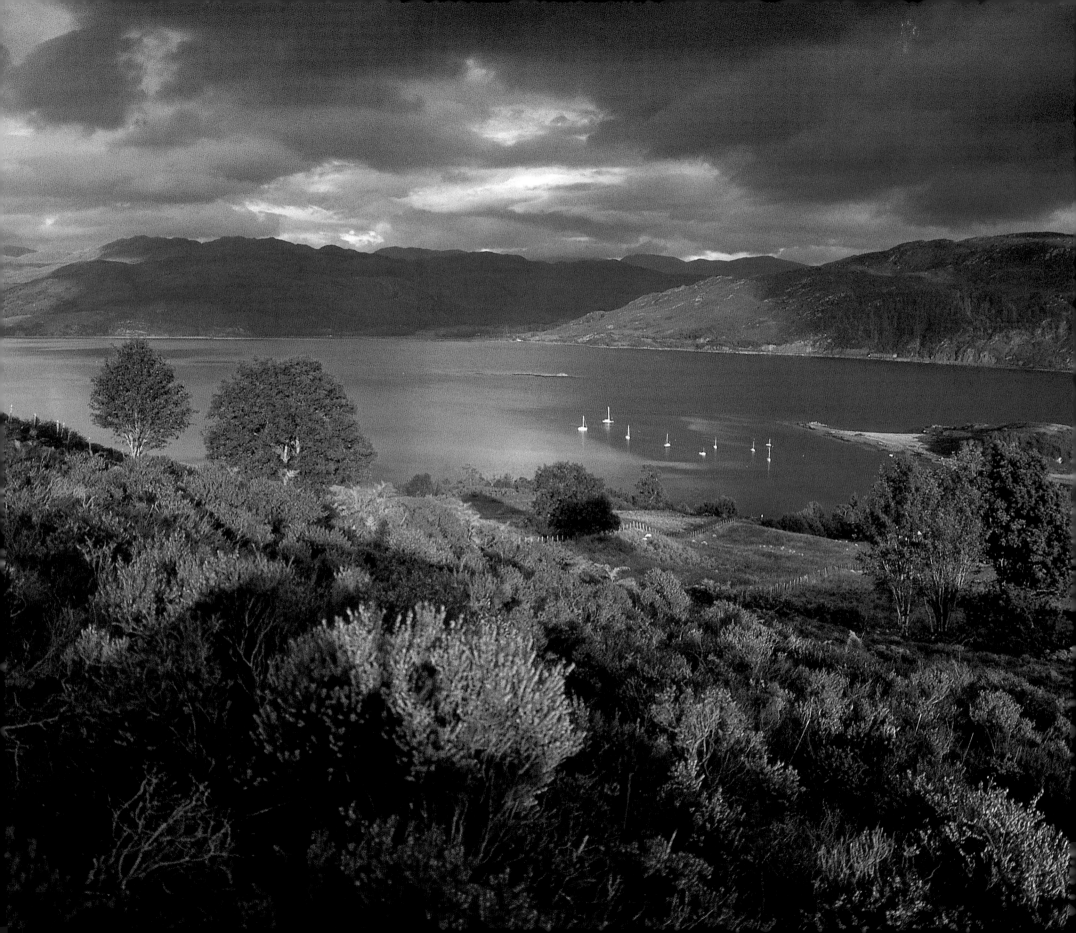

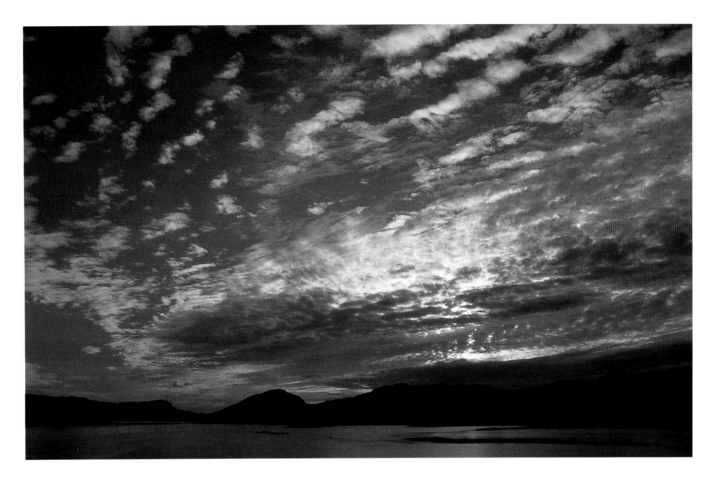

Above

In June the moors come alive with unexpected colour as milkwort, butterwort, tormentil and lousewort come into flower. Most surprising and stately of these blooms are the common spotted and heath spotted orchids, whose white or pale-pink flowered spikes raise their heads above the sedge grasses. These beautiful heath spotted orchids were photographed in Kishorn Glen.

Left

In early September heather on Lochcarron's common grazings makes a colourful foreground for a view over Slumbay harbour and across the loch. The harbour has become increasingly popular as a sure anchorage for private yachts throughout the summer.

Above

Late summer skyscape over Loch Carron.

Left

The village hugs the shoreline for 2¹/₂ miles, thus making a claim to be the longest settlement in Scotland. In this view from the Am Maman viewpoint on the south shore the inbye croft fields are seen running up the hillside in narrow strips. The village became strung out so as to give each home access to the shore for its boat and a croft field behind for cultivation. In 1831 the population reached a peak of 2,136, but the hardship of the potato famines from 1846 to 1850 and the depletion of fish stocks drove many to emigrate or seek work in the cities, and the total declined to 1,390 by 1890.

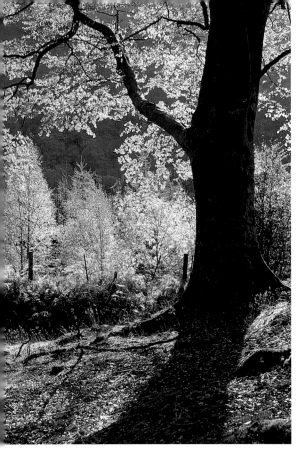

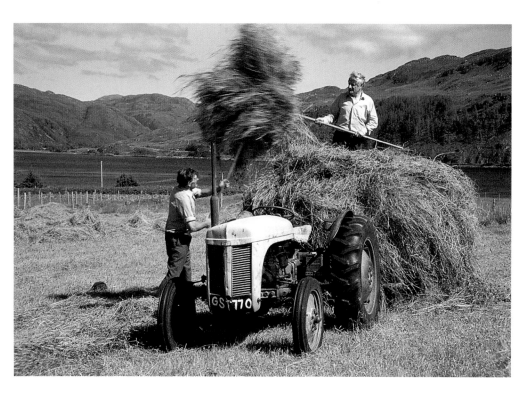

Left
Haymaking in the 1980s on the Slumbay crofts which lie west of Lochcarron. Increasingly the crofters of Wester Ross have found it easier and cheaper to buy in their hay for winter feed from east-coast suppliers. As traditional cropping and harvesting activities have become less common in the area a slow degradation in the quality of enclosed (in-bye) land has occurred.

Above
Early autumn in the woods above Strome by Lochcarron. The silver birch is the most common deciduous tree of the Highlands, clothing the lower slopes and quickly regenerating wherever grazing pressure is slack. Though rarely more than 30ft in height the birch provides the cover and shelter through which larger oaks and pines can grow. Government policy now discriminates in favour of mixed planting schemes, in an attempt to restore native woodland. After the Ice Age an abundant flora and fauna colonised the region, and large tracts were thickly forested. Progressive deforestation, slow acidification of the peat soils, extinction of the wolf and the introduction of large-scale sheep farming led to ecological impoverishment and imbalance. Thankfully more enlightened policies now protect the area's once threatened natural environment.

Right
A peaceful autumn day on the loch shore; the foregound field is cropped short by summer sheep-grazing but increasingly infested by clumps of rushes. Although small-scale crofting remains at the core of the local economy and land use, worsening economic conditions for sheep and cattle rearing have made it difficult to maintain fields and cultivation in the manner of old. Many crofters pursue full-time employment in fish farming or tourism, or else seek the greater rewards of working away in oil-related industries so that their crofting is a spare-time rather than a part-time activity.

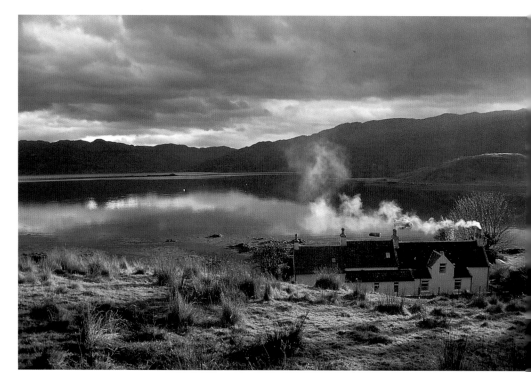

Above
An autumn sycamore leaf in the Allt a'Chuirn gorge above Lochcarron.

Right
Snow rarely reaches down to the coasts of Wester Ross, but for a week or so each year a northerly airflow brings magical winter conditions to the coast of north-west Scotland. The worst blizzard of the 1990s came on Christmas Eve 1995 with a massive snowfall followed by temperatures as low as minus 22 degrees celsius through to New Year's Day. Such icy periods usually come to an abrupt end; when the wind swings back to the south west temperatures can rise by as much as 15 degrees in 24 hours and the snow is soon nothing but a memory.

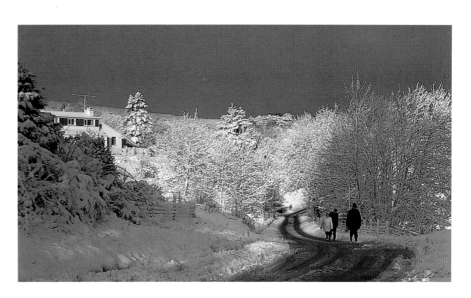

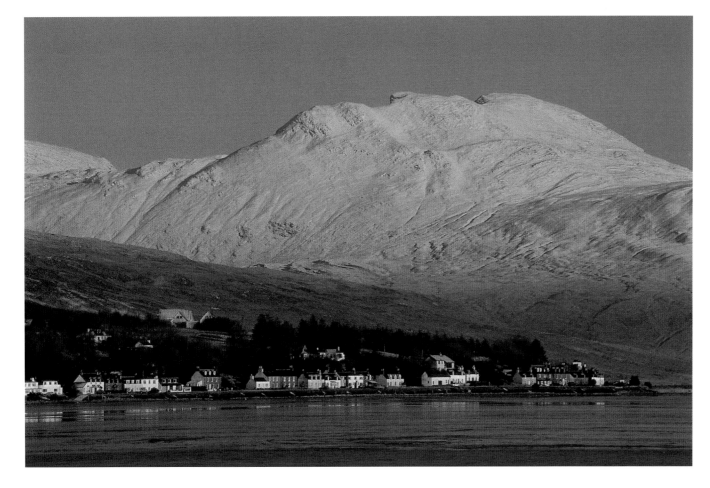

Left
Although not the closest, 2,975ft (907m) Fuar Tholl is the dominant hill overlooking Lochcarron village. Its notched summit profile forms a distinctive skyline to every eastward view in the locality, and the hill is better known to residents as 'Wellington's Nose', the Duke's bridge nose formed by the top of Mainreachan Buttress which drops vertically for over 800ft on the mountain's north side. In many winters the south-west flanks of Fuar Tholl hold snowpatches from mid-December through to early April.

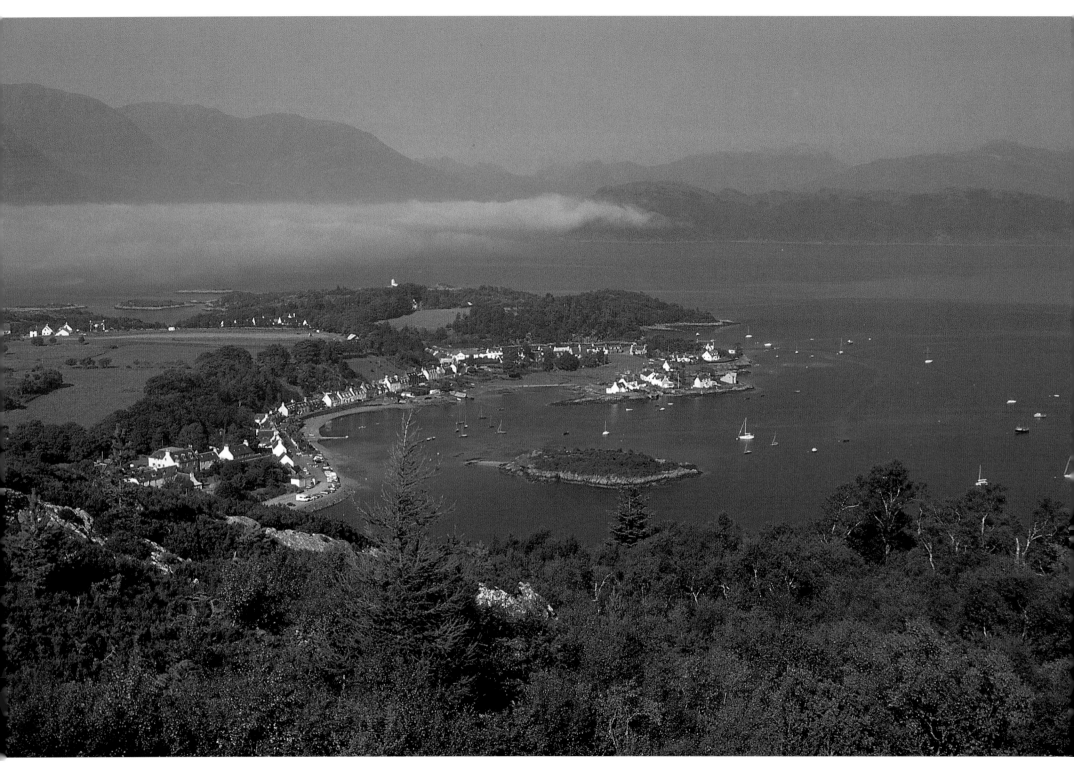

THE ROAD TO THE ISLES

Left

Plockton occupies the finest harbour on lower Loch Carron. Sheltered from the westerly gales and yet close to the open waters of the Inner Sound the bay is a prime anchorage for cruising yachts. The village held its first regatta in 1881 and since 1933 this has become a popular annual event.

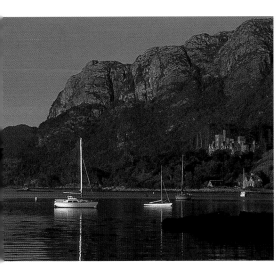

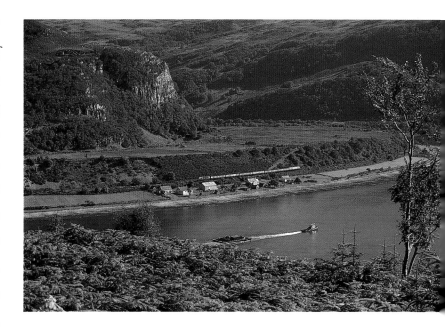

It is by the A87 'Road to the Isles' through Glen Shiel, or the Kyle of Lochalsh railway line, that many people make their first entry to Wester Ross, passing by three of Scotland's finest treasures: the picturesque harbour and village of Plockton, with its wooded hinterland; romantic Eilean Donan Castle, dominating the entrance to Loch Duich; and at the head of Duich the graceful outline of the Five Sisters of Kintail. To quote the words of W.H. Murray, 'in Kintail everything culminates. Nothing lacks. It is the epitome of the West Highland scene'. At Kyle of Lochalsh the Skye bridge is reached, now an immutable part of the landscape and gateway to the great 'winged isle'.

Left

Plockton acquired added distinction in the 1860s when Sir Alexander Matheson ploughed part of his trading fortune into the building of Duncraig Castle on the south-east side of the bay. Extensive plantations were established to merge with the rampant natural birchwood clothing the precipitous slopes of Creag an Duilisg behind. An enclave was created that might stand rank as the most beautiful couple of square miles in Scotland. Not surprisingly Plockton has become a favourite haunt for artists, and with its frontage of palm trees the atmosphere of the village today is far removed from its crofting and fishing origins.

Above

The Kyle of Lochalsh railway brought new prosperity to south-west Ross, even though it has never itself been profitable since its completion in 1897. The lack of freight traffic and competition from an ever-improving road network have long threatened its future. Nevertheless, popular excursions bring thousands of visitors down from Inverness each summer. Beyond Strome narrows the line curves round the raised beach above Portchullin shore and commences its final run through Plockton and Duirinish.

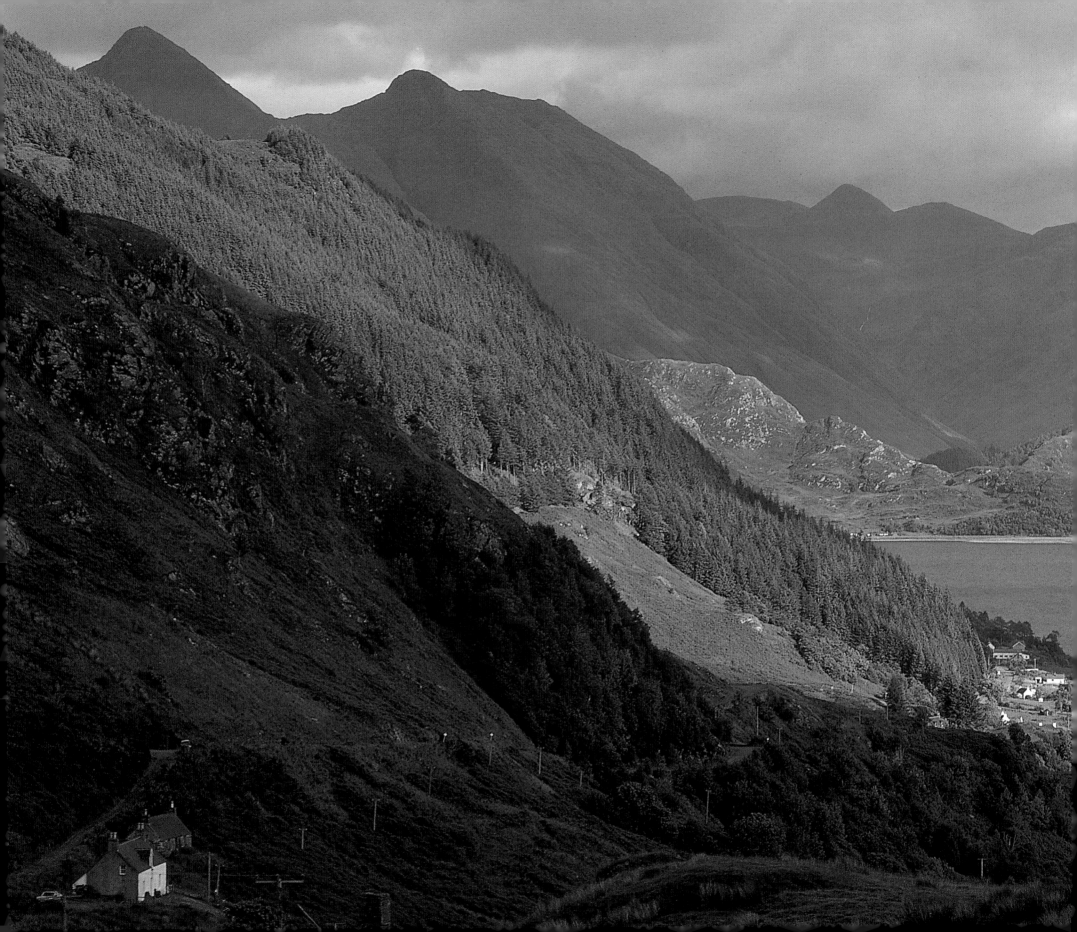

Left

As recently as 1960 the 'Road to the Isles' from Invergarry to Kyle of Lochalsh was a tortuous single-track journey with many detours and a memorable hump-backed climb over Carr Brae above Loch Duich. Ignoring the modern shoreline highway one can still drive to the summit of the old road and enjoy a dramatic view past plunging forested slopes to the head of the loch.

Right

Duirinish township lies 2 miles south west of Plockton on the coast road to Kyle of Lochalsh. Created as a crofting settlement in 1802 its layout is unusual for the West Highlands in that the houses are clustered together on either side of the Duirinish Burn instead of being scattered on their individual landholdings. The original thatched 'black houses' were roofed with corrugated iron around 1900 and more latterly enlarged and slated to make the attractive village of today. Yellow broom and gorse is profuse throughout the Lochalsh peninsula, providing the keynote colour of early summer.

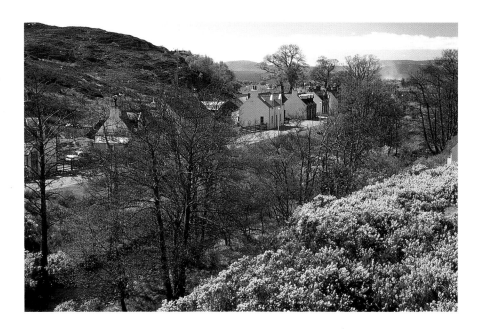

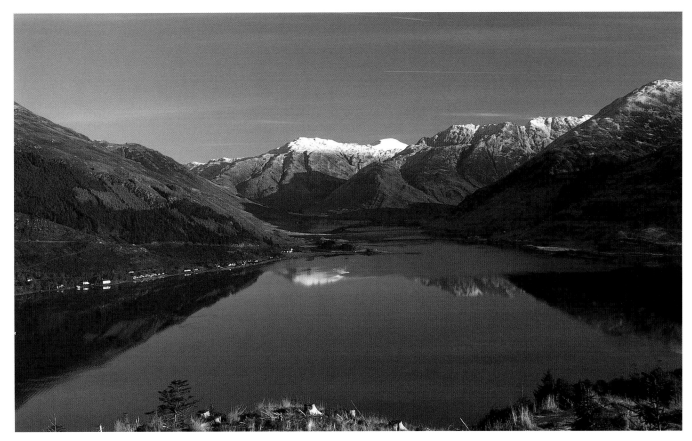

Left

Kintail's name derives from the Gaelic *Ceann da Shaill*, meaning the head of the two seas, the seas being Lochs Duich and Long. From Mam Ratagan on the south side of Loch Duich one sees into the heart of the district, beyond the settlement of Inverinate and the Morvich causeway, and up Strath Croe to the Munro summits of A'Ghlas-bheinn and Beinn Fhada.

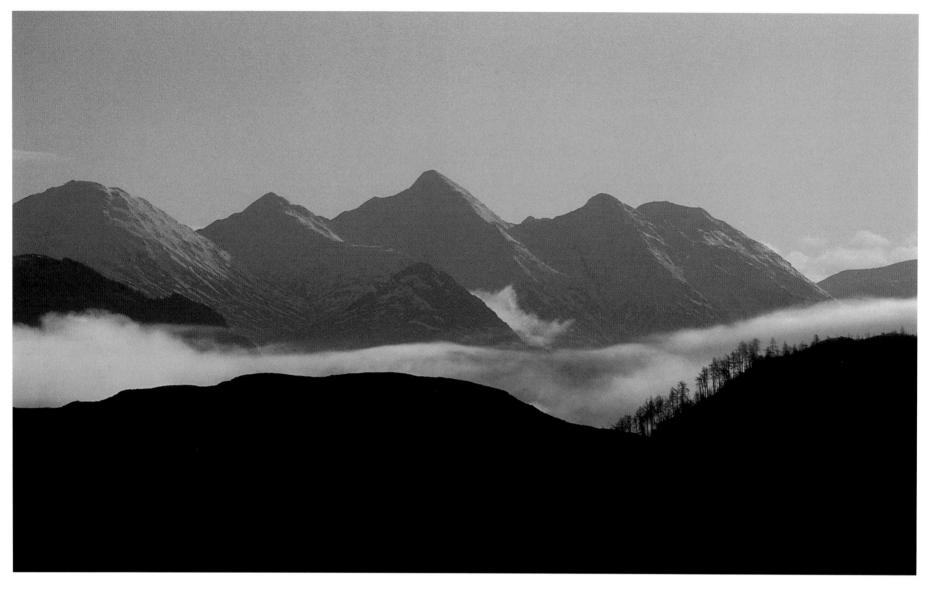

Above

The Five Sisters rise in the virginal splendour of a winter's morn. From left to right the quintet are Sgurr na Moraich, Sgurr nan Saighead, Sgurr Fhuaran, Sgurr na Carnach and Sgurr na Ciste Duibhe. A sixth 'sister', Sgurr nan Spainteach, completes the ridge but is out of sight round the jaws of Glen Shiel. In summer conditions the traverse of the ridge is a strenuous eight–hour undertaking.

Right

The castle of Eilean Donan is named after an Irish monk who settled there in the seventh century. Built in the thirteenth century as the stronghold of the MacKenzie Chiefs of Kintail, and held on their behalf by their men at arms, the MacRaes, the castle was bombarded by Hanoverian warships and destroyed during the 1719 Jacobite uprising. The castle as we see it today was reconstructed according to a plan of the original by John MacRae of Conchra who purchased the island and ruins in 1913. His chief stonemason, Farquhar MacRae, devoted the last 20 years of his life to this remarkable and exorbitantly expensive project. The indulgence was not wasted. Several million people have visited the castle since it was opened to the public in 1955, and whether seen in daylight against a backdrop of the Cuillin Hills or in illuminated splendour at dusk Eilean Donan is one of the great Highland landmarks.

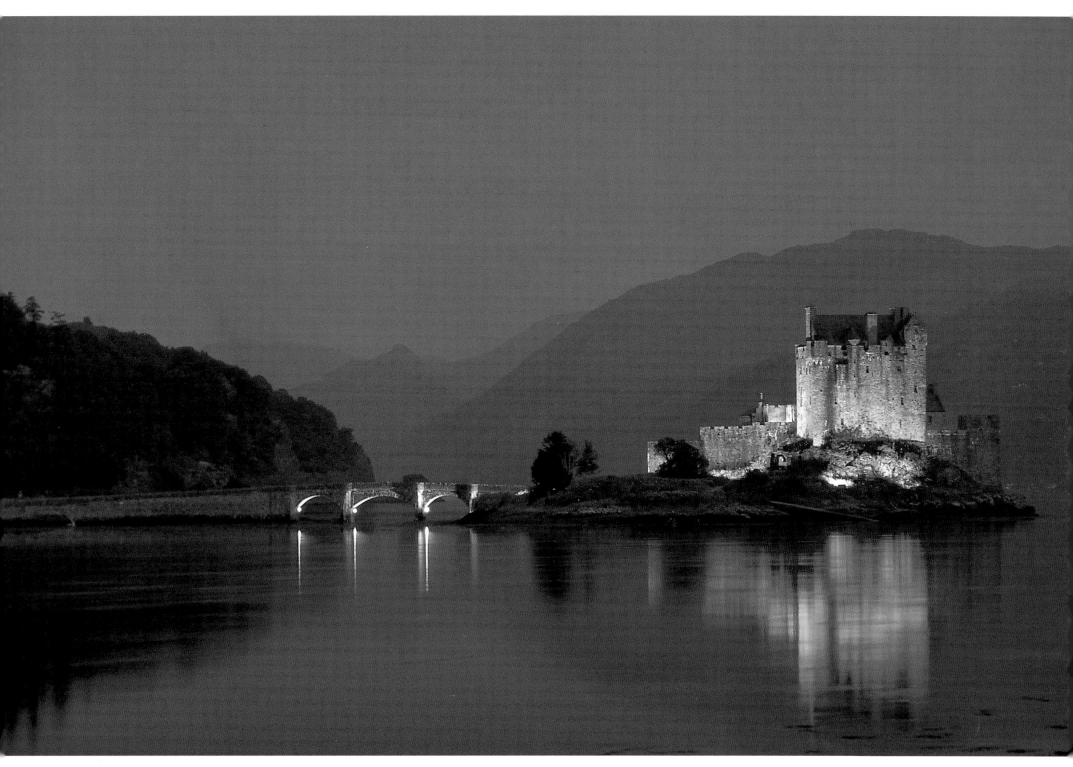

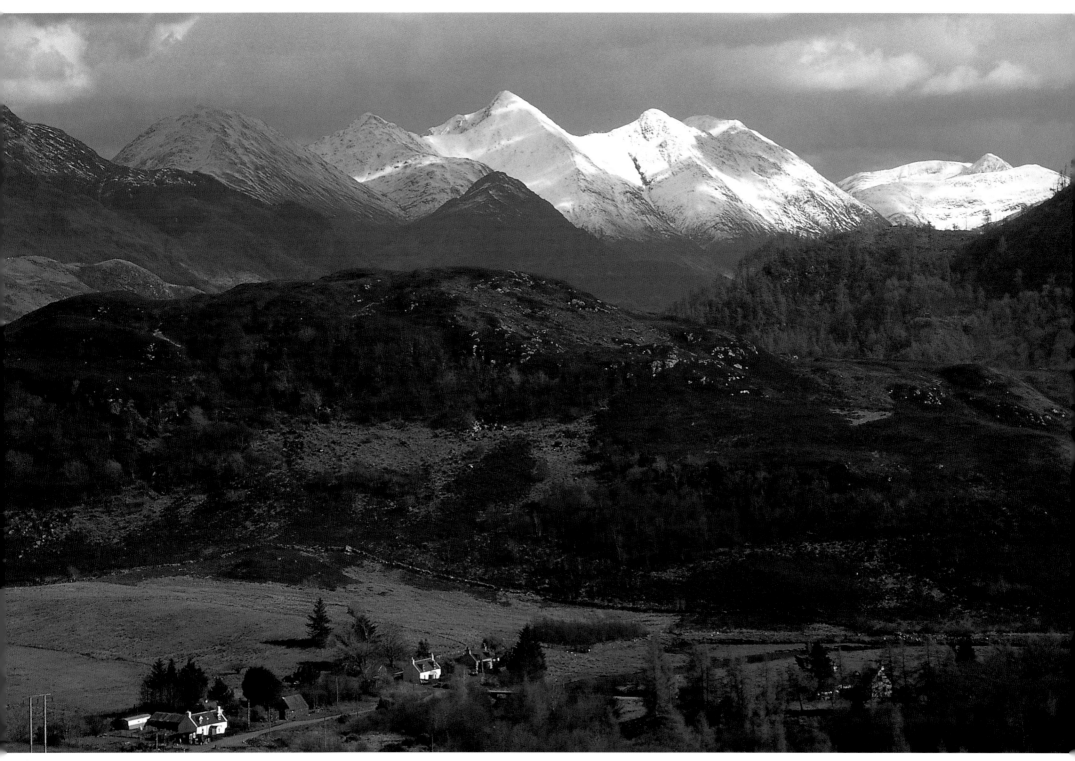

Left

The road to 'The North' begins its journey at Auchtertyre, climbing almost 500ft to a magnificent vantage point for the Five Sisters of Kintail. Though nearly 10 miles distant the Sisters fill the horizon, rising above the hamlet of Nostie and the intervening ridges around Loch Duich.

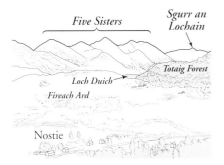

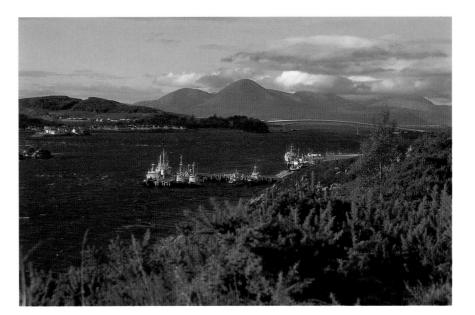

Below

The Skye bridge was opened in October 1995 amid political controversy and vigorous protest against the level of tolls, ending an islandic isolation which had endured since the retreat of the Ice Age glaciers. The bridge is vital to carry modern volumes of traffic and provides a base for Skye's future prosperity; over 3,000 vehicles a day cross over in summer. By contrast in 1917 just 600 passengers and 40 vehicles were conveyed on the row-boat ferry between Kyle and Kyleakin in the whole year! Those romantics who mourn the passing of the ferry can still make the crossing by boat 6 miles south at Kylerhea.

Above right

The Highland Rail Company saw Kyle of Lochalsh as an ideal railhead to compete for trade with the West Highland terminus at Mallaig 20 miles to the south. The coming of the railroad in 1897 transformed a hamlet of just two crofts and an inn to a thriving port with a population of nearly 1,000. The ferry links to Portree and the Outer Isles have long since disappeared, and the Kyleakin ferry runs no more, but Kyle retains an important naval base for the British Underwater Testing and Evaluation Centre supporting submarine trials and tests in the Inner Sound. The narrows of Kyle Acin were named in honour of the Viking King Hakon who anchored here in 1263 en route to defeat at the Battle of Largs. The sound is notorious for its strong tidal race, yet ferry boats plied the passage to the village of Kyleakin for over a century.

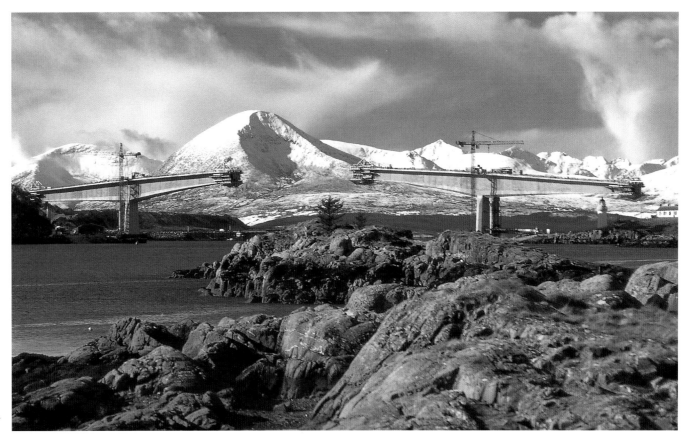

99

THE ISLE OF SKYE: INTRODUCTION

The landscape of Skye is a paradoxical mixture of the dull and the dramatic. The wonders of the island offer no easy access to the casual visitor: the majestic Cuillin range, the centrepiece, is shrouded in mist for half the year. It is hardly surprising that the most popular conjecture upon the island's name is the Norse *sky*, a cloud, and *ey*, an island, now popularised in the Gaelic *Eilean a'Cheo*, the Misty Isle. Denied a mountain focus the eye may scan the interior of the island for stimulation, but in vain, for the peat moors and forest plantations provide an uninspiring view. Unfortunately, the main trunk roads are largely routed across and round this central area so that the car-bound visitor gets a less than flattering impression.

So where is the magic, life and excitement of the island? Much of the answer lies in the coastline and the peninsulas which make up the bulk of Skye's 7,000sq mile area. Skye is thought by some to mean the winged island, the name deriving from the Gaelic for wing, *sgiath*. This is entirely plausible when a map of the island is laid out. From Sleat in the south, through Strathaird, Minginish, Duirinish, Waternish and finally to Trotternish in the

north, Skye is a series of bold promontories, so deeply indented by sea lochs that no point on the island is more than 5 miles (8km) from the sea. The peninsulas possess contrasting characteristics of landforms and settlement, whilst their rugged coastlines increase in scale to the magnificent cliffed headlands of Duirinish and Trotternish. It is also on the peninsulas that much of Skye's traditional settlement and crofting agriculture is found. With over 370 miles of coastline 'the winged isle' has potential for a lifetime of intimate exploration.

Geologically, Skye is not part of the Caledonian mountain mass which forms much of the Highlands. Some 50 million years ago Skye was a seething cauldron of molten magma, repeatedly spilling out in massive lava flows. Earlier rocks were fused by the heat or else overwhelmed by these outpourings. Ice Age glaciations have left the most impressive volcanic landscape in the British Isles, but one must scratch the surface to see it.

The historic association is inseparable from Skye's geography. This is an island where tourists admire the imposing edifices of Armadale and Dunvegan Castles yet simultaneously recoil in pity at the heartbreak of the many thousands who were forced to emigrate in the

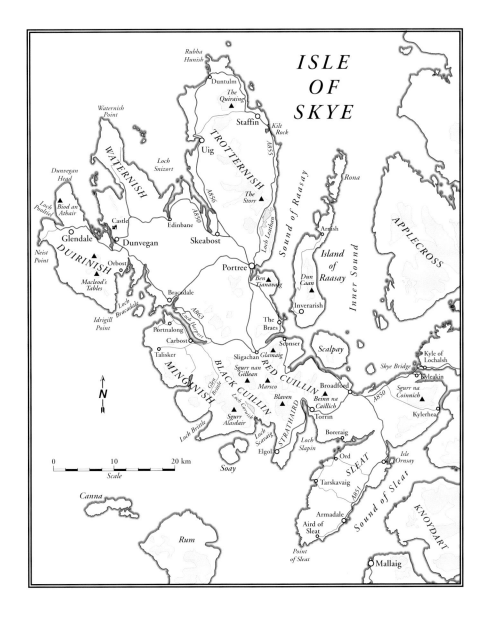

And when the clouds break then Britain's finest mountain chain reveals its glory. The Cuillin are the background to the desolate view of moor or abandoned settlement, ever-present and, in the words of the Gaelic poet Sorley MacLean, ever-watchful, 'rising on the other side of sorrow' beyond all the sins and wrongs which have been enacted on the island in its turbulent history. The composition of utter bleakness against this saw-toothed gullied mountain range is Skye's hallmark of beauty, the unbowed and untamed sprawl of raw Nature. Here you can sense the unforgiving power and scale of the planet, here you can revel in the vast expanse of the ocean to the west, here you can truly know the worth of home and warmth.

These qualities of Skye only emerge with the expenditure of time and energy, the time to watch and patiently wait for the changes of weather and the energy to explore the furthest tips of its many wings. For all those who are repelled by climate or initial impression there are many who properly explore the island and decide that they never want to live anywhere else.

nineteenth century. A deeper emotional entanglement in Skye's history, in particular that of the Clearances, leaves a yearning sadness, for no amount of hand-wringing or moralising can cure past sufferings. Every view of the place is tinted by that reflection.

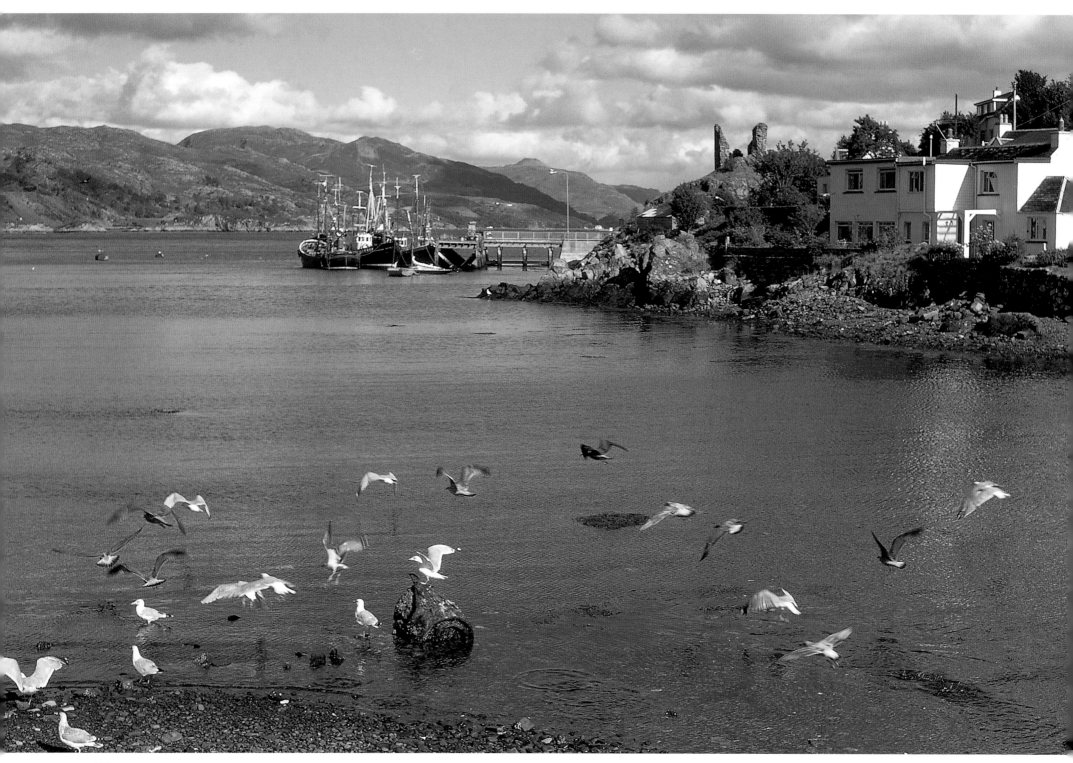

SKYE'S SECRET GARDENS

The scenery of Skye is not all bold gestures and sweeping vistas. The Sleat peninsula and Island of Raasay possess delicate charms which well repay their exploration. Having crossed the Skye bridge or disembarked from the Mallaig ferry at Armadale many visitors make a headlong dash for Sligachan, Portree and the north of the island without more than a passing glance toward Sleat or Raasay. Sleat is deservedly known as 'the garden of Skye' and the 14-mile stretch of Raasay is a fascinating mix of woodland, settlement and wilderness. Their acquaintance is perhaps best delayed until Skye's greater attractions have been seen or conquered, and one is ready to appreciate more intimate landscapes.

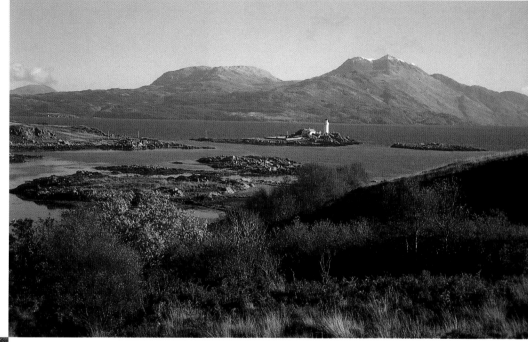

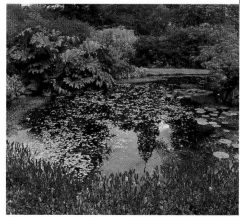

Left
Though now bypassed by the Skye Bridge, Kyleakin village is worth visiting to see the ruins of Caisteal Maol, built in the thirteenth century, reputedly by the daughter of a Viking king in order to exact tolls on shipping using the strait. A range of hills rises behind Kyleakin to a height of 2,424ft (739m) at Sgurr na Coinnich, and to their south the Sleat peninsula begins.

Left
Armadale Castle (built around 1820) was once the seat of the MacDonald clan but now lies in a ruinous condition. However, its woodlands and ornamental gardens have been preserved and provide Sleat's greatest tourist attraction, with hundreds of species of exotic shrubs and trees, showing what can be achieved in the more fertile parts of the island.

Above
Isle Ornsay typifies the gentler pleasures of Sleat. The island protects an excellent anchorage, much favoured by recreational sailors, and the wooded shore harbours an inn and hamlet of pretty houses. Beyond the island's lighthouse and across the Sound of Sleat on the mainland stands the trident-topped summit of Beinn Sgritheall.

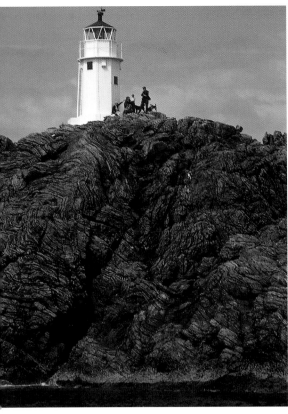

Far left

Skye's southern tip, the Point of Sleat; the lighthouse sits on a crag of gnarled Lewisian gneiss and can be reached by a walk of little over an hour from the roadend at Aird.

Left

Yellow primrose are profuse in every dell and woodland glade of Raasay and Skye. Flowering in April they signal the arrival of spring and delight the wandering eye.

Right

The settlements on the west coast of Sleat are linked by a sinuous loop road which weaves through an intricate series of dales wooded with native oak and birch trees. Tarskavaig is the largest township, occupying an enviable position on the open ground above the sandy bay of the same name, with a tremendous panorama of Blaven and the Cuillin behind.

Right

Aird of Sleat lies 3 miles beyond Armadale and is the most southerly community of the peninsula, looking out over the Sound of Sleat to the hills of Knoydart and Loch Nevis.

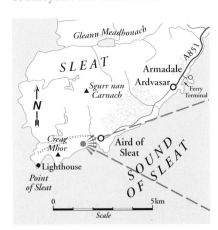

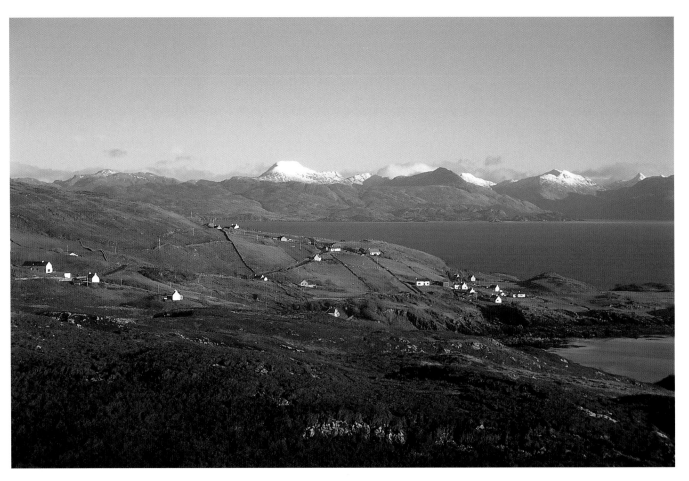

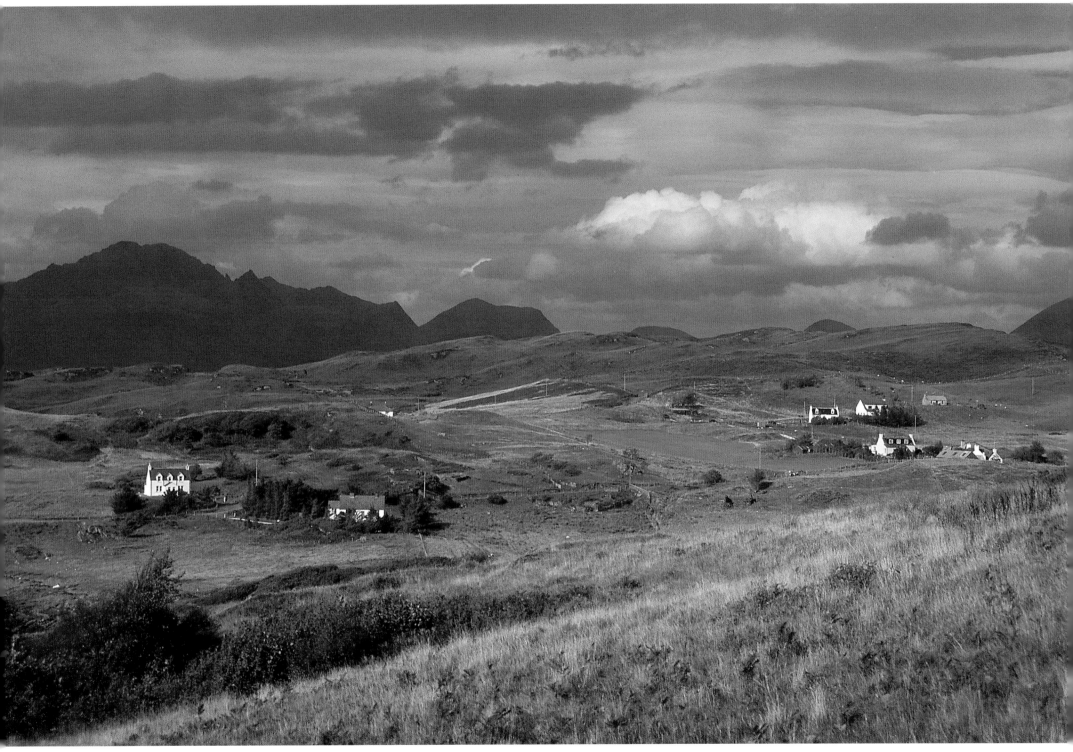

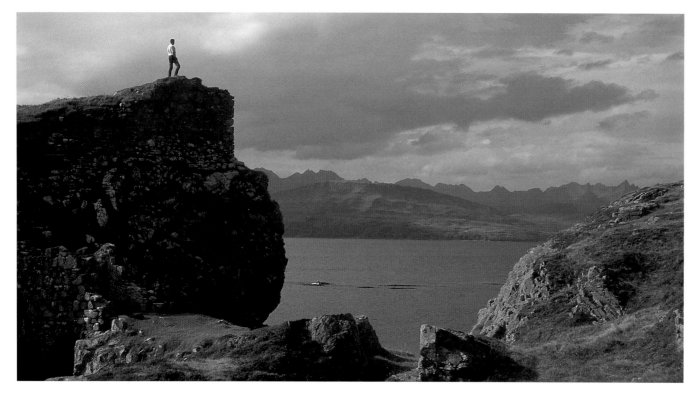

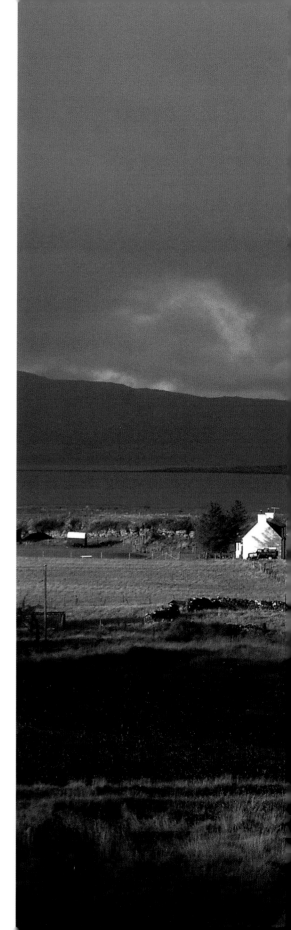

Above

Just north of Tarskavaig on the north side of Ob Gauscavaig (the east bay) stands a prominent obelisk of rock upon which lie the remains of Dunscaith Castle, which legend suggests was a stronghold long before the twelfth century. Having been a MacDonald fortress the castle was vacated early in the seventeenth century, and were it not for the survival of the arched entrance bridge modern visitors would have difficulty in identifying it from a distance.

Left

An otter enjoys a meal of freshly caught crab by the shore. Sightings of otters are always possible around Skye's coast given sufficient time and patience. After a disturbing decline in numbers, legal protection since 1981 and a local sanctuary at Broadford have ensured that the otter population on Skye has remained stable between 300 and 350. Road traffic now poses their greatest danger. Forest Enterprise runs a viewing hide at Kylerhea.

Right

The coastline from Kyleakin to Broadford is a series of low-relief beaches and headlands which offer views across the Inner Sound to the islands of Pabay, Longay, Scalpay and finally the long spine of Raasay, which is easily identified by the chiselled summit of Dun Caan. The ferry crossing to Raasay departs from Sconser, 15 miles along the road to Portree.

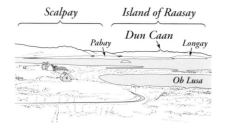

106

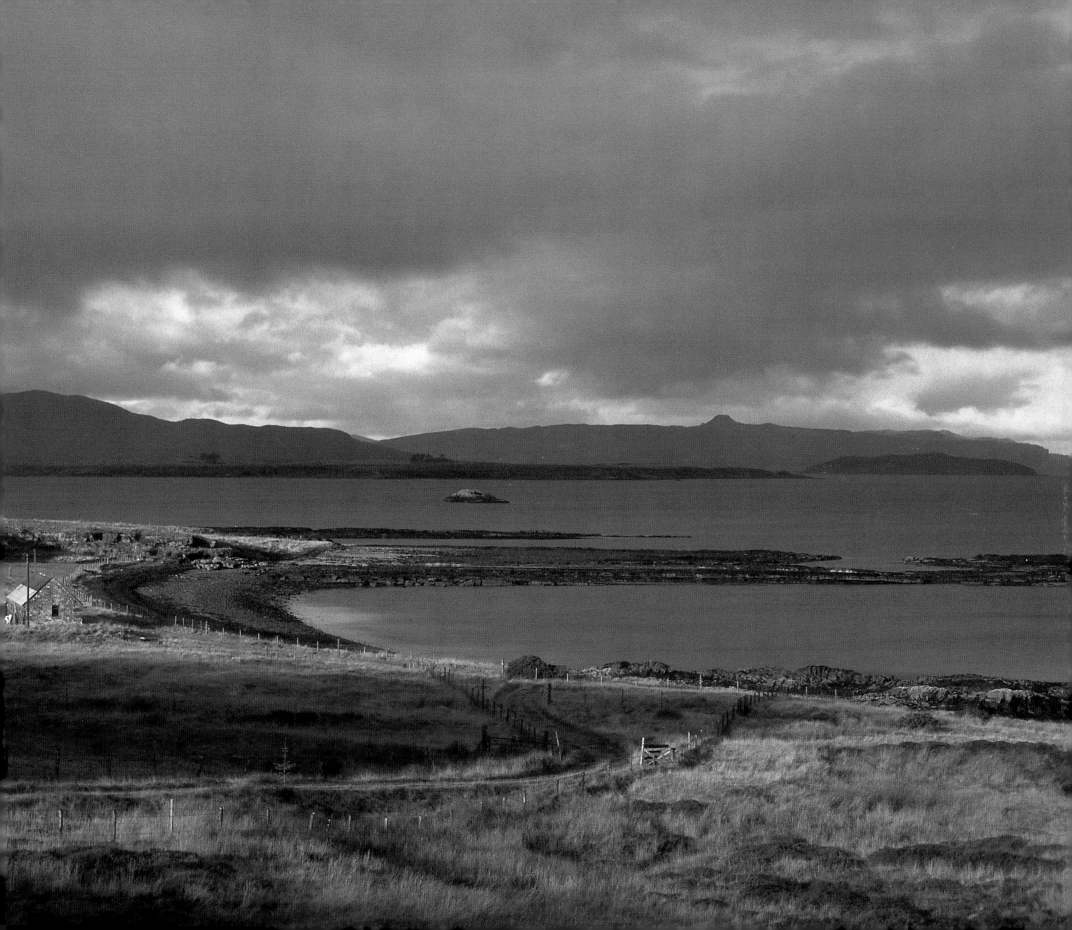

Below

Dun Caan is often mistaken for an extinct volcanic plug, but in fact is merely the eroded remnant of a lava flow. Raasay's highest point at 1,455ft (443m) altitude, Dun Caan can be climbed on a good path in little over an hour from the Inverarish to Arnish road. Positioned centrally between the Cuillin and the mainland peaks of Applecross and Torridon, the table-top summit offers a wide-ranging panorama.

Right

Raasay possesses a rugged northern arm of Lewisian rock stretching the island's total length. A tortuous road from Inverarish reaches its terminus on this peninsula at the crofting settlement of Arnish. The final 3,000yd of the road was built single-handedly by the late Calum MacLeod over a period of ten years. Twisting round bare rock knolls and across deep peat groughs Calum's Road is a remarkable testimony to the product of determined labour, and a roadside cairn commemorates his achievement.

Above

Raasay, *Eilean Ratharsair* or roe-isle, is an island of contrasts. Just north of Inverarish lies Raasay House, the laird's house built in the 1740s by the MacLeods, and considerably aggrandised in Victorian times. However, Raasay has also known great hardships. After the 1745 rebellion Government troops razed nearly every house in reprisal for the Chief's support of the Jacobites; in the nineteenth century over 120 families were forced to emigrate by a new laird who introduced sheep farming. The house is currently tenanted by Raasay Outdoor Centre.

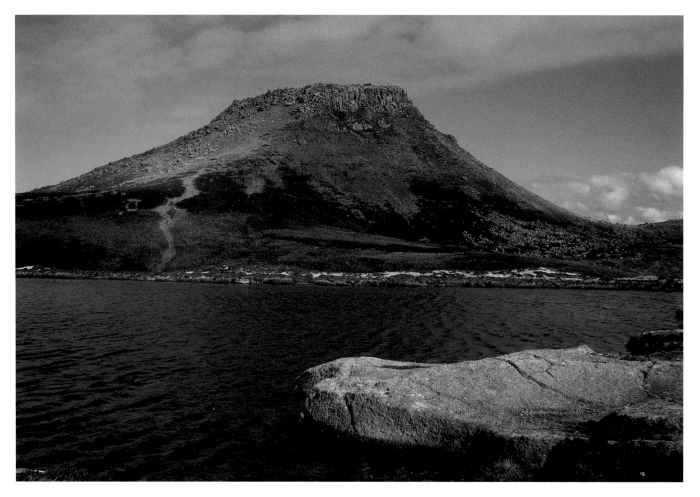

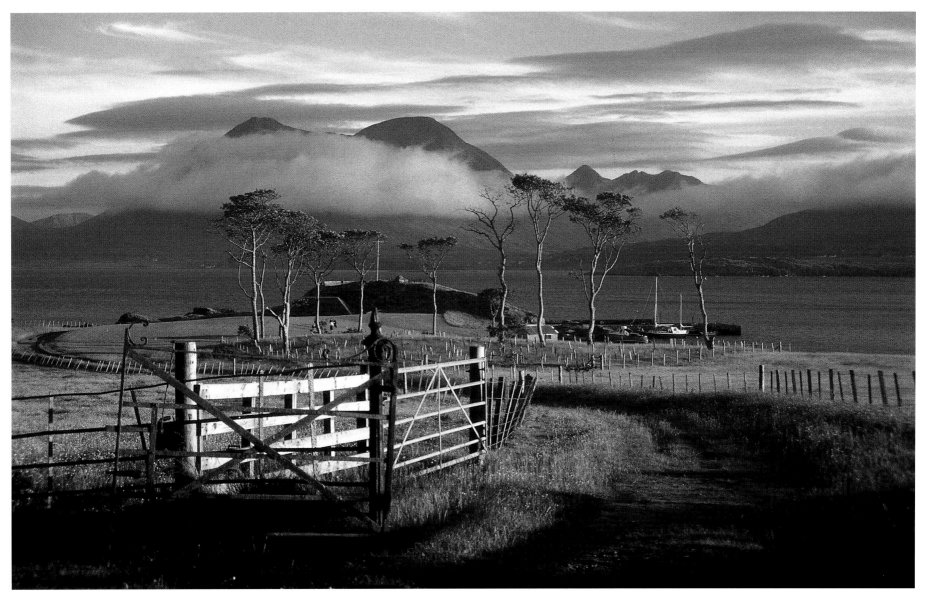

Above
'We saw before us a beautiful bay, well defended, with a rocky coast; a good gentleman's house, a fine verdure about it, a considerable number of trees, and beyond it hills and mountains in gradation of wildness.'

James Boswell's initial impression of Raasay on his visit with Johnson in 1773 is confirmed in the summer evening view from Raasay House across to the Cuillin Hills.

Right
The main village of Raasay, Inverarish, is unusual for the Hebrides in being laid out in terraced rows. These were built to house workers at nearby iron mines which were worked intensively for a few years before and during the First World War, when German prisoners were used as extra labour.

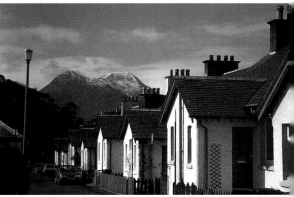

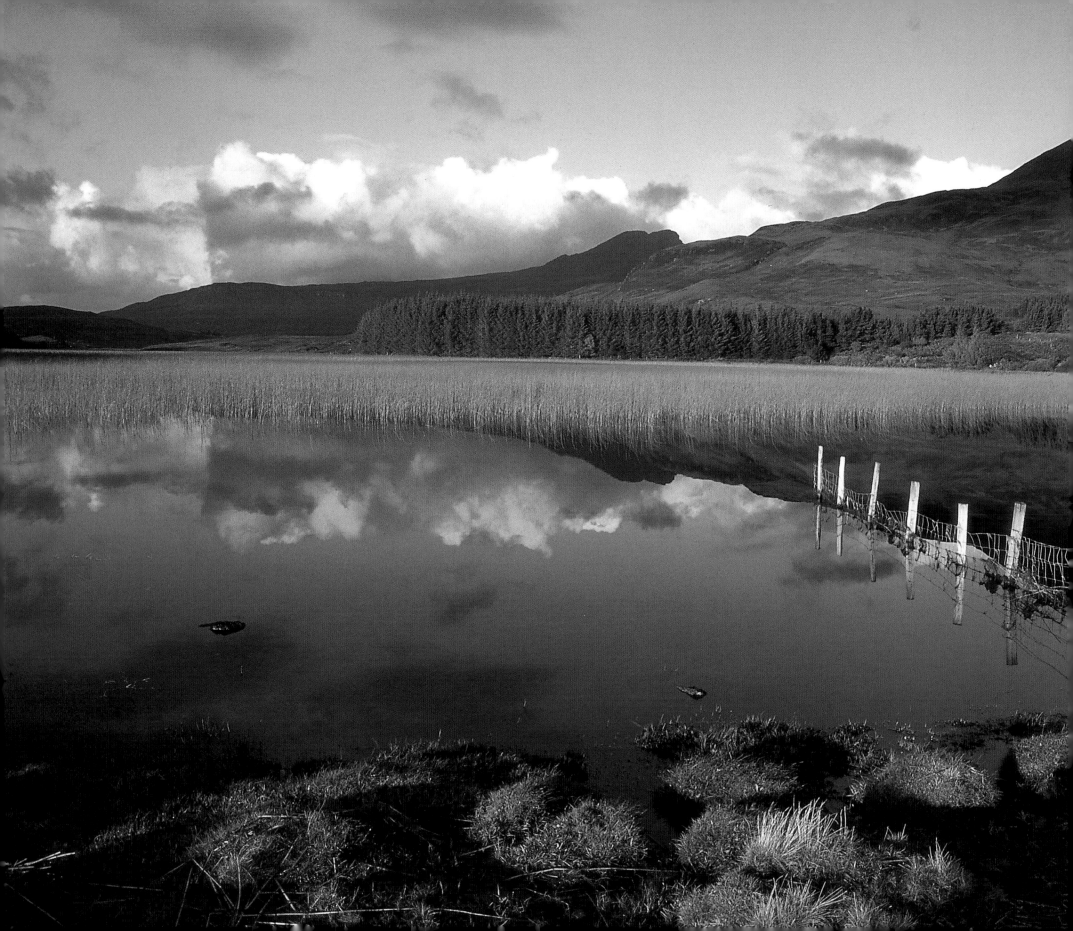

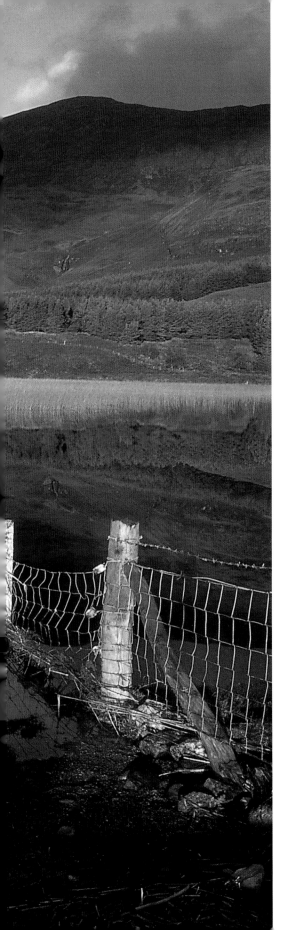

RED HILLS – BLACK HILLS

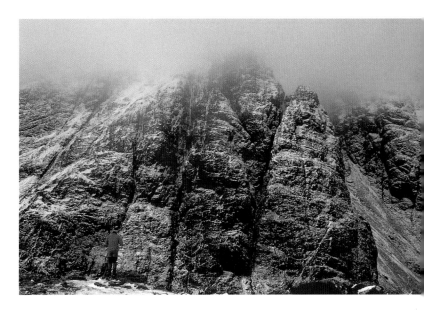

T he B8083 road from Broadford to Elgol passes through some of the most varied scenery on Skye, from the rounded granite domes of the Red Cuillin, the limestone and marble shelves of Strath Suardal and Torrin and the compelling serrated crest of Blaven and Clach Glas, to finish on sandstone crags at the tip of the Strathaird headland. As a final reward the grassy braes of Elgol offer perhaps the finest of all panoramas of the Cuillin range across Loch Scavaig. And from here it is possible to penetrate further into Skye's mountains, either by boat trip or by a wonderful coastal hike via Camasunary. These scenes provided some of Sir Walter Scott's inspiration for his romantic poem 'The Lord of the Isles', which did much to establish Skye on the Victorian tourist trail.

Above
Deep gullies split the East Face of Blaven. Each has been formed by dyke intrusions of fine-grained lava through joints in the gabbro which have crumbled and been eroded into deep clefts through successive glaciations. This is terrain to entice the exploratory climber.

Left
Loch Cill Chriosd, the loch of Christ's church, lies just south of the ruined church and graveyard of the MacKinnon family in Strath Suardal. Though shallow and clogged with reeds the loch is a wintering ground for swans, and offers a beautiful prospect south west to Blaven.

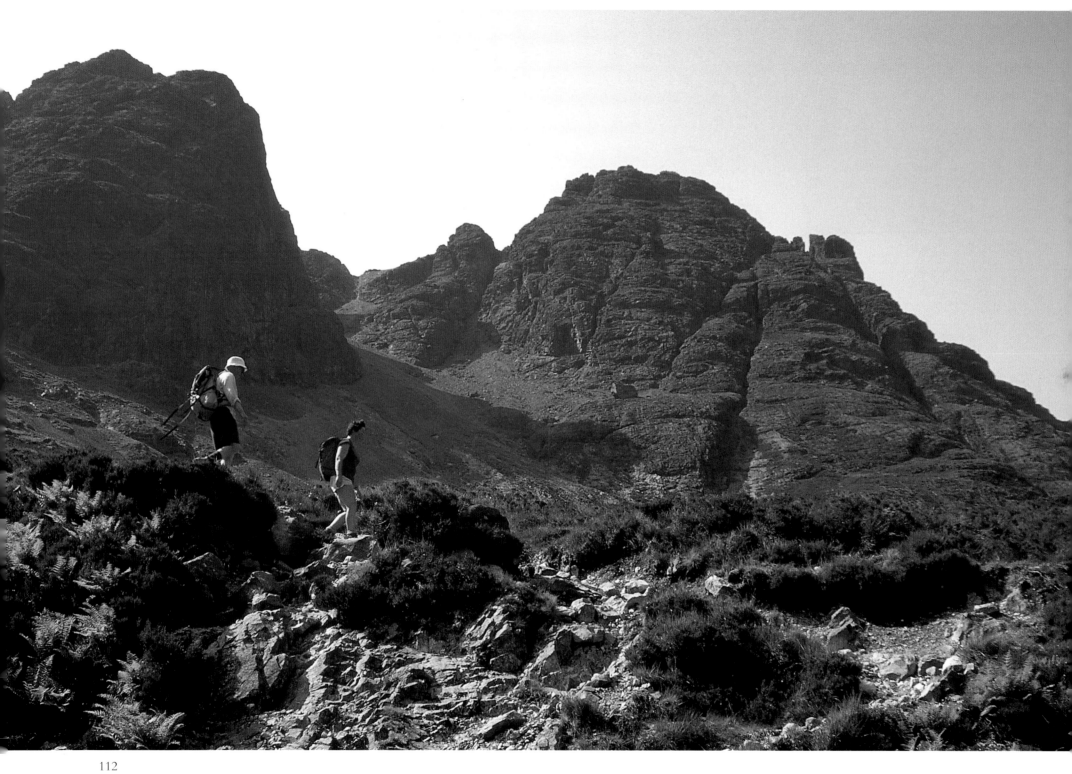

Left

Blaven, *Bla Bheinn* or blue mountain, is the only peak of the Black Cuillin which stands in isolation. Linked to its craggy subordinate, Clach Glas, Blaven makes a profile which combines savage grandeur with classic composition when seen from the east. As Skye's '12th Munro' the 3,042ft (928m) summit is a very popular summer excursion, especially as the 'tourist route' to the top is without exposure or difficulty. The approach path has been extensively repaired under direction of the John Muir Trust who have managed Blaven as part of their Strathaird estate since 1994.

Below

The curvaceous rumps of Beinn Dearg Mhor and Beinn Dearg Bheag, seen across the head of Loch Slapin from the slopes of Blaven, are buffeted by winter squalls. These rounded hills of the Red Cuillin form the perfect foil to the jagged profiles of the main Cuillin Ridge, being formed of acidic granites from a later intrusion of magma. The mineral structure of

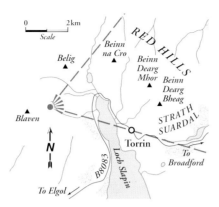

the granites favours decomposition under surface weathering so that the resultant hills form regular domes liberally covered in fine scree.

Right

Most imposing of Blaven's many crags is the 300ft (100m) blade of The Great Prow which can be viewed by a short detour from the tourist path near the summit. A rock climber is preparing to make the exposed traverse out on to the upper crest of the prow.

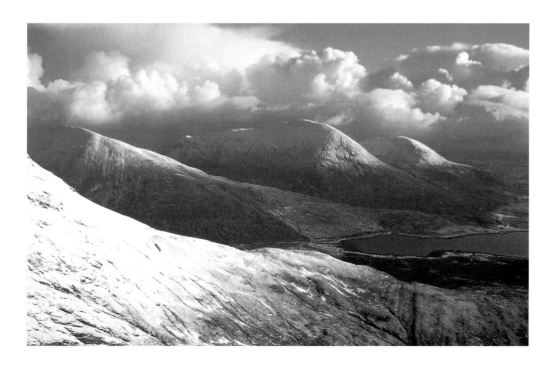

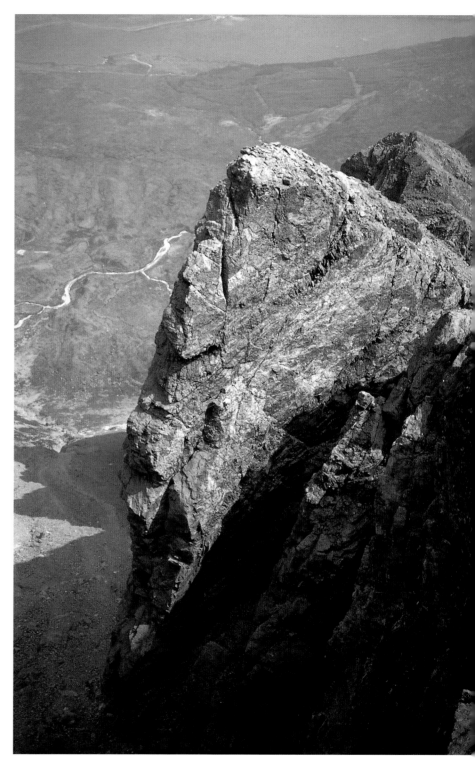

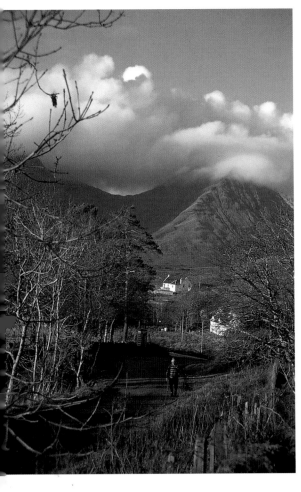

Below
A seam of Jurassic limestone runs from the east slope of Strathaird, across Loch Slapin and through Strath Suardal to the coast near Broadford, sporting many caves. Where this band came in close contact with the molten magma during the building of the Cuillin mountains the limestone was fused into marble. In the nineteenth century a quarrying industry flourished in Strath Suardal and a narrow-gauge railway was built to take the marble stone to the pier at Broadford. Only the quarry at Torrin has survived into the twenty-first century, providing important employment and a splash of vivid colour on the autumn landscape.

Right
Blaven's summit view encompasses the whole of the main Cuillin Ridge which is seen across Strath na Creitheach. However, the pointed tip of Marsco to the north provides the greatest focus in the panorama. Surrounded by a cohort of the lesser Red Cuillin the 2,414ft (736m) peak is one of Skye's copyright mountain profiles whether viewed from above or below.

Above
The Elgol road weaves a switchback route through the crofts and cottages of Torrin township, bordered by copses of ash and birch trees.

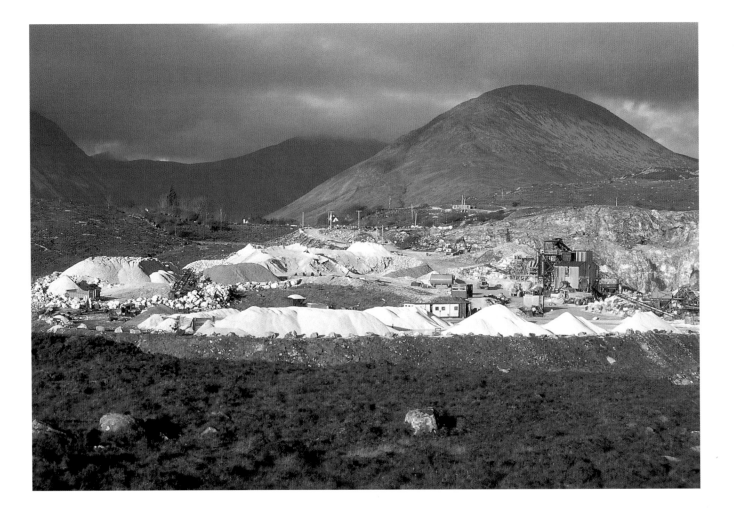

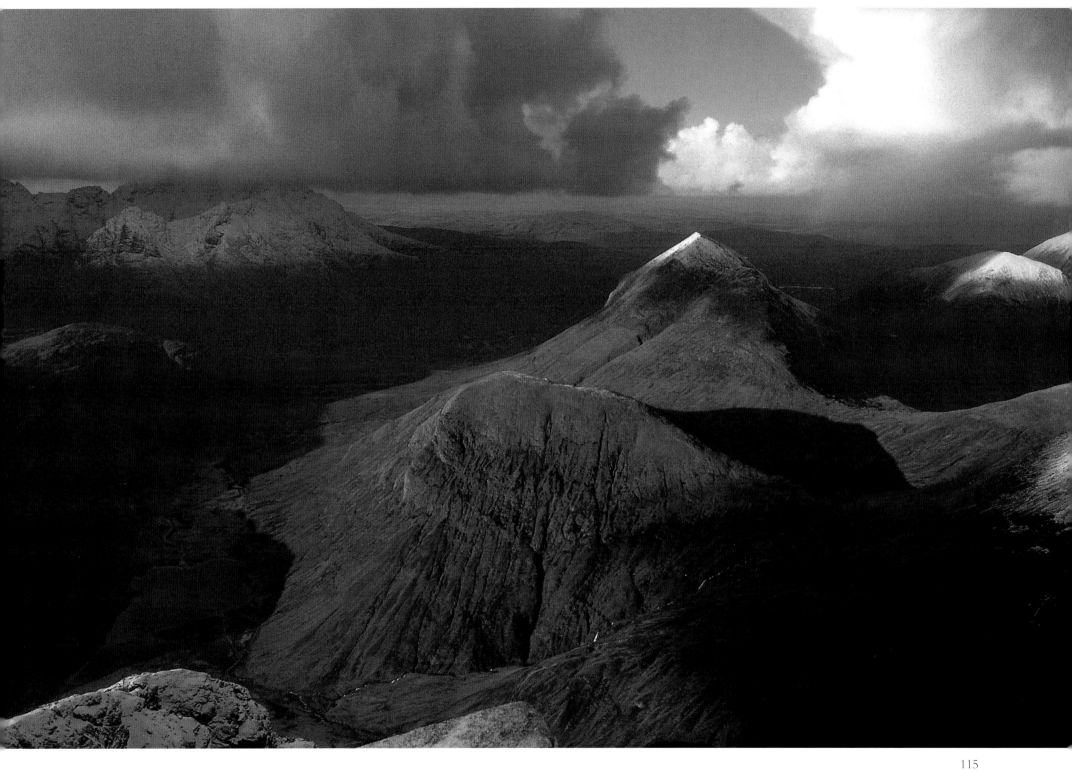

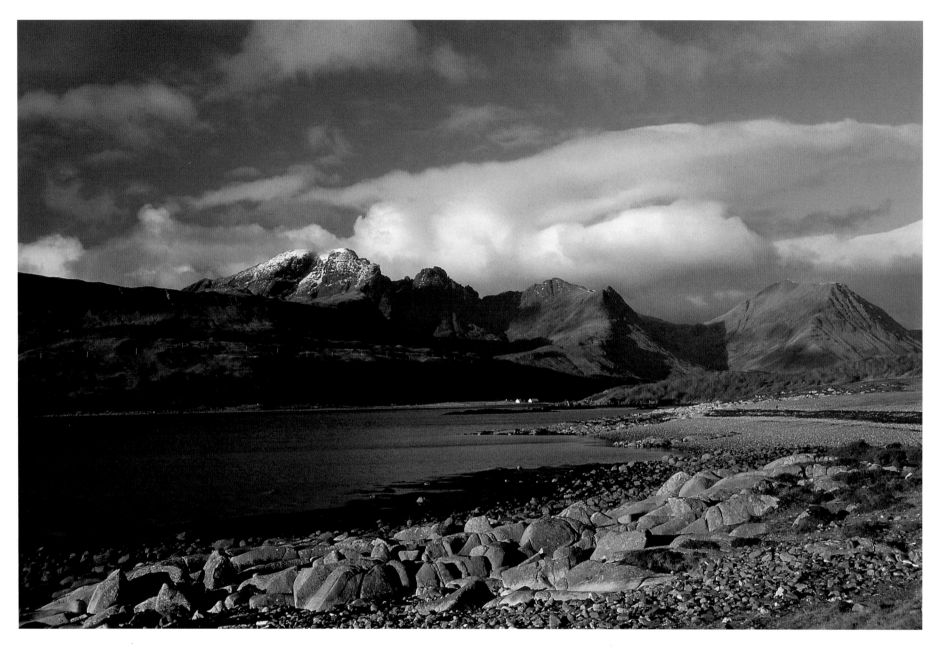

Above

The east shore of Loch Slapin gives a wide retrospect to Blaven and its satellites Clach Glas, Sgurr nan Each and Belig. Two miles south is Suisnish, site of a crofting village which was cleared with callous cruelty between 1852 and 1854 by the factors of Lord MacDonald to make way for open sheep grazings. The coast path from Boreraig round to Suisnish and along Loch Slapin to Kilbride retraces the final walk of the evicted families, many of whom were shipped to Australia.

Right

The mountains of Skye are displayed with unequalled majesty to walkers on the coast path which runs from Elgol round to the house and bothy at Camasunary. On the left the main Cuillin Ridge commences with the spear-head of Gars-bheinn. The shaggy peak of 1,623ft (494m) Sgurr na Stri takes the middle ground, while the south ridge of Blaven rises to the right.

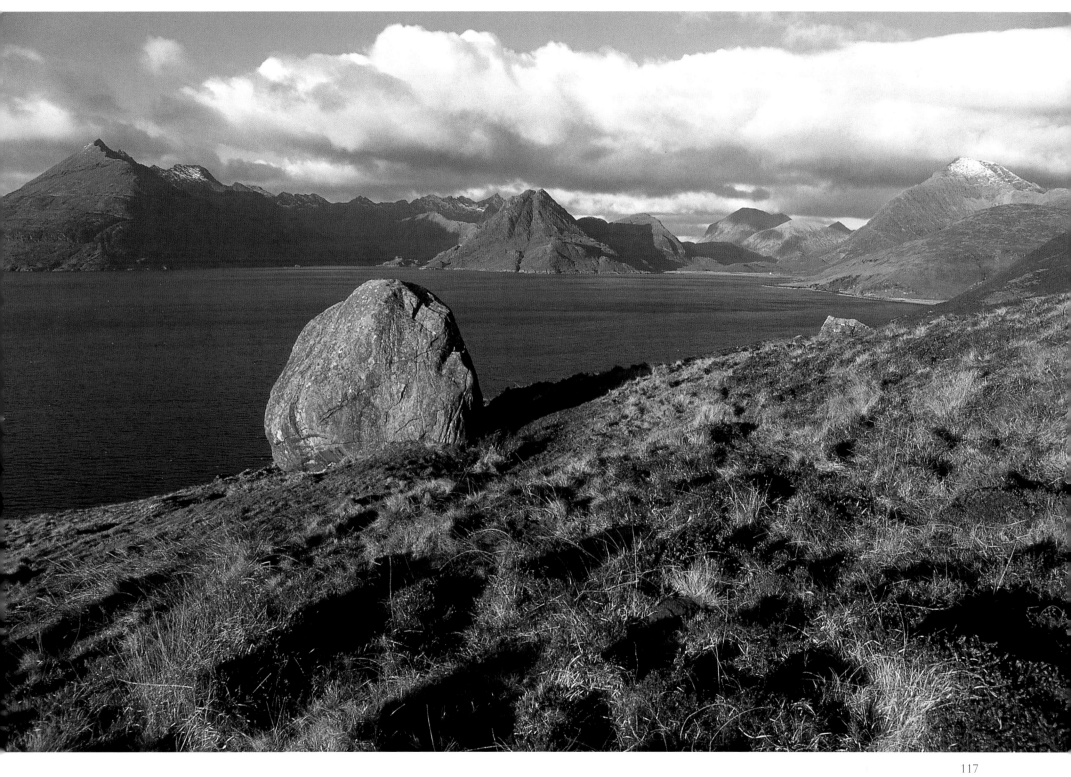

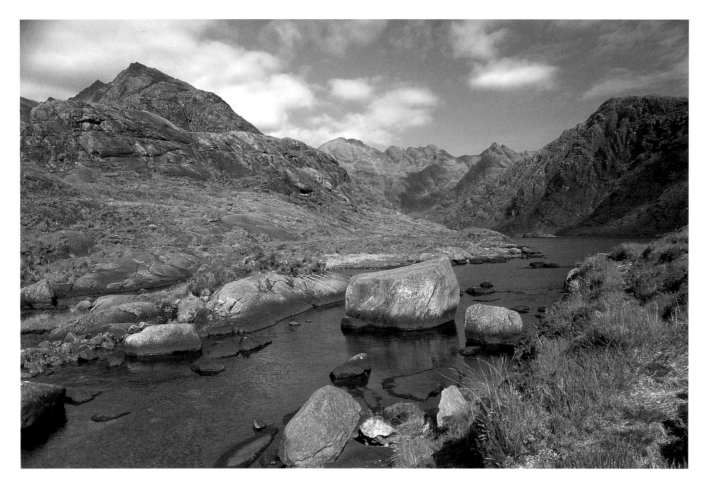

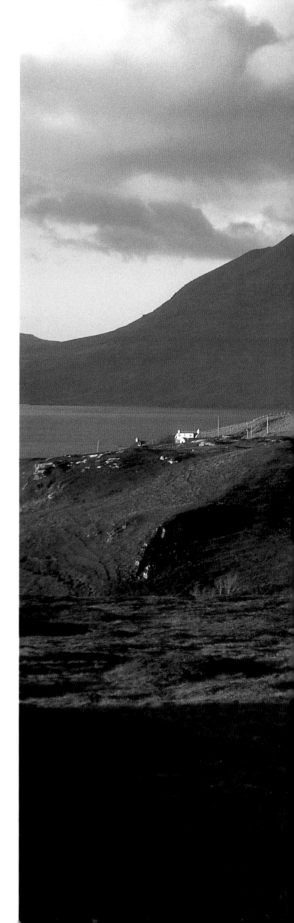

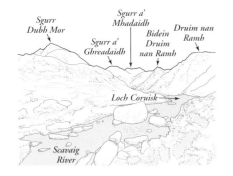

Above

'*Rarely human eye has known, A scene so stern as that dread lake*': Scott's description of Loch Coruisk in 'Lord of the Isles' evokes the stormiest image of the central jewel in the Cuillin crown, yet in the warmth of early summer the place may be as tranquil as it can be wild. The outlet of the loch runs down gabbro waterslides to the sea shore of Loch Scavaig. In spate the stepping stones crossing the river may be covered by water and highly treacherous. A daily boat service from Elgol brings visitors to Coruisk between April and October, while many walkers make the 6-mile pilgrimage from Elgol or Sligachan to visit Skye's inner sanctum.

Right

The houses of Elgol spread across the open hillside above Port na Cullaidh, just a mile from the tip of the Strathaird peninsula. Though possessing a jetty and good anchorage the township is exposed to every gale the Atlantic can throw at it, but equally covets some of the best seaward views in the Hebrides to the islands of Eigg and Rum, while the Cuillin stand on permanent guard to its north.

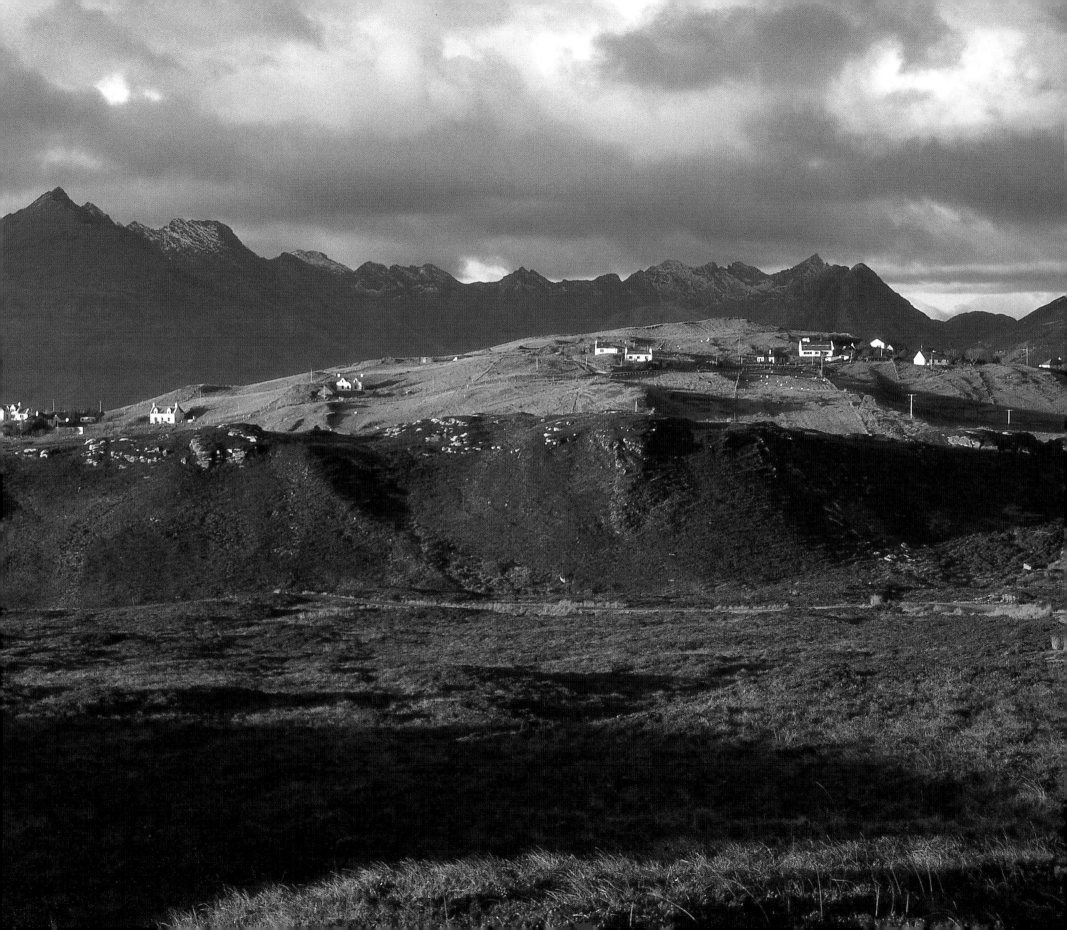

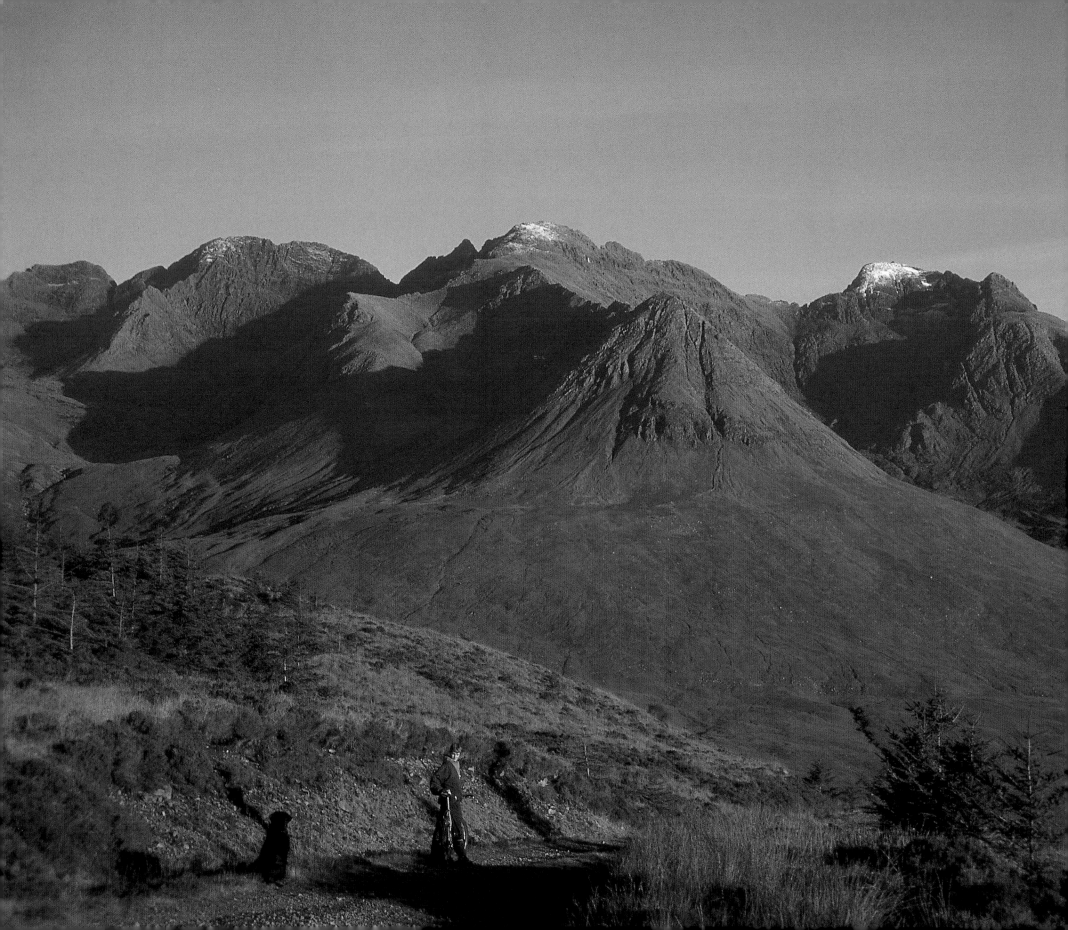

THE CUILLIN TRAVERSE

Perhaps the only 'real' mountaineering expedition in the British Isles and certainly the finest, the traverse of the Black Cuillin Ridge challenges thousands of climbers every year. From Gars-bheinn to Sgurr nan Gillean the Ridge twists over 11 Munro summits in a 7-mile switchback of bewildering complexity and brooding splendour. The Black Cuillin is a pyroclastic chaos formed in the volcanic furnace of the Tertiary epoch some 50 million years ago, then stripped and gouged by successive Ice Ages into its present sawtoothed outline. Forget all your prior notions of ridge walking: much of this ridge is exposed scrambling terrain where progress demands the use of hands as well as feet, culminating in half-a-dozen famous passages of genuine rock climbing. But besides its geology and difficulty it is the incomparable position of the Ridge, high above the seas and islands of the Hebrides, that lends the traverse a quality that is not surpassed by mountain ranges thrice the height. Such glorious landscape should never be prey to the wrangles of private ownership or disfigured for commercial gain.

Left
Seen across Glen Brittle, the Cuillin fairly stake their claim to be Britain's finest mountain chain. The play of autumnal sunshine and shadow displays the architectural elegance of the Ridge with its transverse series of western spurs.

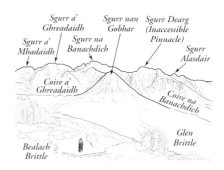

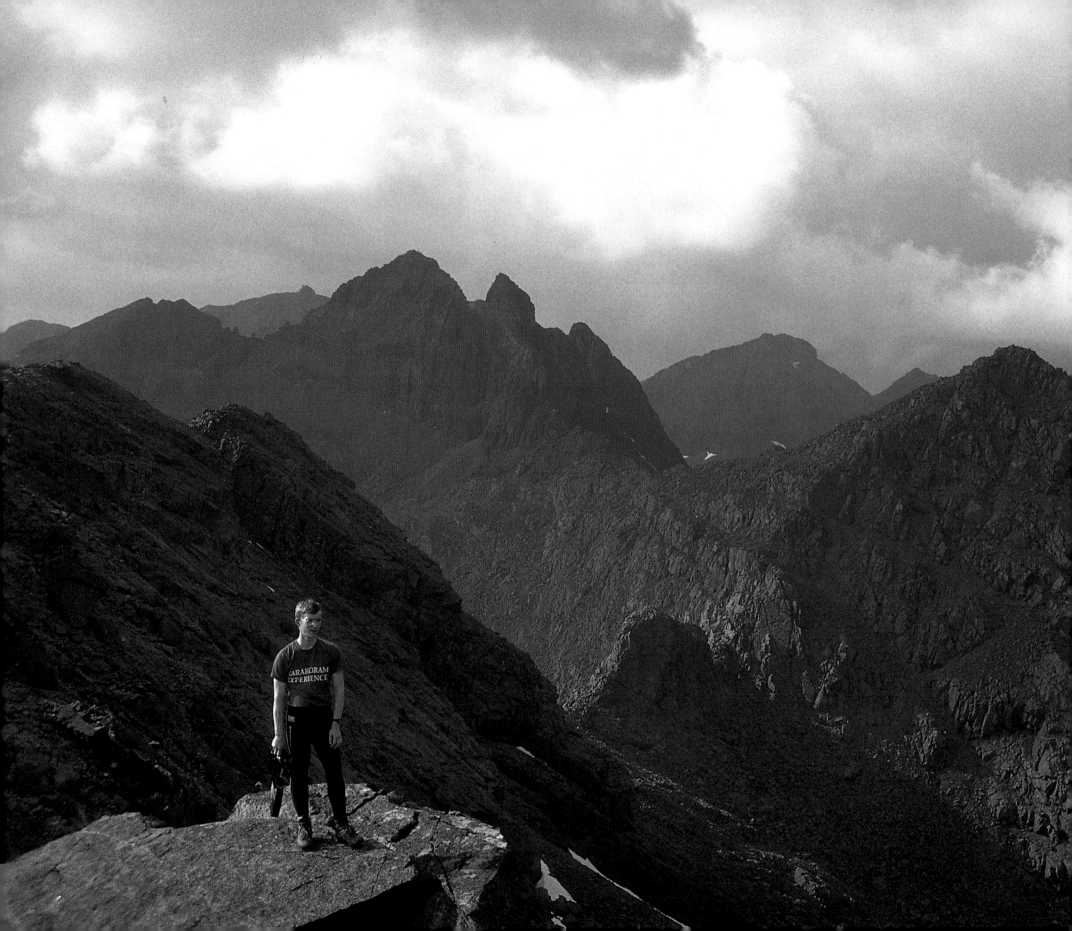

Left

At last one stands on the dragon's spine ready to start the traverse. The first section is easy, but the view north along the bristles of the Ridge gives food for thought. The first traverse of the Ridge was achieved by Shadbolt and MacLaren in 1911. Ninety years later the record time stood at 3hr 32min, but most climbers take between 12 and 16 hours and make a bivouac either at the start or half-way point. The twin peaks of Sgurr Alasdair and Sgurr Thearlaich feature prominently in this view from the first Munro, Sgurr nan Eag.

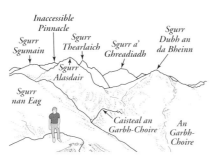

Right

Whether by habit or from subconscious desire to finish in proximity to the Sligachan Inn, most climbers make the traverse from south to north. The approach to Gars-bheinn from Glen Brittle involves a 4-mile tramp over boggy moorland followed by a purgatorial climb of uniform scree and boulder slopes to the summit. On a hot day these three hours of toil can sap the strength and the constant calling of the resident cuckoo down in the woods by the Soay Sound can drive the most patient to the verge of dementia. Long vistas over a shimmering sea to the islands of Rum and Canna do their best to compensate!

Below left and below right

A bed of moss campion in the barren boulderfields under the Caisteal a'Garbh Choire. Few plants can tolerate the harsh environment here; arctic species like dwarf willow and club moss, and a few alpines such as lady's mantle and roseroot, manage to survive in sheltered nooks and damp gullies.

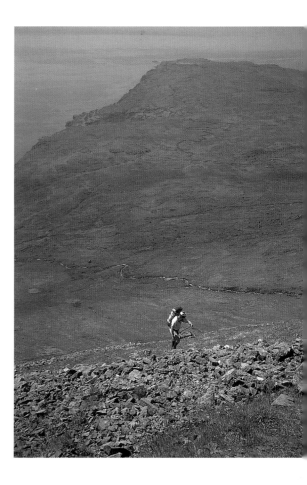

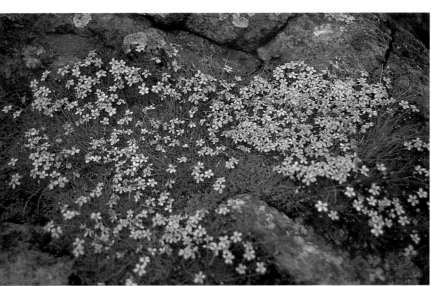

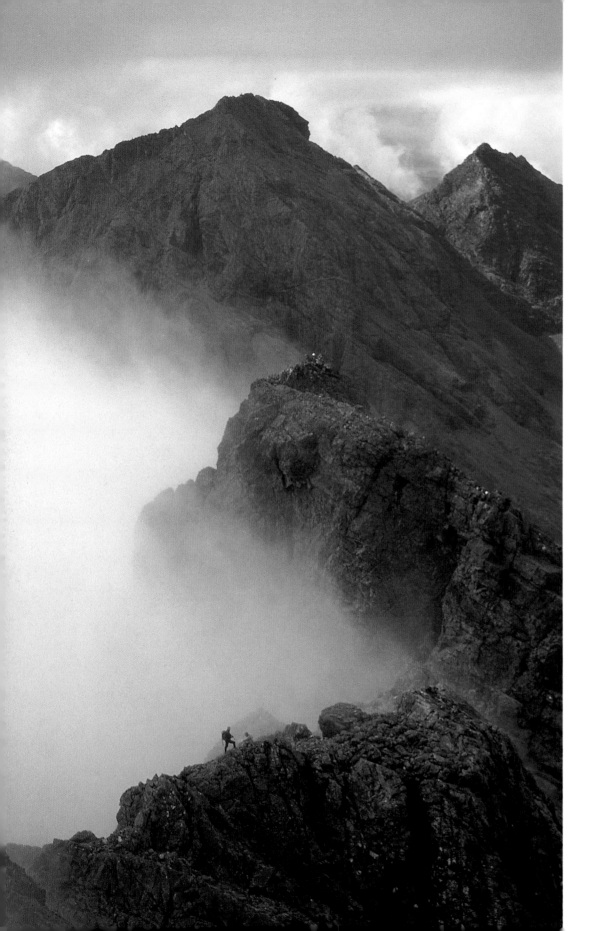

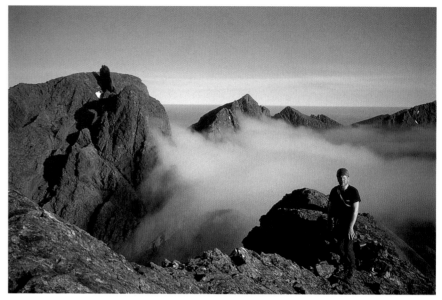

Left

Mist hugs the rim of Coire Lagan, a famous and pivotal section of the Ridge. From Sgurr Thearlaich the Ridge snakes down to the Bealach Mhic Choinnich in a series of slabs and crumbling walls. Beyond rise the vertical crags of Sgurr Mhic Choinnich, MacKenzie's Peak, titled in honour of John MacKenzie, a local shepherd from Sconser who became Britain's first mountain guide. These are out–flanked by a remarkable spiral terrace, Collie's Ledge, named after Norman Collie, an eminent chemist and MacKenzie's long-standing partner in early Cuillin exploration before 1914. The Cuillin are the only mountain range in Britain where several of the tops are named after their con-quistadors. Sgurr a'Ghreadaidh looms behind, four summits and three hours away on the traverse.

Above

In the early morning peace and solitude reign on the Ridge. The air is at its coolest and the light often at its most vivid. Dawn mists lap close to the crest of Sgurr Mhic Choinnich looking towards the fin of the Inaccessible Pinnacle. The 'In Pinn' sits incongruously on the back of Sgurr Dearg and has long been renowned as the most difficult Munro summit.

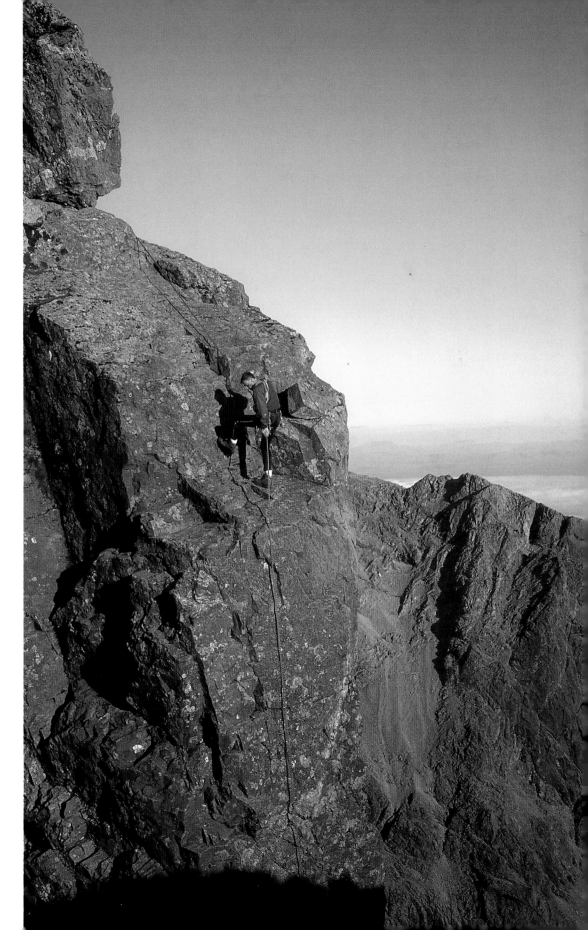

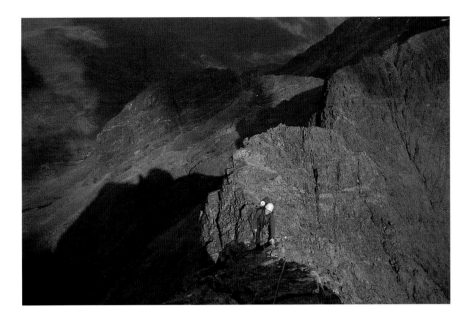

Above

Arrival on the summit of the Inaccessible Pinnacle is a seminal moment for every budding Munroist. For many this is the highlight of the whole traverse, especially in the warm light of mid-evening after the crowds have gone. In the play of sunlight and shadow the mountains regain their visual majesty. The only sound may be the tinkle of rolling screes as a late party descends the Great Stone Shoot into Coire Lagan. The East Ridge is the longest but easiest way up the pinnacle. The Pilkington brothers on making the first ascent in 1880 reported 'a razor-like edge with an overhanging and infinite drop on one side and a drop even steeper and longer on the other'. Notwithstanding Victorian hyper bole, this is an airy but delightful romp, a veritable stairway to heaven.

Right

The abseil off the Inaccessible Pinnacle drops straight down its short side, an abrupt but mercifully brief return to horizontal terrain. For many who attempt the Ridge completion of the Pinnacle engenders such a mood of joyous relief that determination to complete the traverse fast evaporates. Be warned and steel your resolve; over half of the Ridge remains and there are harder climbs yet to be tackled!

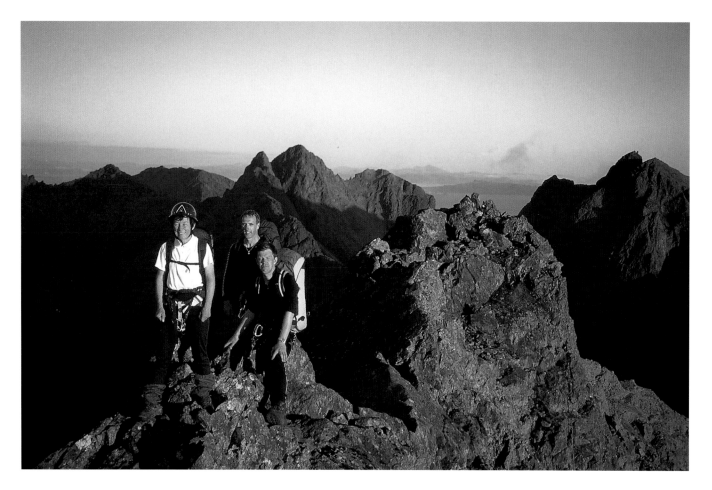

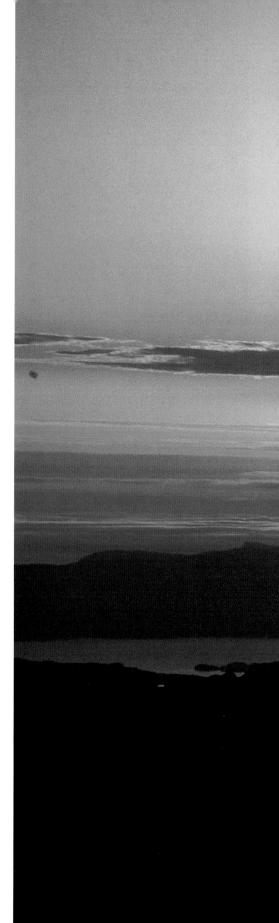

Above

The crest of Sgurr a'Ghreadaidh offers a continuous scramble of the highest quality without any especial difficulties, giving quick progress as the shadows lengthen at the end of a hard day.

Right

On a fine June evening one can keep climbing until 10pm, choose a couch of moss for a bivouac, then lie out and enjoy a golden sunset over Minginish as the tea brews. Spending a night out on the Ridge can be heaven or hell, depending on the weather and choice of bivouac site. If there is much wind or any possibility of rain, there are several caves and rock overhangs en route offering reasonable shelter. Here the climber can rest secure, regain some energy for the morrow and even catch a couple of hours sleep.

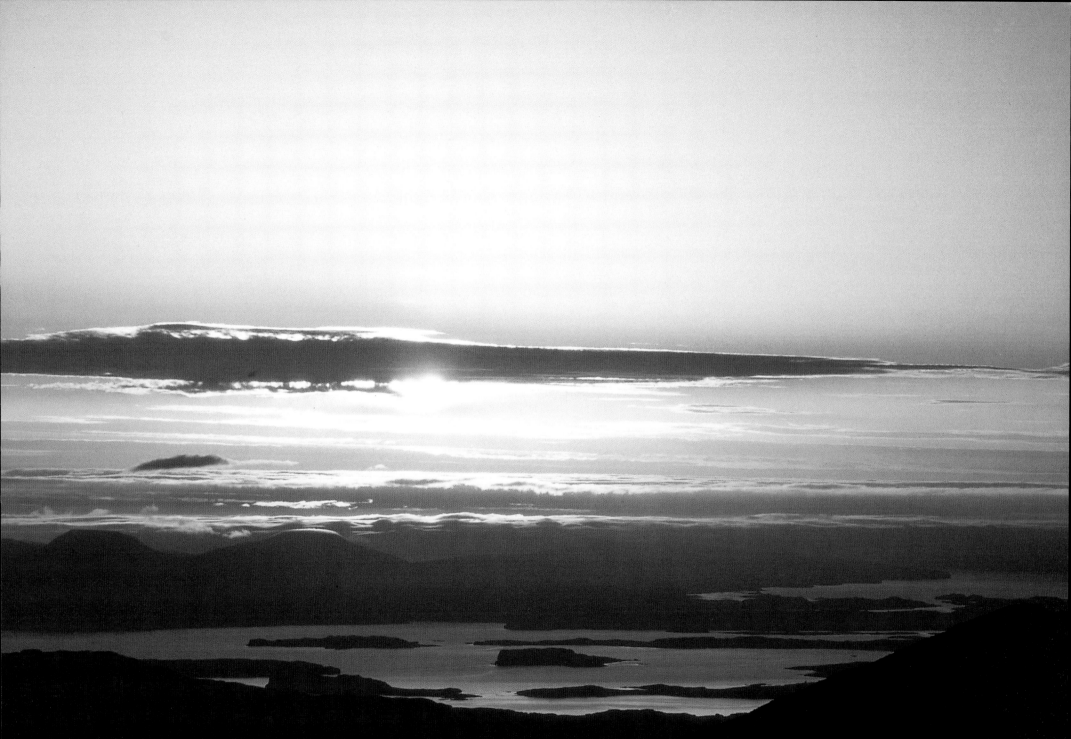

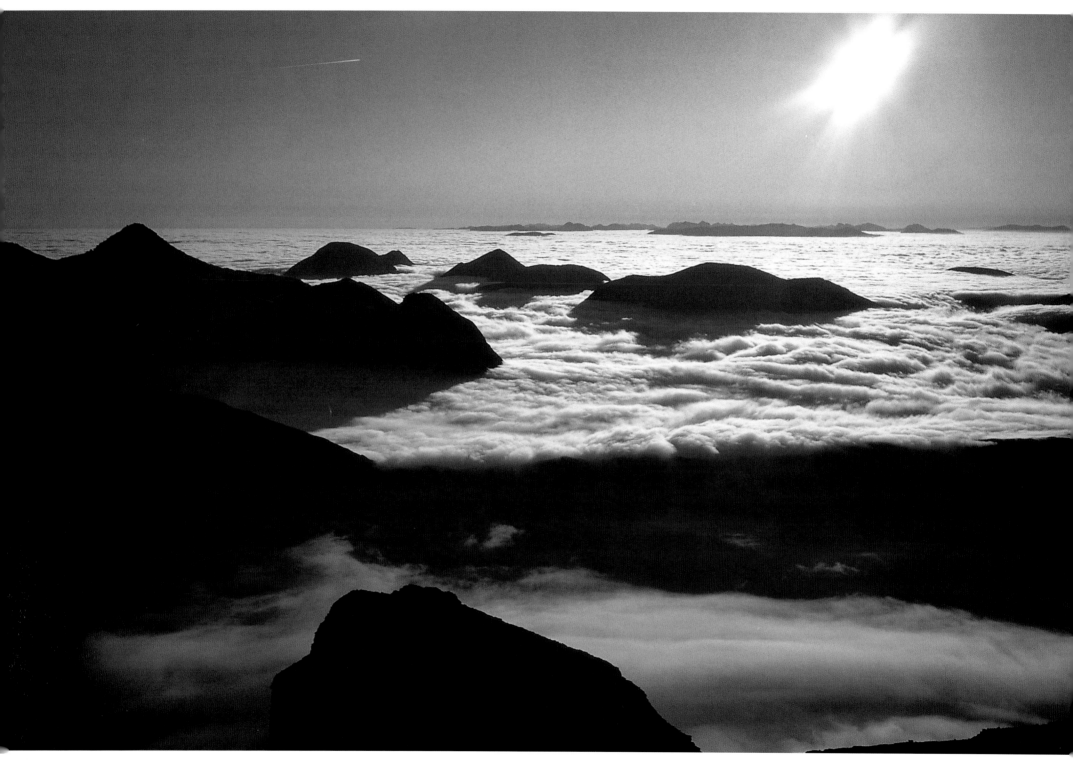

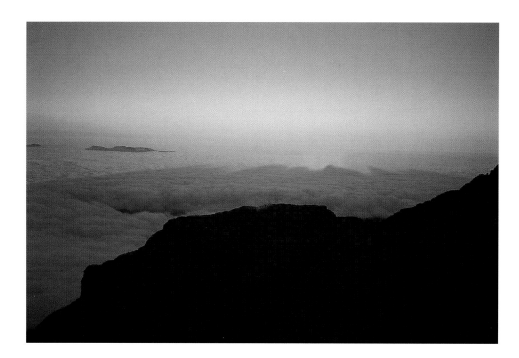

Left and above

Dawn over the northern Cuillin viewed from a bivouac on Sgurr Dubh an Da Bheinn (left). Cloud inversions are always possible when atmospheric pressure is high and sinking air masses trap a cooler moist layer near sea level. Diffraction of the light off the opaque cloud surface can cause visual distortion of distant horizons, thrusting up the mainland skyline into a series of square-topped desert buttes and mesas. Out to the west the Cuillin outline is projected in silhouette on to an unbroken sea of cloud (above).

Right

Beyond Sgurr a'Mhadaidh the Cuillin crest becomes particularly tormented, weaving east down to its lowest point at the Bealach na Glaic Moire, then over the triple-topped Bidein Druim nan Ramh, and finally back north to the next major summit, Bruach na Frithe. The constant scrambling, so exhilarating on the first day, may become gruelling and nerve-racking, requiring a focused attitude and the courage to jump gaps, such as this one on An Caisteal.

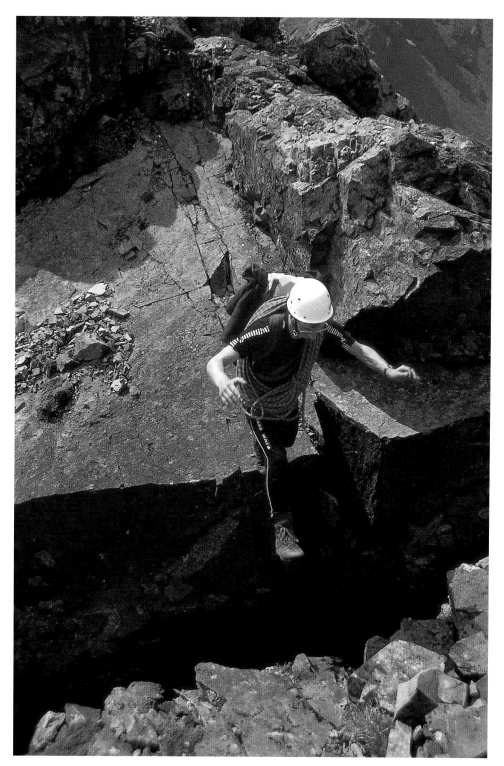

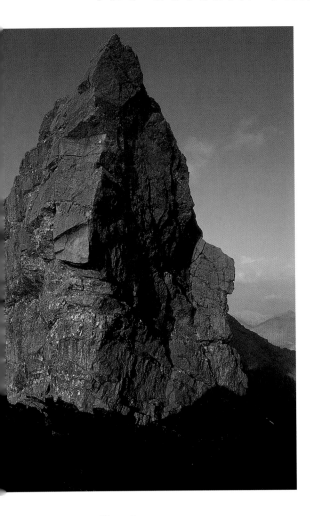

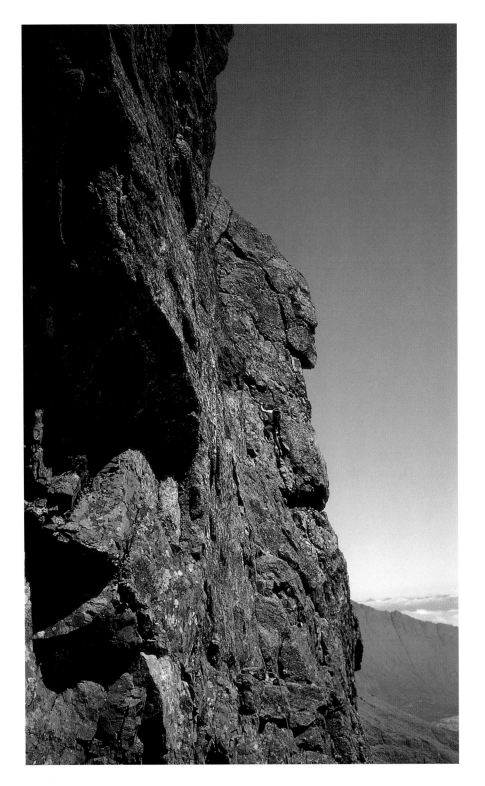

Left and right
With arrival at Bruach na Frithe the final stretch of the ridge begins, but one last obstacle bars the path to completion, the mighty prow of the Bhasteir Tooth (left). The origin of the name Bhasteir is obscure. 'Executioner' has been suggested as a possible meaning, and when the stepped overhanging edge of the Tooth is seen in profile it resembles a hatchet poised ready to strike. The most direct and classic way of surmounting the Tooth is Naismith's Route which climbs ledges and walls just right of the edge in a wonderfully exposed situation (right). Remarkably, this climb was pioneered in 1898 by Willie Naismith, one of the founding fathers of Scottish mountaineering.

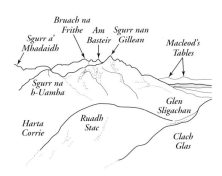

Opposite
Viewed across Glen Sligachan from Clach Glas, the noble assemblage of northern Cuillin culminates in Sgurr nan Gillean, the Peak of the Young Men. Gillean was described by Sorley MacLean as 'the sgurr of Skye above the rest of them', its pre-eminence being owed to its pinnacled northern ridge and relative isolation as the Ridge's final sentinel. There could be no finer finish to the traverse than to clamber on to the crow's nest summit and survey one of the world's great mountain views. The eye can rove at will across Skye's mosaic of sea inlets,

conical hills, brown moors and shoreline townships, but the weary climber may be excused for focusing on the whitewashed cluster of buildings at Sligachan. Only there, at the hotel which has succoured Cuillin climbers for over a century, lies the promise of well-earned refreshment.

130

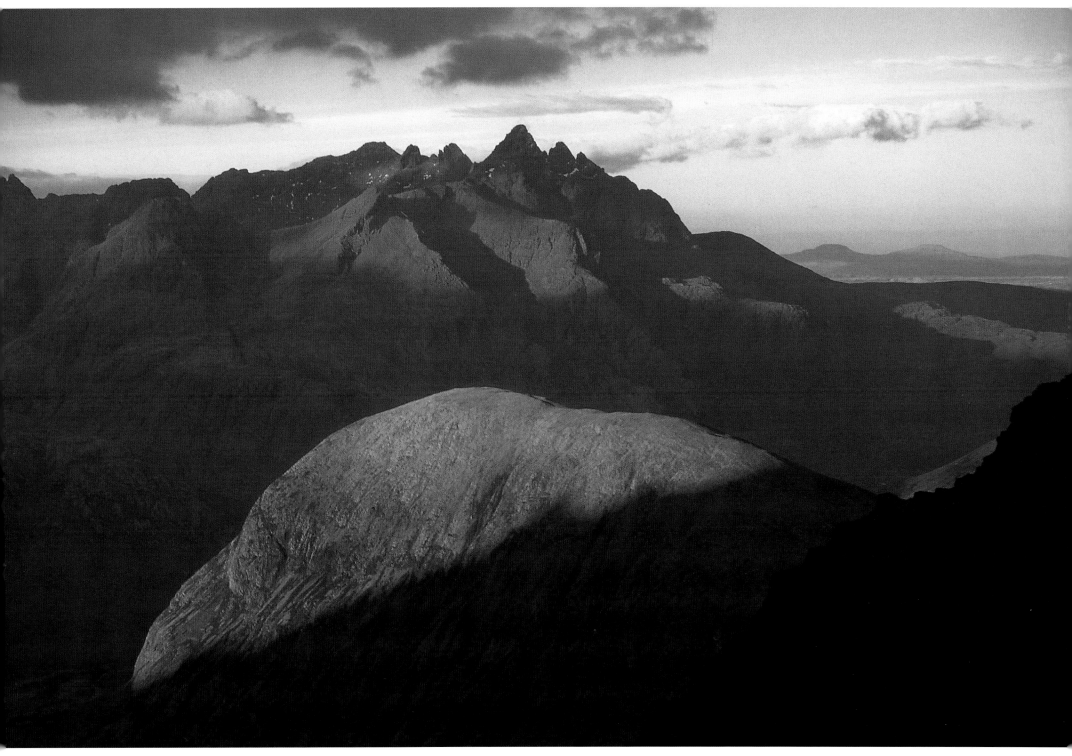

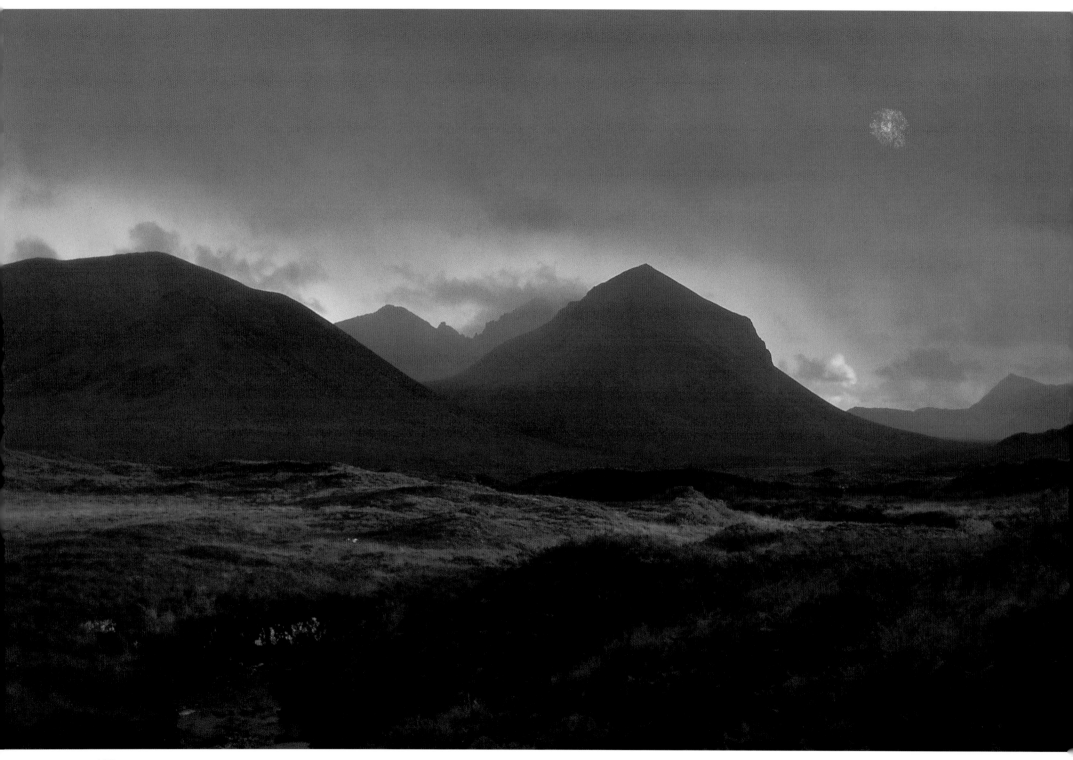

HEARTLAND

The heart of Skye is a broad slice of somewhat dreary moorland some 6 miles wide which runs north west from the Cuillin to the northern sea inlets of Lochs Snizort and Dunvegan. If the immediate surroundings are unexceptional, the area is fringed by natural scenery of the highest order. To the east is the bay of Portree and lofty cone of Ben Tianavaig, to its west the peninsula of Minginish which possesses a coastline to match with any on the island and to the south rise the famous northern ramparts of the Cuillin. Skye's heartland is essentially an area from which to look outward in wonder.

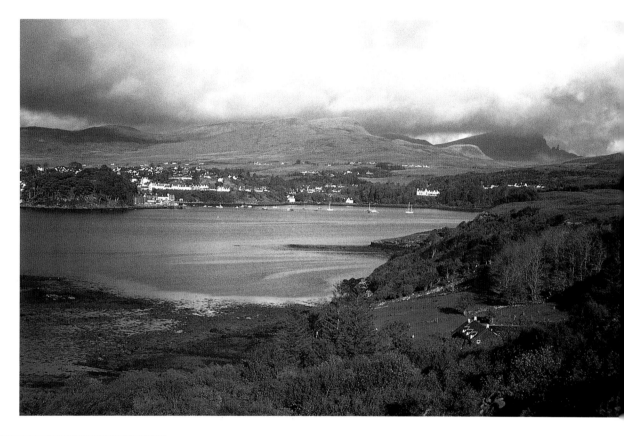

Left
An autumn sunset lights the moors above Sligachan while the peaks of Marsco, Blaven and Clach Glas brood in shadow.

Right
The delicate tracery of a spider's web holds the morning dew.

Above
Portree, *Port an Righ* or King's Harbour, was named following the visit of James V in 1540, but the modern town dates from the nineteenth century. Favoured by its central position in the island and remarkable natural anchorage Portree soon grew into Skye's undisputed capital. The view from Penifiler on the south side of the bay with The Storr on the horizon confirms the town's claim to have one of the finest settings in the Highlands. The central streets and square are attractively grouped behind the rocky wooded eminence known as The Lump.

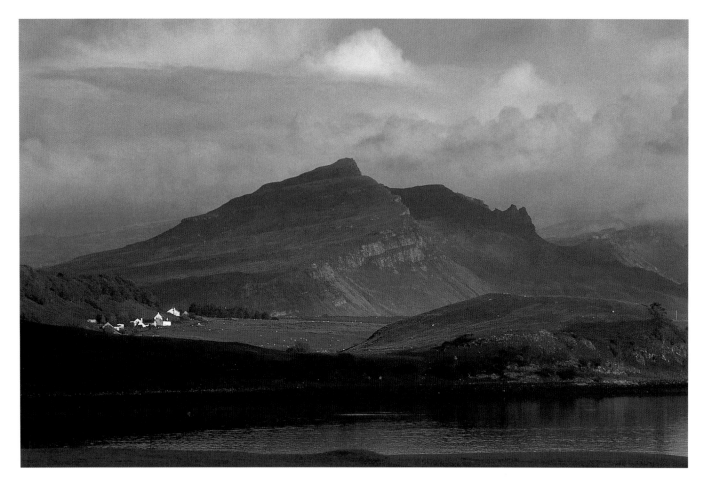

Above

Ben Tianavaig (1,355ft/413m), the southern sentinel of Portree bay, is unmistakable in this view from Sconser shore. Just across the mouth of Loch Sligachan lie the townships of The Braes, where in 1882 a pitched battle was fought between aggrieved crofters and a force of 50 policemen. Denied access to the nearby hill for grazing the local folk refused to pay their rents to the landlord, Lord MacDonald, who then threatened eviction. The police were driven back and the evictions resisted. The Battle of the Braes, together with the protests at Glendale,

at last brought the crofters' complaints to the notice of the Government.

Right

The northern peaks of the Cuillin Ridge from the left are Sgurr nan Gillean, Am Basteir and Sgurr a' Bhasteir. This is the view which has launched a thousand climbing careers and is the *raison d'être* of the Sligachan Inn, one of Britain's oldest and most famous mountain hotels. From here at Sligachan the first parties of the Scottish Mountaineering Club embarked on their pioneering climbs in the Cuillin range in the 1890s.

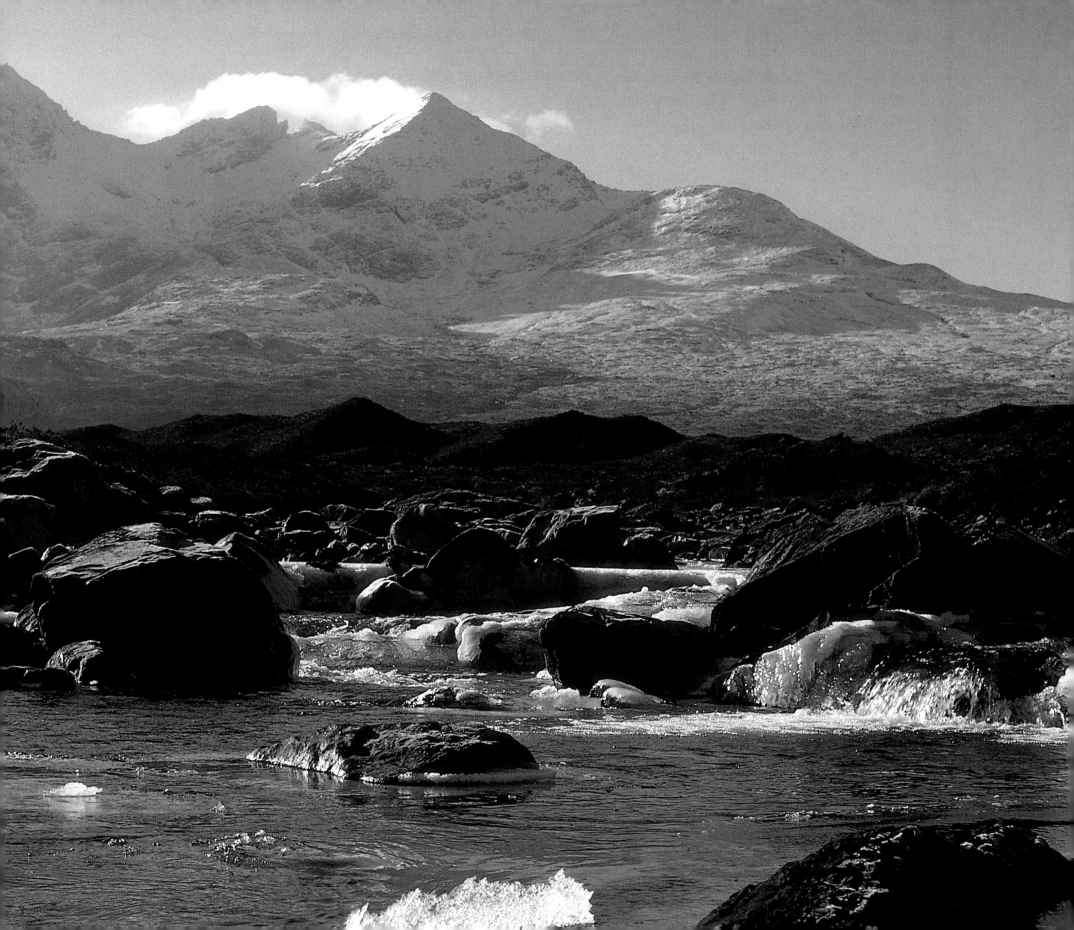

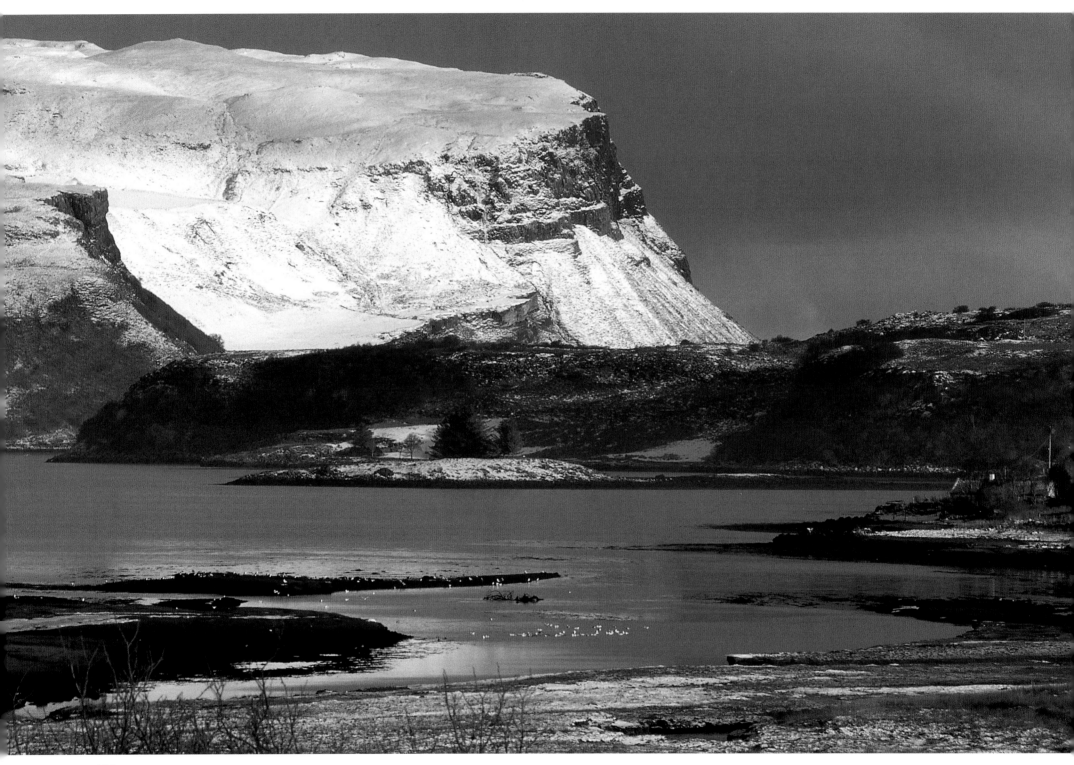

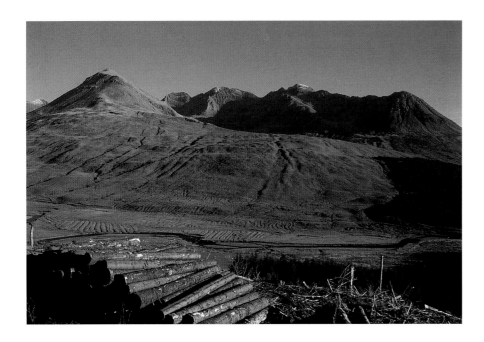

Left
Large tracts of central Skye have been given over to commercial forest plantations. Those on the west flank of Glen Brittle have been harvested at some 60 years of age. Forest roads traverse high above the glen giving a magnificent view of Coire a'Ghreadaidh and its encircling peaks, Sgurr Thuilm, Sgurr a'Mhadaidh, Sgurr a'Ghreadaidh and Sgurr na Banachdich. The furrows of old lazybeds on the floor of the glen evidence past cultivation and settlement which finally expired during the nineteenth-century Clearances.

Below
Minginish means the Great Promontory. Although the traditional demarcation of the district included the main Cuillin range, Minginish is more commonly defined today as the peninsula between Glen Brittle and Loch Harport. Barren moorland rises to flat-topped summits between 1,000 and 1,500ft in altitude. At the head of Glen Eynort the road from Carbost makes a steep descent and a vista opens across forested ridges to the central Cuillin chain.

Left
The imposing cliffs of Sithean Bhealaich Chumhaing rear straight from the sea to a height of 1,286ft (392m) to form the northern bulwark of Loch Portree. Together with Ben Tianavaig the headland holds Portree in a firm but safe clasp. Seagulls and waders feed in the estuary of the Varagill river as a winter squall approaches from the north east.

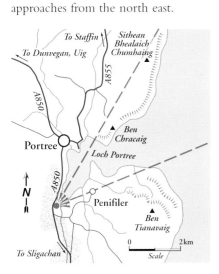

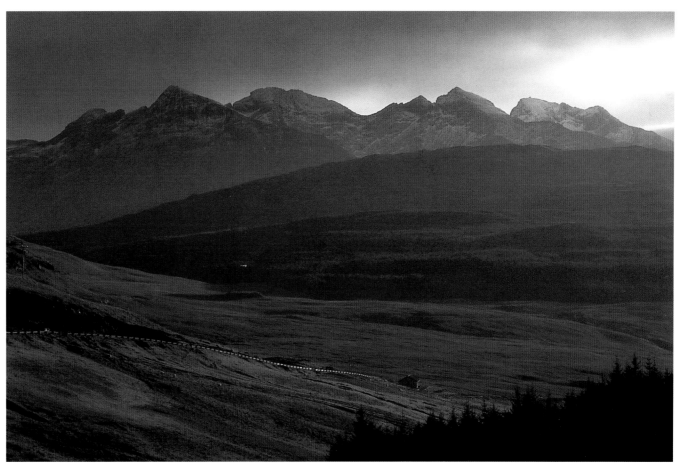

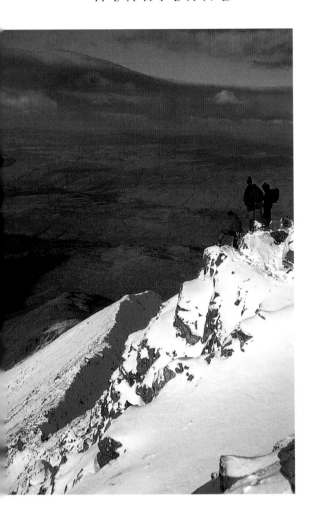

Left

From the north-west ridge of Bruach na Frithe climbers look out to the long sea arm of Loch Harport and the empty moorlands of Skye's interior.

Right

Talisker Bay with its sweeping beach and girdling cliffs is one of the most delectable spots in west Skye. Yet after his visit with Boswell in 1773 Samuel Johnson wrote of Talisker as '*the place beyond all that I have seen from which the gay and the jovial seem utterly excluded*'. Perhaps Johnson was referring to the comforts of his accommodation at Talisker House rather than the surrounding scenery. The house lies half a mile from the beach close under the craggy nose of Preshal More surrounded by well-tended gardens and copses. Talisker means 'the house at the rock', and the name has acquired world-renown as Skye's distinctive whisky, which is distilled 4 miles back over the hill at Carbost.

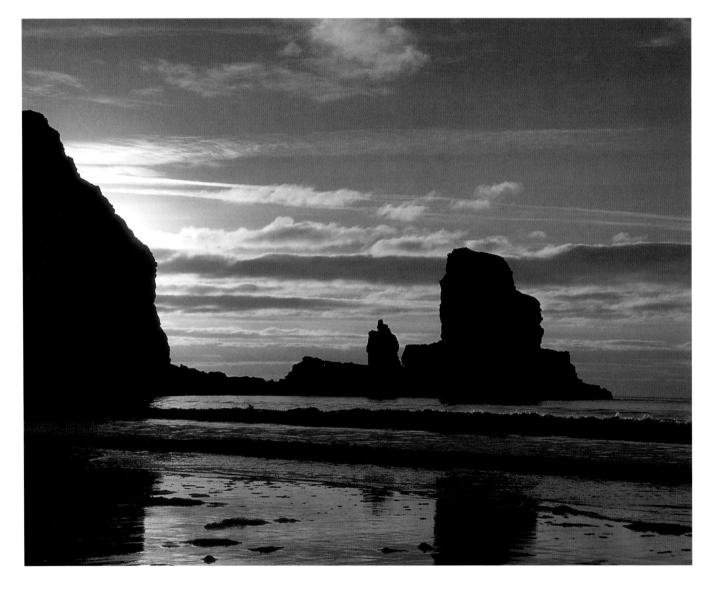

Right

Talisker beach and the Stac an Fhucadair (the fuller's stack) on a winter afternoon.

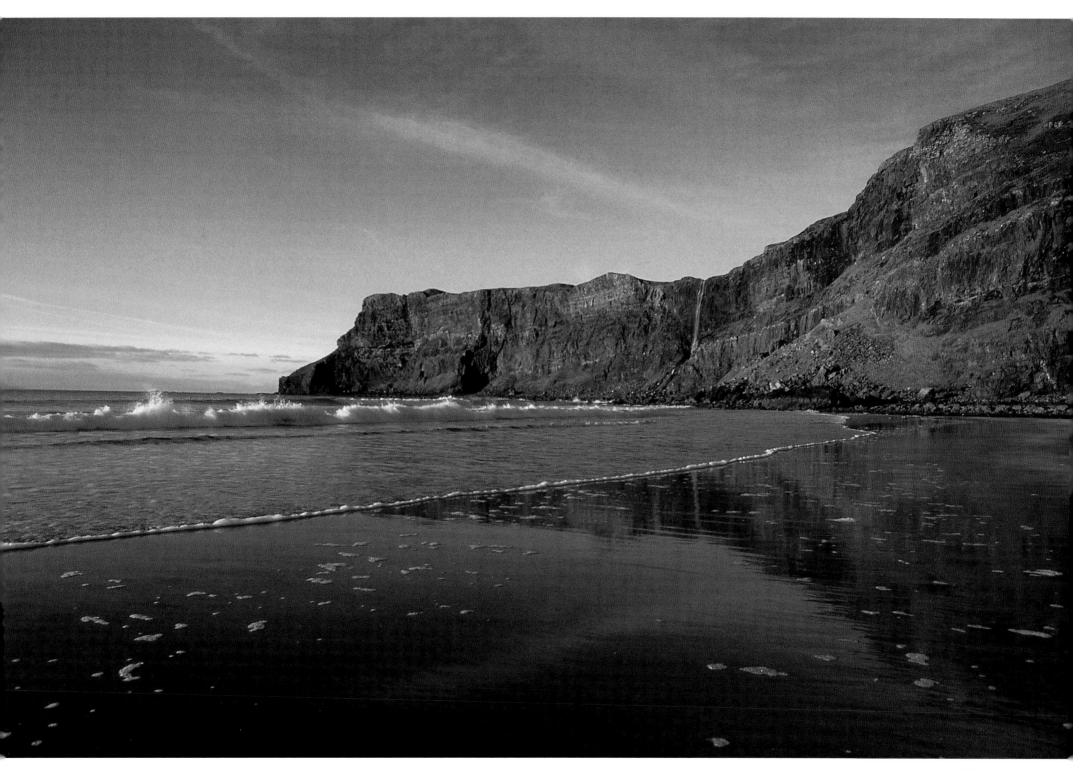

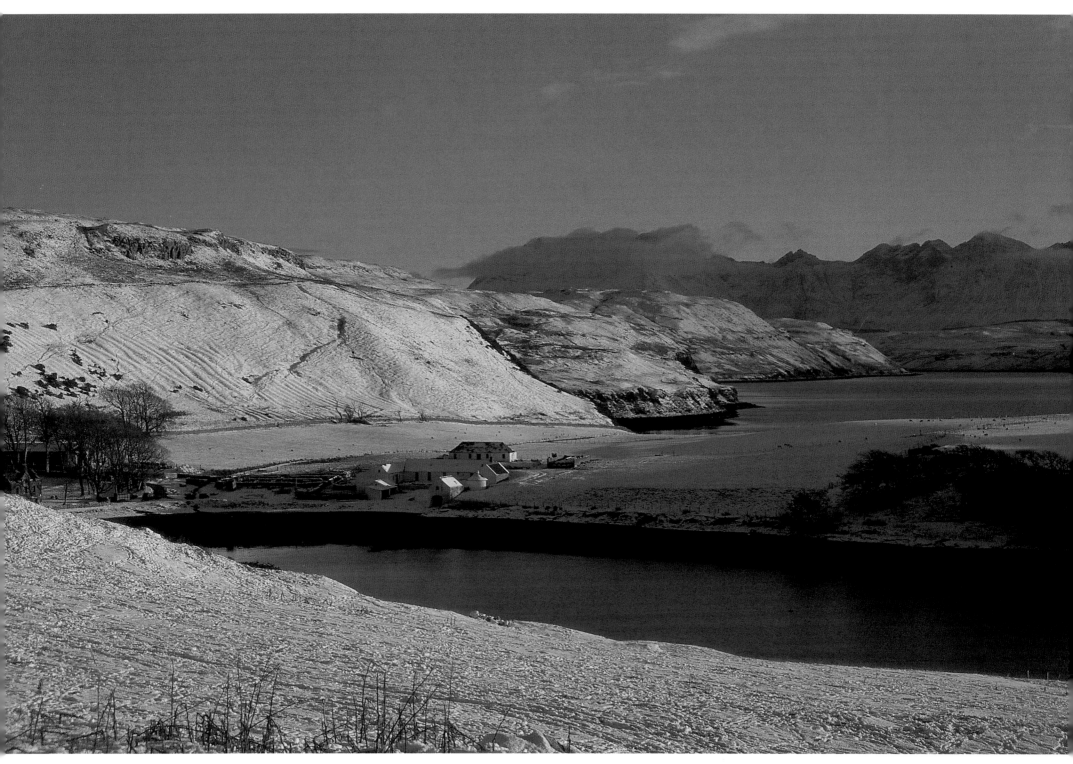

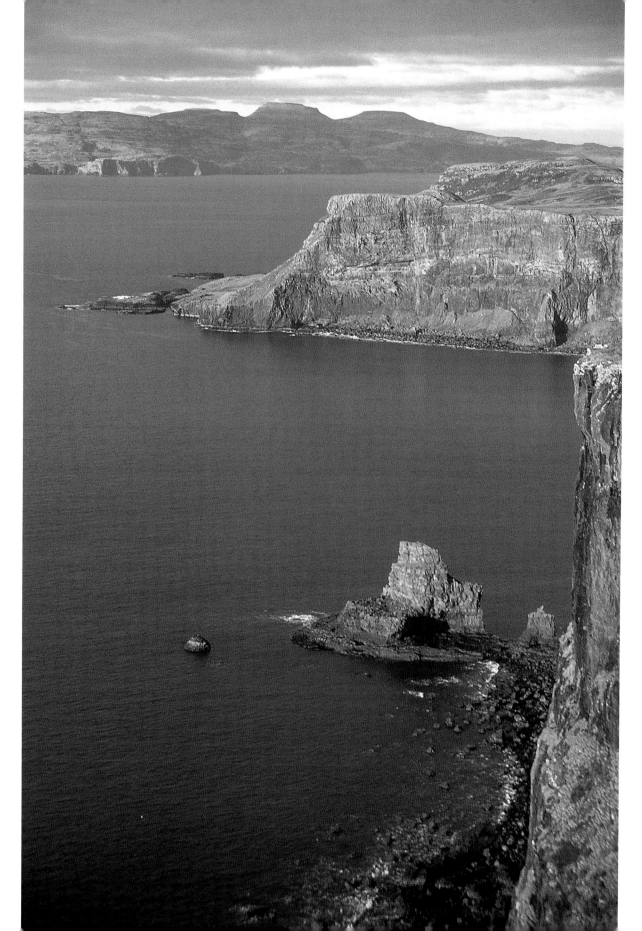

Left

Just over a mile before Bracadale village the A863 Dunvegan road makes a curving seaward descent above Gesto Bay to provide a prized panorama of Loch Harport and the distant Cuillin. Gesto is one of Skye's oldest habitations and the modern barns and stables set the foreground for this mid-winter view. The grassy hillsides behind Gesto are dotted with ruins of Iron Age duns and the lazybeds of eighteenth- and nineteenth-century cultivation.

The Cuillin

Beinn Dubh

Bidein Druim nan Ramh

Sgurr a' Ghreadaidh

Sgurr a' Mhadaidh

Gesto House

Loch Harport

Gesto Bay

Right

The west coastline of Minginish is a continuous barrier of vertical cliffs broken only by the inlet of Loch Eynort and the bay at Talisker. Between these weaknesses the ramparts of lava rise to 920ft in height at Biod Ruadh, and the cliff-top walk is as lonely as it is spectacular. Approaching Talisker Bay the northward view from the cliff edge includes the Stac an Fhucadair, the cliffs of Rubha Cruinn beyond Talisker, while across Loch Bracadale the outlines of MacLeod's Tables make a familiar horizon.

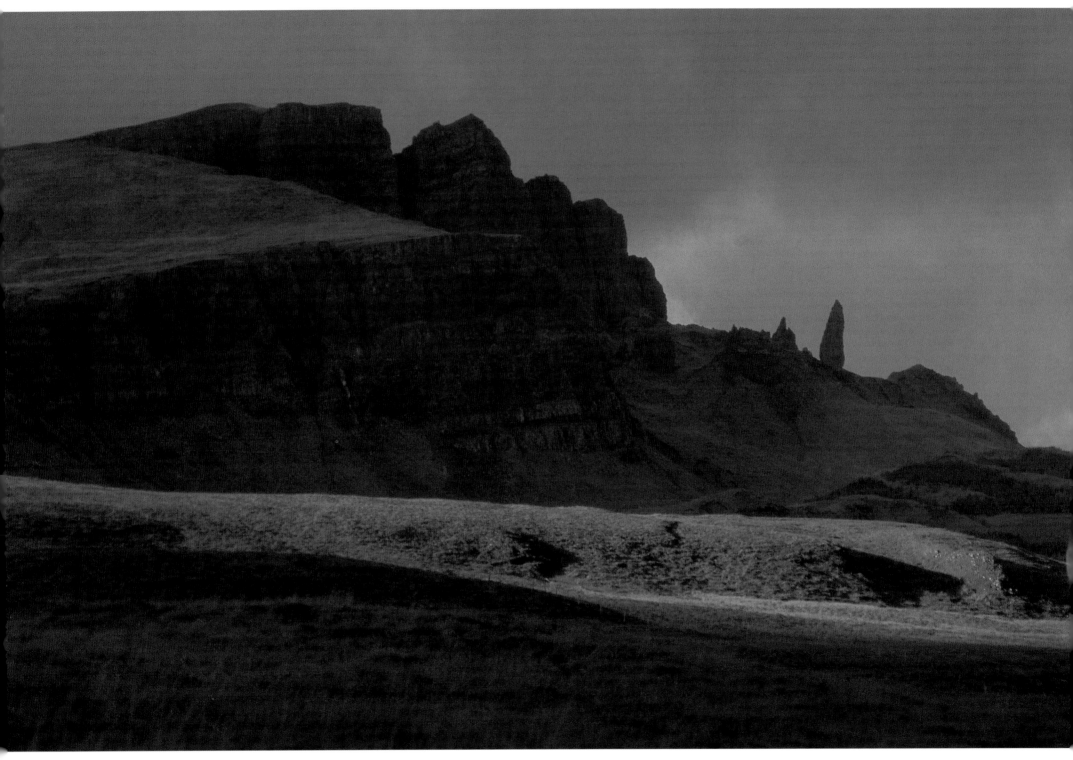

TROTTERNISH

Trotternish is the largest of Skye's 'wings', spreading for 20 miles north of Portree to the island's northern headland at Rubha Hunish. A long chain of lava hills forms a central ridge, culminating at 2,350ft in The Storr. The eastern escarpments of the ridge and the coastal cliffs below contain the most striking of all Skye landforms. The Quiraing, Kilt Rock, The Old Man of Storr and its Sanctuary are justly famous attractions, unique in Britain. Elsewhere in Trotternish there are fertile croft lands, endless acres of short-cropped sheep grazings, the Uig ferry terminal to the Outer Isles and many historic sites which include Flora MacDonald's grave and the storm-battered ruins of Duntulm Castle.

Left
From the moors beside Loch Leathan, The Storr and its Old Man make a particularly dramatic profile, and the origin of so isolated a pinnacle may be a matter of some puzzlement.

Left
The hydro-electric power station at the outlet of Storr Lochs provided Skye's first electricity supply when it came on stream in May 1952. The power is generated from a 300ft fall of water into Bearreraig Bay. The rim of cliffs of the bay are dolerite formed by a horizontal intrusion of magma, but the lower rock beds are of Jurassic origin and contain a rich supply of fossils.

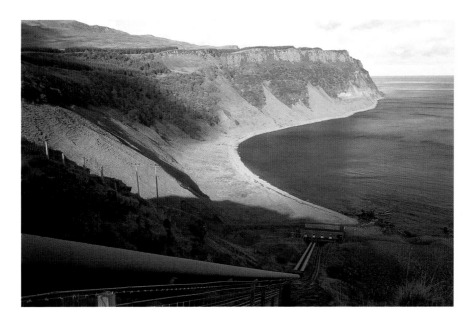

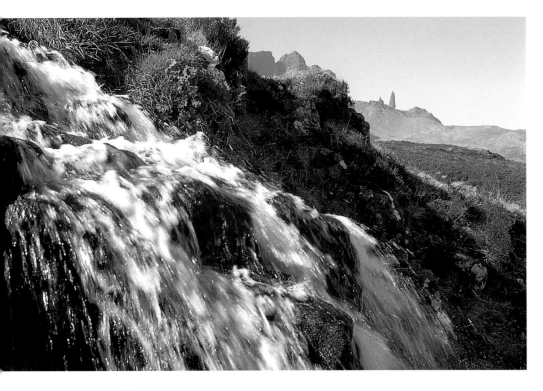

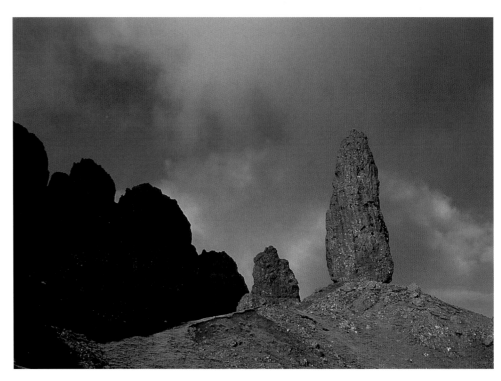

Above

The profile of The Old Man of Storr is immediately spied from the Staffin road as it climbs out of Portree.

Above right

The structure of The Storr becomes more obvious when the escarpment is viewed directly from below. The Old Man is in fact one of several remnants from massive landslips. These were initiated when the thick overlayers of basalt lavas caused weak underlying Jurassic sediments to slide on their base. Great chunks of the lava escarpment were carried hundreds of feet downwards and then eroded and glaciated over millions of years to leave the tottering pinnacles of today.

Below right

The Old Man is 180ft (55m) in height and is undercut around its base. The lava rock is variously smooth and compact or loose and crumbling, and early climbers dismissed the possibility of it ever being climbed. In 1955 Don Whillans made the bold first ascent, but its reputation remains undiminished and few climbers venture near.

Opposite

The area around the Old Man is a profusion of rotten pinnacles together with shelves and dells of green turf, and is known as The Sanctuary. A well-engineered access path climbs through forest plantings above the Portree–Staffin road. Views southward from The Sanctuary are spectacular. In good weather walkers can scramble northwards under the summit cliffs to gain a ridge which leads back south above the scarp to the summit of The Storr. This is perhaps the most rewarding half-day excursion in Skye.

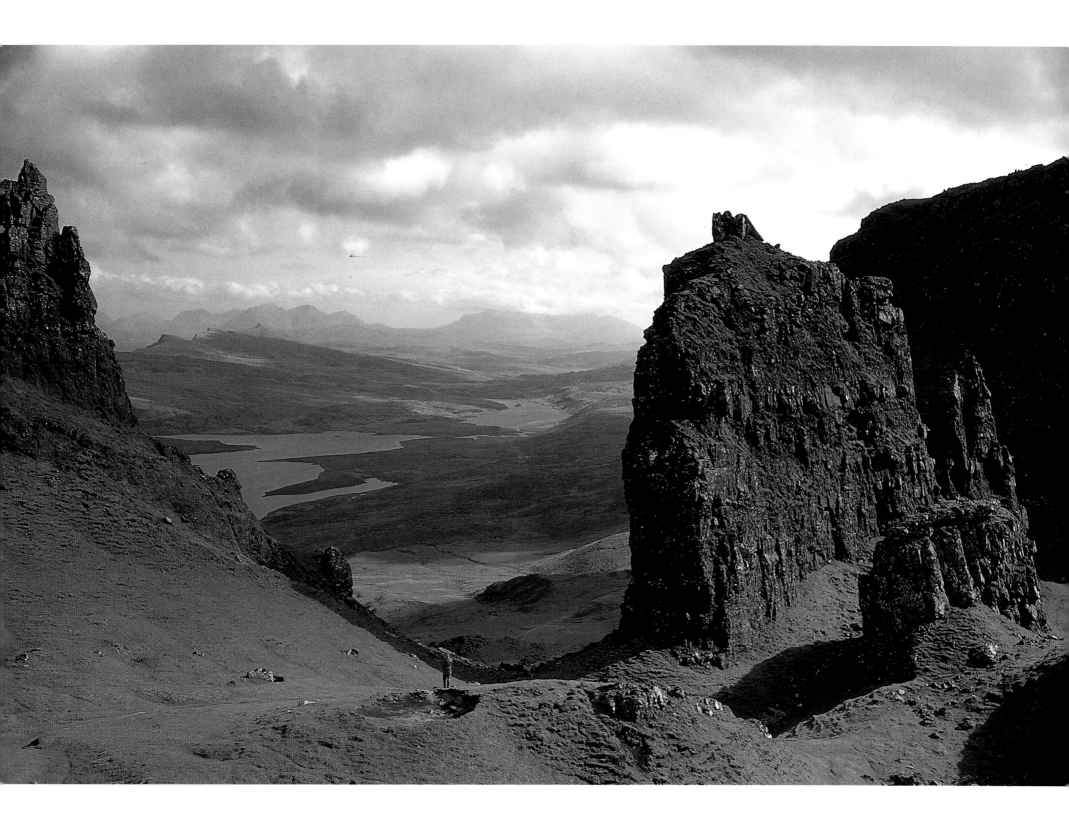

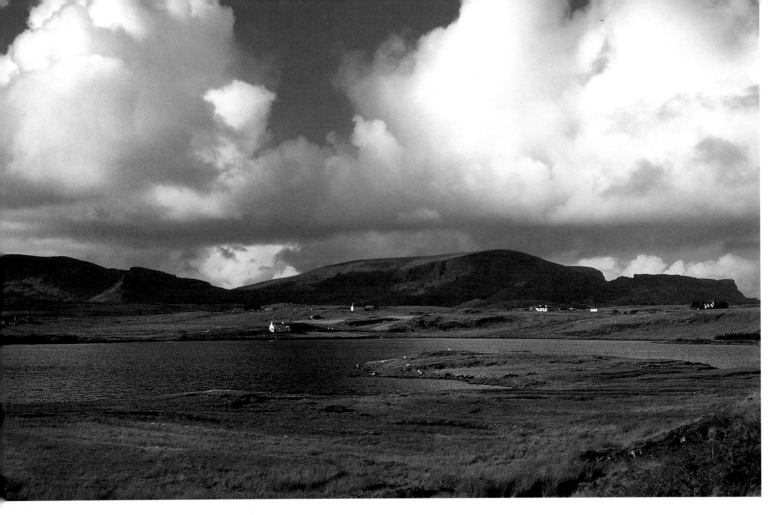

A rim of impressive coastal cliffs runs parallel to the central ridge of Trotternish culminating in the columnar nose of Kilt Rock. The rock is dolerite, formed by a horizontal intrusion of magma between pre-existing sediments. This magma sill contracted on cooling into a hexagonal vertical joint pattern. The resultant cliffs resemble the pleats of a kilt and are over 160ft in height. Excellent views can be obtained by scrambling along the cliff edge north of Valtos. However, the grassy brink is a treacherous place on a windy day and the viewing platform below Loch Mealt makes a safer vantage.

Above
The Trotternish ridge rolls north from The Storr in a series of whaleback swells at a continuous altitude between 1,000 and 2,000ft. Precipitous east-facing scarps accompany the ridge throughout the 12-mile range. Strong

walkers can make a complete traverse of the ridge in a single magnificent expedition. In the view from Loch Mealt past the croft houses of Elishader the skyline hills are Bioda Buidhe and, to the right, 1,782ft (543m) Meall na Suiramach.

Right
Staffin means 'the place of the upright pillars' and Kilt Rock is one of the many dolerite cliffs which lie in the vicinity. A large community is formed by several crofting townships which are strung around the curving arc of Staffin Bay. Despite the profusion of crags Staffin also has some of Skye's most fertile ground and best grazing in its hinterland.

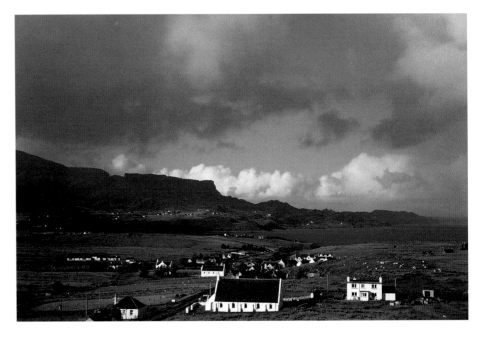

146

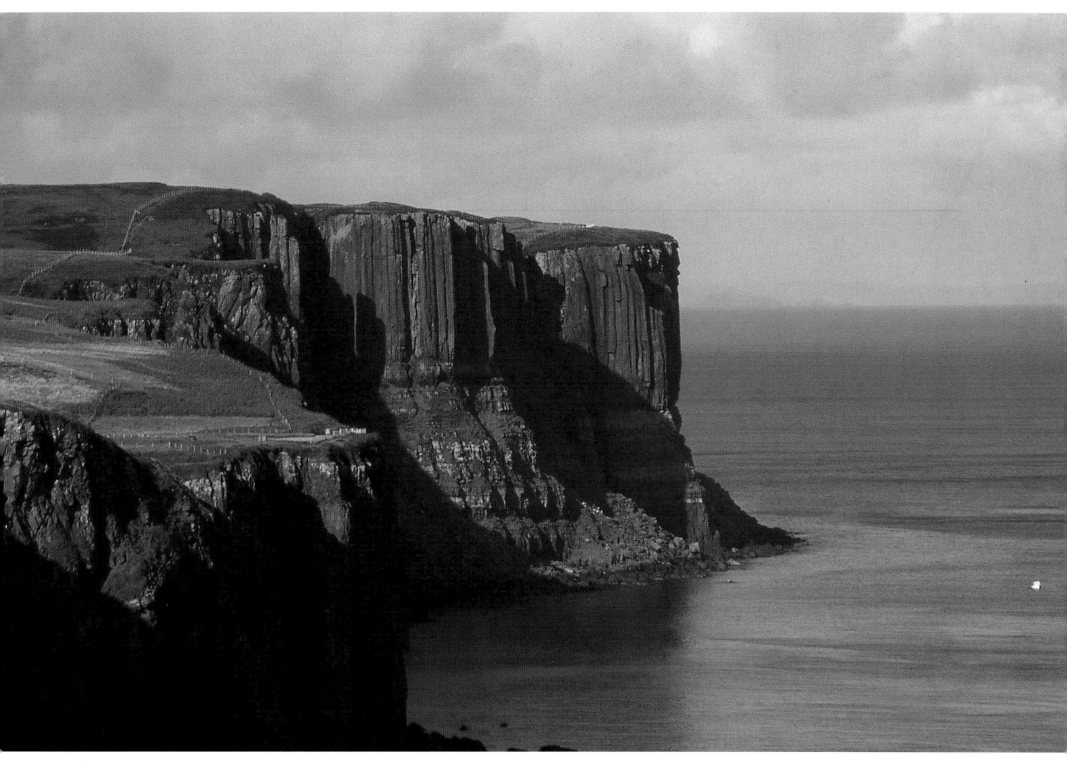

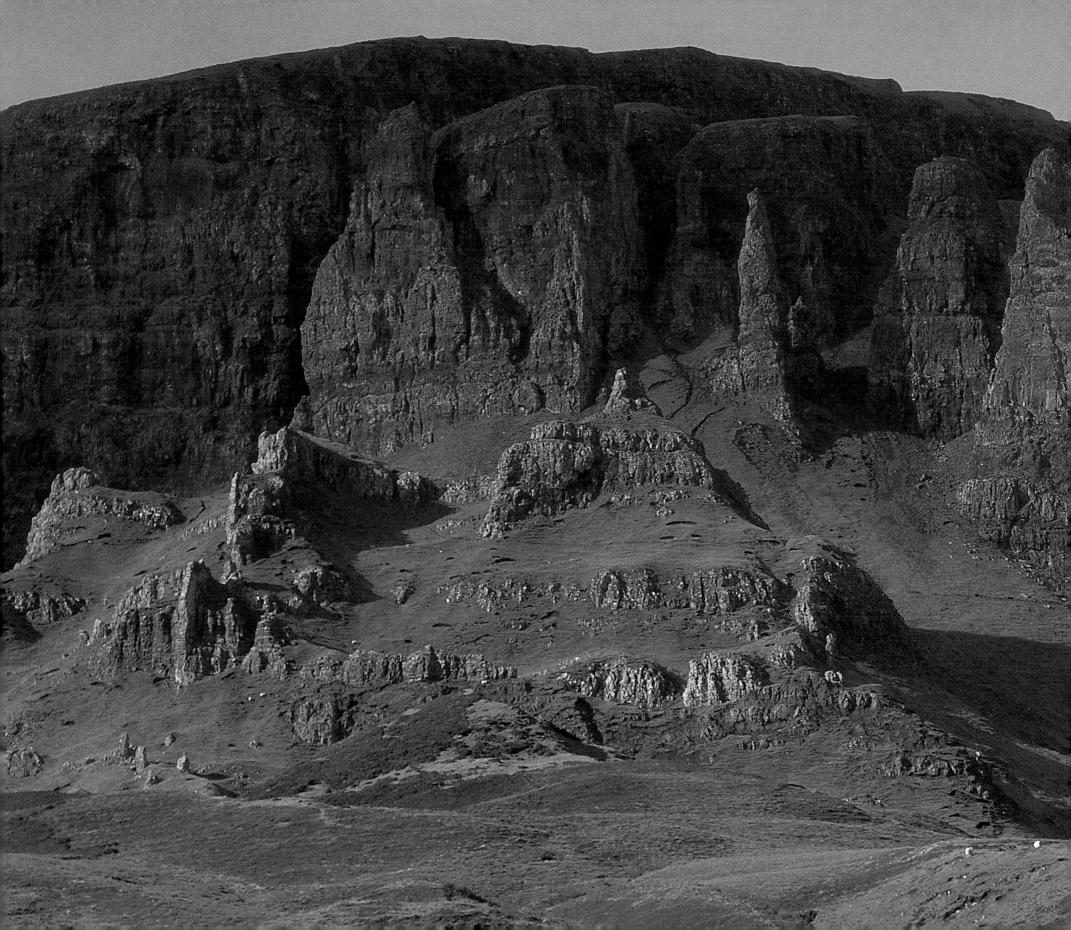

Left

The Quiraing is another series of ancient landslips, more chaotic and impressive than those which formed The Old Man, yet bearing uncanny resemblance to The Storr when viewed from the access road from Staffin. The name Quiraing means the round fold or pen, in reference to The Table, a horizontal plinth of cropped grass almost 100ft in diameter, locked away high in the shattered cliffs. The Table can only be reached by a steep climb on screes through the lower pinnacles and forms a cul-de-sac. There is no route up the final barrier of crags to gain access to the summit of Meall na Suiramach behind. The whole area of landslips can be explored by adventurous scramblers in a couple of hours.

Below

At Duntulm Castle the Island of Skye makes its final gesture of defiance to the encroaching seas. The Trotternish coast stretches a couple of miles further north to its terminus at the cliffed headland of Rubha Hunish, but for most travellers Duntulm is where they make a final stop before turning back south to Portree. Originating in the fifteenth century the castle was a seat of the MacDonalds of the Isles until being vacated in the 1730s. Much of the stonework of the building was plundered, first by the MacDonald chief for his new building 5 miles away at Monkstadt, and later by local farmers in the nineteenth century. The remaining ruins barely hint at the castle's former scale and glory.

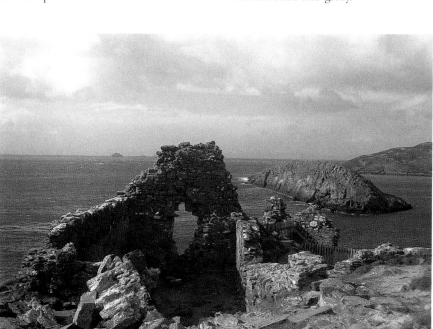

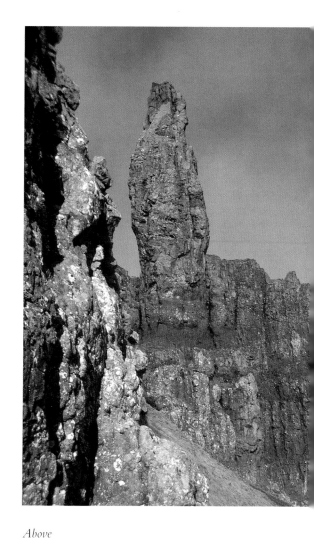

Above

Like The Storr, the Quiraing has one pinnacle which stands out from the rest. The slender tower of The Needle is over 130ft in height. Composed of the most dubious sandwich of basalt lavas the 1996 climbing guidebook to Skye recorded its first ascent 'more as a warning than as a recommendation'.

149

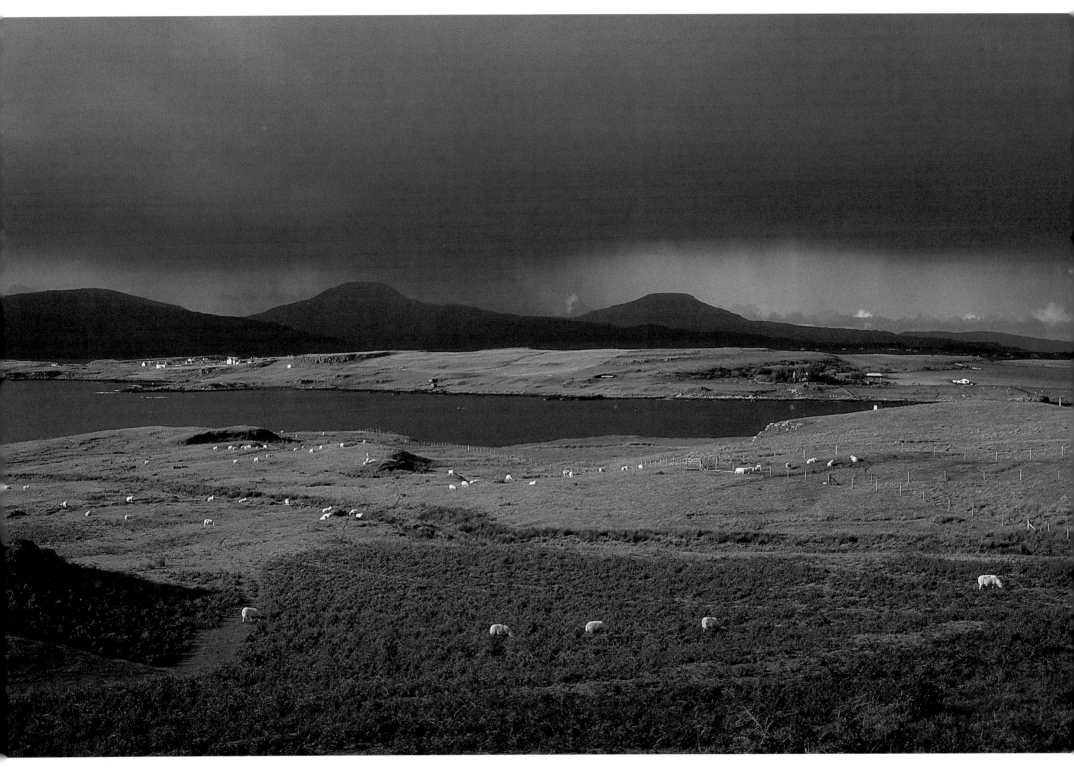

MACLEOD COUNTRY

Autumn days can mix the rich colour of the golden heath with scudding cloudbanks and oblique sunlight, creating the perfect mood to visit the peninsula of Duirinish in north-west Skye. The inflections of light and shade capture the essence of this coastal wilderness and display its crofting settlements with pride and strength as they prepare to face the winter's storms. The photographer can gain in a single day what might take weeks of patience in less favourable weather. Each passing shower and every change of scene produce new opportunities, and when the sun's final rays are fortuitously cast on Dunvegan and its castle one's sense of elation is matched only by a humble admiration of the beauty one has shared.

Left
Healabhal Bheag and Healabhal Mhor, the flat-topped twins more familiarly known as MacLeod's Tables, dominate the skyline of Duirinish. Their name is of Norse origin, Healabhal being derived from *helgi fjall*, meaning holy fell. As a shower gathers over their summits morning sunshine bathes the Harlosh peninsula and its string of croft houses in striking colour.

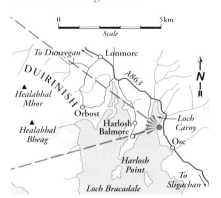

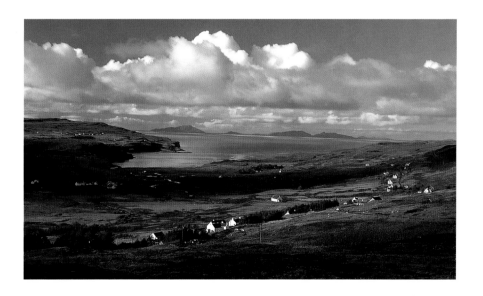

Left
Glendale is the only valley in Duirinish which is still heavily populated. Reached by an 8-mile drive from Dunvegan over the pass of Ben Totaig, the glen possesses a certain detachment from the rest of the island. In 1882 local crofters under the leadership of John MacPherson mounted vigorous opposition to the oppression of their landlords, who had cleared many families from their land and even forbade the collection of driftwood or keeping of dogs. The protests were subdued by the arrival of a gunboat in Loch Pooltiel and several ringleaders imprisoned. However, in 1883 the Government responded to the underlying injustices by appointing the Napier Commission to investigate the crofters' grievances. This resulted in the Crofters Act of 1886 which for the first time gave security of tenure at fair rents.

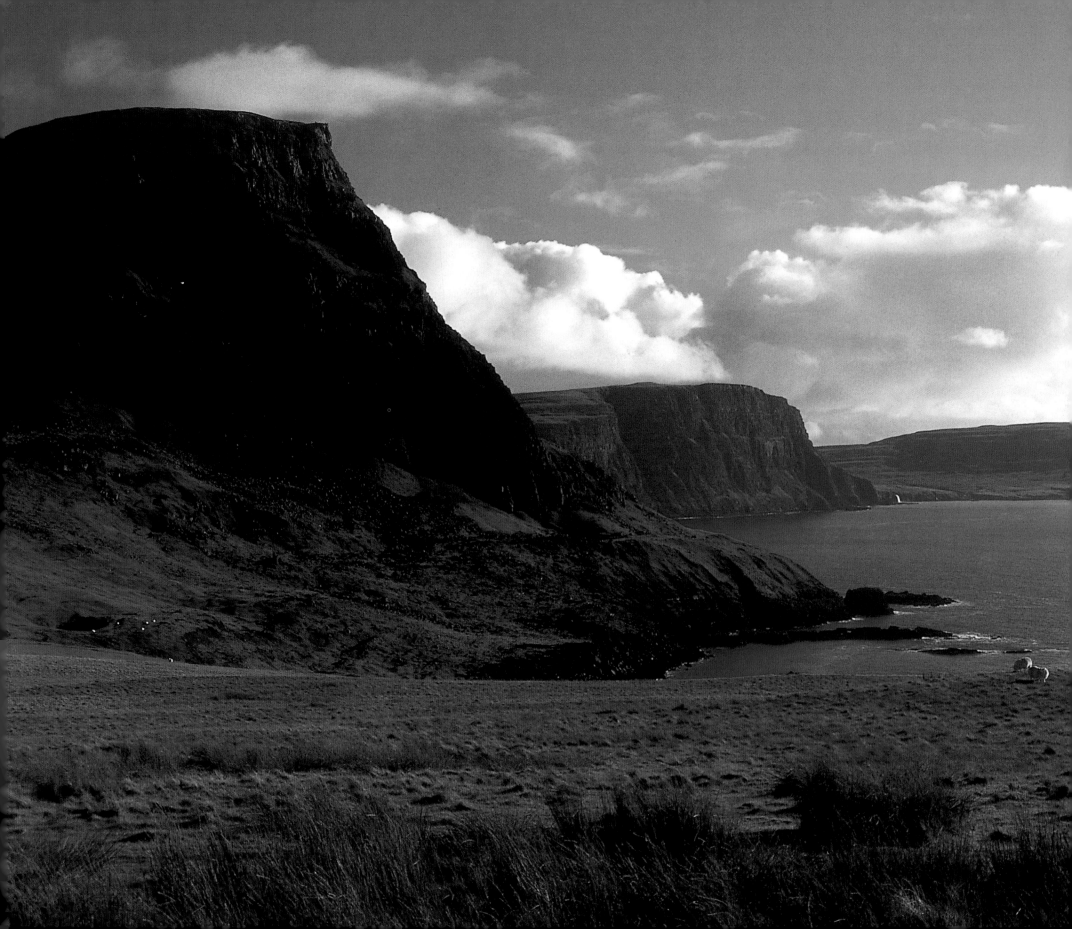

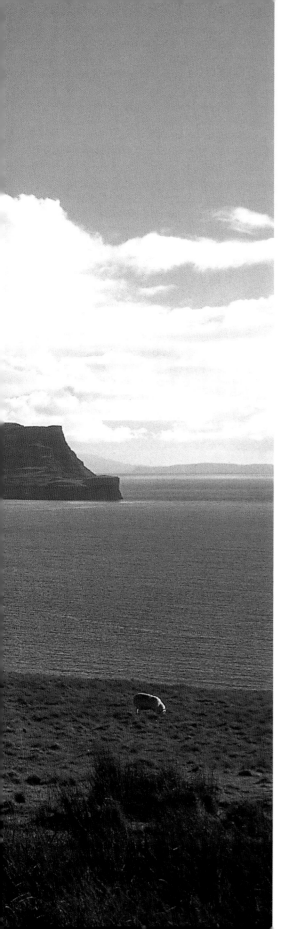

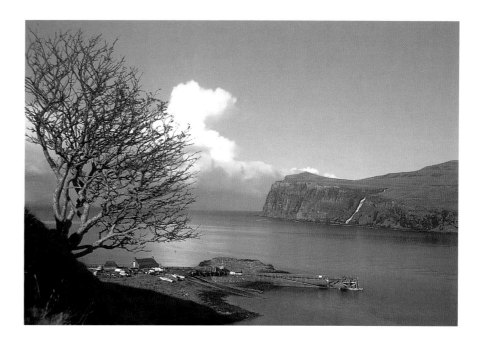

Right

The pier at Meanish on Loch Pooltiel was once a regular calling point of coastal steamer services but is now used largely by local fishermen. The loch is the only sheltered anchorage on a coastline of unremitting grandeur. On its far side the cliffs rise to over 1,000ft in height at Biod an Athair, the 'sky cliff', the highest on the island.

Left

At Waterstein Head, 971ft (296m), a magnificent cliff-top traverse commences. Sheer walls of basalt and dolerite, broken only occasionally by narrow valleys, stretch south east for 10$^{1}/_{2}$ miles to Idrigill Point, where the coast turns back north for a further 4 miles to the road-end at Orbost. This coast is uninhabited, and the walk is perhaps best enjoyed over two days with a camp half-way.

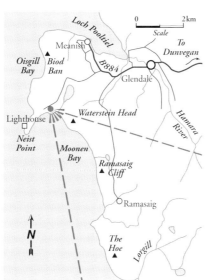

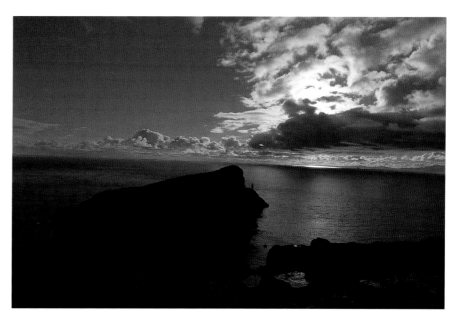

Above

Neist Point forms the most westerly tip of Skye and its lighthouse looks out across The Minch to North and South Uist. Since 1989 the light has been unmanned, but the house provides self-catering accommodation. The name Neist, *an eist* – the horse – derives from the equine resemblance of the profile of the headland. The pronounced hump is An t-Aigeach, the stallion, rising to 300ft.

South of Dunvegan low peat moors and sea inlets provide open vistas across Loch Bracadale to the Cuillin. The distant mountains, already sprinkled with snow, lend a haunting beauty to the peaceful evening scene.

Inquisitive sheep graze on the cliff tops between Neist Point and Oisgill Bay as the afternoon light casts a warm glow on the walls of Biod Ban behind. In 2000 there were 94,987 sheep on Skye, spread between some 1,500 croft holdings. The superior quality of the grasslands on the lava flows which cover much of the island can support a much higher density of grazing than the coarse sedge and heather on the mainland.

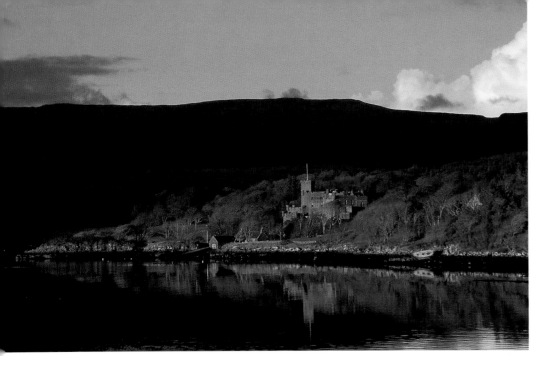

Above
Dunvegan Castle has been the stronghold and seat of the MacLeod clan since its formation in the thirteenth century, although most of the present building and its forested grounds date from the nineteenth century. With a history spanning the medieval feuds between MacLeods and MacDonalds, through the Victorian embellishment to the cost-conscious management of today, the castle contains the showpiece relics of the Fairy Flag, Dunvegan Cup and Rory Mor's Drinking Horn. The building is still the main home of the MacLeod family, even though much of it is open to visitors throughout the year. Catching the afternoon sunlight the castle shows its majesty in the view from the west shore of Dunvegan Bay at Uiginish.

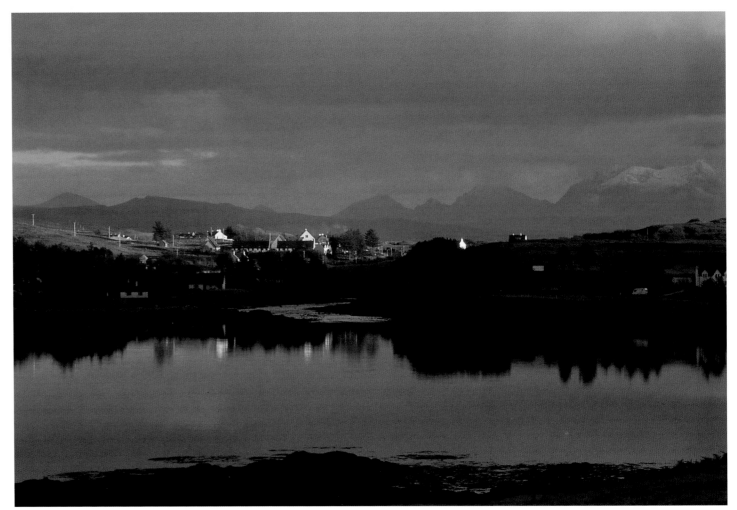

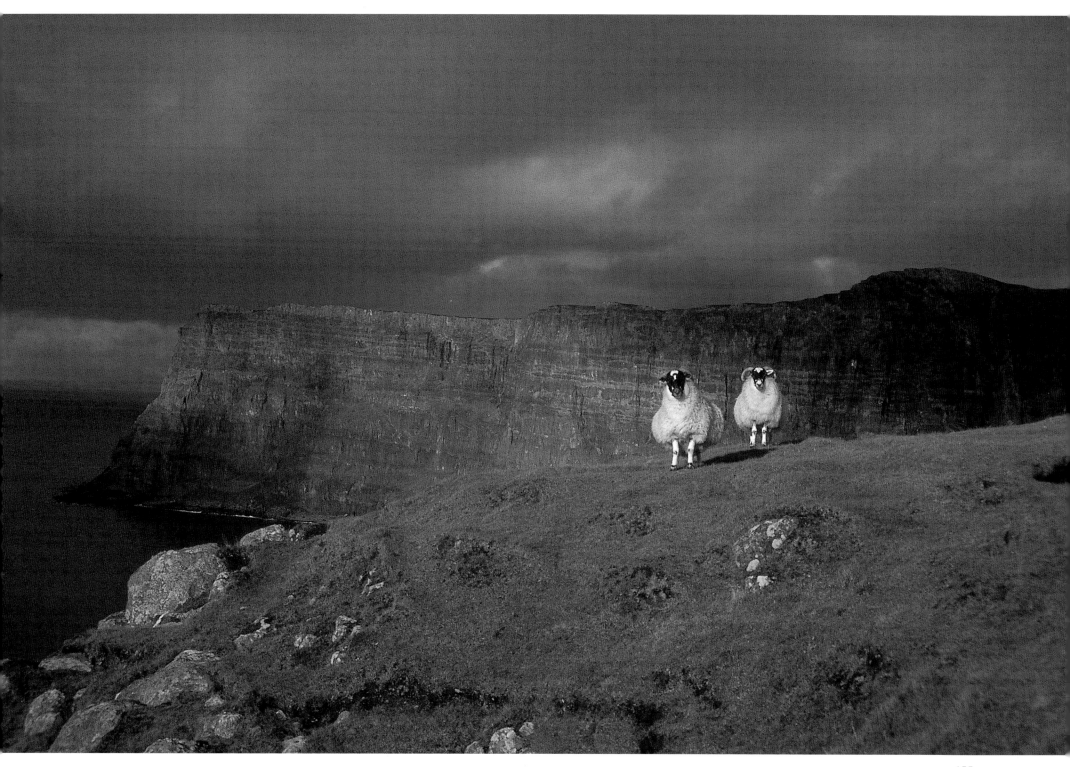

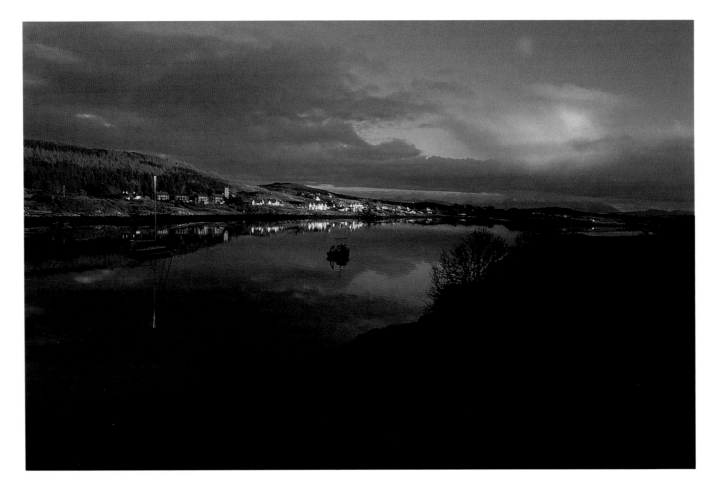

Above

Dunvegan village and harbour catch the last glints of the day's sun and a chill night gathers. Already at the end of October there are some 14 hours of darkness, and every hour of available sunlight is precious, making the aspect of a settlement of vital importance. With a south-west facing frontage and open relief to the south, Dunvegan's hotels, shops and homes can be assured of some sunshine hours throughout the year. Being sufficiently far from the moisture sponge of the Cuillin mountains, the townships of north Skye enjoy a considerably drier climate than might be expected.

Right

On the homeward drive down the shores of Loch Bracadale the sun makes a final appearance before setting behind the clouds. Whether visiting or living on Skye such moments are to be treasured, for by morning the wind may be howling and the sky heavy with the threat of rain.

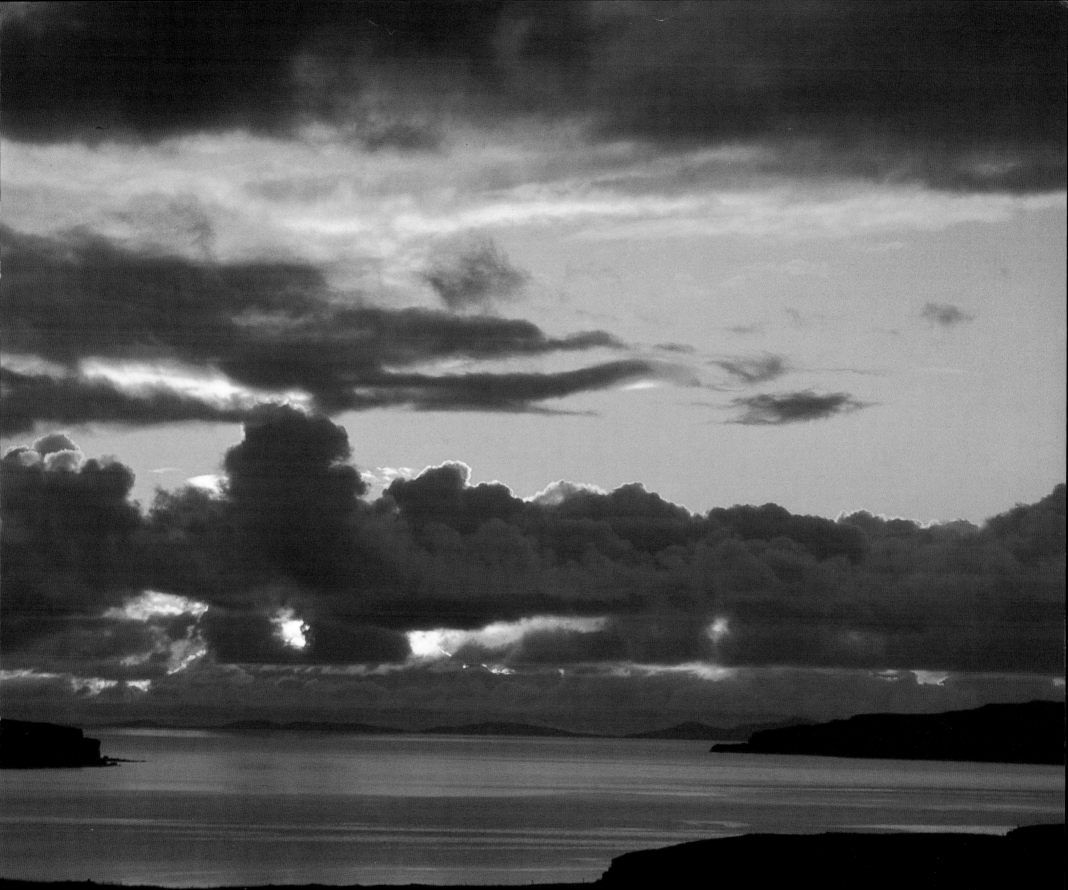

NOTES ON PHOTOGRAPHY

The pictures in the book span a period of 20 years between 1980 and 2000, with only a few shots dating from earlier, using a standard selection of equipment familiar to any keen amateur photographer.

Nearly all the photographs were taken on manually operated Pentax, Ricoh and Minolta SLR cameras except for a few of the mountain-top views which were shot on Olympus and Canon compact cameras. Standard lenses were used on the SLR cameras – 24mm, 28-70mm, and an 80-200mm zoom – with an optional selection of polarising, weak warming, 85B, grey and tobac gradation filters. Most pictures were shot with a tripod, using self-timing rather than cable shutter release.

Almost all the pictures were shot on Fuji 100 Sensia slide film.

The Wester Ross selection was made from Clarrie Pashley's archive collection of over 15,000 slides with the addition of some mountain shots on An Teallach and the Torridon peaks. With the benefit of living locally, brief periods of exceptional lighting or cloud effects could be exploited with a short drive and a few minutes' walk.

By contrast, completion of the Skye portfolio required several specific journeys round the island during the year 2000. With good judgement of weather and an element of luck a success rate of 75 per cent was achieved between productive and wasted days. Mobile weather conditions with a combination of sunshine, showers, shifting clouds and crystal-clear air provided the most fruitful results in colour and contrast, whereas settled days with unbroken skies often failed to inspire despite wide views. The frustrations of hazy undifferentiated summer days was replaced by the thrill of capturing the precious colours and stunning light of autumn and early winter. Martin Moran took the Cuillin Ridge selection over a period of 15 years which included 26 complete traverses of the Main Ridge, nearly all of them in May and June.

ACKNOWLEDGEMENTS

I would like to dedicate this book to my wife Barbara who, for over 50 years, has patiently put up with me waiting with my camera, often for hours on end, for the light to change or for a sunset to reach its optimum.

Also, my special thanks are due to Martin for initiating and preparing this book, for his massive contribution of text and captions, and for his inspiring photographs of some of the high places that I could not reach.

Martin and I finally wish to express our great appreciation to Sue Viccars, Les Dominey, and Ethan Danielson, for their vision and hard work in editing text and pictures, arranging page layouts and producing excellent maps and diagrams, to bring this book to publication.

CLARRIE PASHLEY

BIBLIOGRAPHY *Books currently in print (in historical order)*

Historical Guides and Gazetteers

Martin, Martin. *A Description of the Western Islands of Scotland c1695* (Birlinn, 1999): the earliest account of society on the Isle of Skye; now reprinted

Johnson, Samuel and Boswell, James. *A Journey to the Western Islands of Scotland*, and *A Journal of a Tour to the Hebrides* (Penguin Classics, 1775/1984): reprint of Johnson's and Boswell's classic accounts of their 1773 tour of the Highlands

Smith, Alexander. *A Summer in Skye* (Birlinn, 1995): account of a sojourn on Skye in the summer of 1865

Dixon, John. *Gairloch and Guide to Loch Maree* (Gairloch Heritage Society, 1886/1974): Victorian gazetteer to the environs of Gairloch with a wealth of detailed observation and history

Macrow, Brenda. *Torridon Highlands* (Hale, 1953/1974): classic romantic account of the Torridon hills and area written in the 1940s

The Tertiary Volcanic Districts of Scotland 3rd edition (British Geological Survey, HMSO, 1961): the geological secrets of Skye's landforms

Charnley, Bob. *Over to Skye.. Before the Bridge* (Clan Books, 1995): album of photos spanning the history of the Kyle–Kyleakin ferry

Cooper, Derek. *Skye* (Birlinn, 1970/1995): highly informative gazetteer originally written in the 1960s

Hunter, James. *Skye: The Island* (Mainstream, 1997): social and historical commentary on the island

Uncles, Geoffrey. *Old Ways through Wester Ross* (Stenlake, 1998)

Lowe, Chris. *Torridon – the Nature of the Place* (Wester Ross Net, 2000): geology, natural history, flora and fauna of Torridon

Photographic Books

Poucher, Walter A. *The Magic of Skye* (Constable, 1949/1989): Poucher's landmark portfolio of monochrome photographs of Skye, especially the Cuillin

Stainforth, Gordon. *The Cuillin – Great Mountain Ridge of Skye* (Constable, 1994): acclaimed photographic collection from a year spent in the Cuillin mountains

Paterson, David. *A Long Walk on the Isle of Skye* (Peak Publishing, 1999): beautiful photographic selection based on a walking route through the island

General, Walking and Scrambling Guidebooks

Fabian, D.J., Little, G.E., and Williams, D.N. *The Islands of Scotland including Skye* (SMC District Guide, 1989)

Barton, Peter. *Torridon – A Walker's Guide* (Cicerone Press, 1989)

Bennet, D.J. and Strang, T. *The North West Highlands* (SMC District Guide, 1990)

Welsh, Mary. *Walks on the Isle of Skye* (Clan Walks Guides, 1990/1999)

Welsh, Mary. *Walks in Wester Ross* (Clan Walks Guides, 1991/1999)

Nicholson, Angela. *Gairloch & Torridon – the Complete Travellers Guide* (Thistle Press, 1993)

Atkinson, Tom. *The North West Highlands – Road to the Isles* (Luath Press, 1993)

Newton, Norman. *Skye* (Pevensey Island Guides, 1995)

Storer, Ralph. *50 Best Routes on Skye and Raasay* (David & Charles, 1996)

OS Pathfinder Guide. *Skye and the North West Highlands Walks* (Jarrold, 1996)

Marsh, Terry. *The Isle of Skye – a Walker's Guide* (Cicerone Press, 1996)

Clark, Pamela. *Knoydart, Skye & Wester Ross – West Coast Walks* (Kittiwake, 2000)

Brown, Hamish. *25 Walks – Skye and Kintail* (Mercat, 2000)

Koch-Osborne, Peter D. *The Glens of Ross-shire – a guide for walkers and mountaineers* (Book 9 The Scottish Glens, 2000)

Williams, Noel. *Scrambles on Skye* (SMC, 2000)

Maps

Ordnance Survey 1:50000 Landranger series
Nos 15 Loch Assynt;
19 Gairloch and Ullapool;
20 Beinn Dearg;
23 North Skye;
24 Raasay; Applecross and Loch Torridon;
25 Glen Carron;
32 South Skye;
33 Loch Alsh and Glen Albyn

Ordnance Survey 1:25000 Outdoor Leisure Series
No 8 The Cuillin and Torridon Hills

Harveys Superwalker Maps 1:25000
The Cuillin; Kintail (Glen Shiel); Torridon

Collins Tourist Map: Skye & Torridon